The contours of multimedia

Recent technological, theoretical and empirical developments

Edited by

Nicholas W. Jankowski

and

Lucien Hanssen

Acamedia Research Monograph 19

UNIVERSITY
UP of JL
LUTON PRESS

British Library Cataloguing in Publication Data
A catalogue record for this book is available from the British Library

ISBN: 1 86020 511 9
ISSN: 0956–9057

Series Editor: Manuel Alvarado

Published by

John Libbey Media
Faculty of Humanities
University of Luton
75 Castle Street
Luton
Bedfordshire LU1 3AJ
United Kingdom
Telephone: +44 (0) 1582 743297; Fax: +44 (0) 1582 743298
e-mail: john.libbey@luton.ac.uk

Printed in Great Britain by Whitstable Litho, Whitstable, Kent, U.K.

Contents

Technical and Market Developments

Theoretical Perspectives

Case Studies of Applications

Research Considerations

Acknowledgements

This volume has its origins in presentations given at two seminars – 'meetings of experts' – held in 1993 and 1994. These seminars were hosted and sponsored by the Foundation for Public Information on Science and Technology (PWT) in Utrecht and the Department of Communication at the University of Nijmegen, both in the Netherlands. Further, the Centre for Telematics Research in Amsterdam provided financial assistance for the editorial and production phases of the book. We are grateful for the support these institutions have lent to the project.

All too often volumes such as this have long gestation periods. Initial drafts required refining and some of the contributions had to be translated. In spite of delays encountered, the authors remained enthusiastic and consented to frequent requests for revisons and updates of their work. We as editors are particularly grateful for their support, and look forward to future opportunities to explore with them the parameters and ramifications of multimedia.

Nicholas W. Jankowski and Lucien Hanssen
Nijmegen/Utrecht
The Netherlands

Contributors

Harry Bouwman (1953) is senior researcher at the Institute of Policy Studies (TNO-STB) and lecturer at the Department of Communication, University of Amsterdam. His research interests include information technology policy and organizational use of multimedia. More specifically, he has interest in policy formulation regarding National Information Infrastructures, multimedia interface, cost-benefit analysis, and use of multimedia. These are also the topics on which he lectures at the University of Amsterdam. (email: bouwman@pscw.nl)

Jak Boumans (1945) is managing director of Electronic Media Reporting, a consultancy and marketing research bureau in the field of electronic publishing, based in Utrecht, the Netherlands. Boumans has been active in the field of electronic publishing since 1970 and in the field of on-line and CD media since 1980. In 1984 he launched the electronic newsletter *IDB Online* for the computer industry on behalf of the publisher VNU. He has written books on database marketing, on-line information retrieval, multimedia investments and production of CD media titles. Presently he is completing a study of digital dailies on Internet and interactive cable systems. (e-mail: jak@euronet.nl)

Maddy D. Brouwer-Janse (1943) is a Senior Scientist at Philips Research Laboratories Institute for Perception Research in Eindhoven, the Netherlands. Her major interests are human-machine communication, user-interface design and product creation processes, individual differences of users and the effects of human life-span development which concern users of advanced information technology in new applications such as multimedia. Before joining Philips she worked in Advanced Systems Development at Sperry Corporation (Unisys) and at the Centre for Research in Learning, Perception and Cognition of the University of Minnesota, where she received a PhD in Cognition and Developmental Psychology. (e-mail: brouwerm@natlab.rcscarch.philips.com)

Reinier Etienne (1971) studied Administration Science at Erasmus University in Rotterdam and Communication Science at the University of Nijmegen in the Netherlands, where he completed his master's degree in 1995 with a theoretical

study of the concept interactivity. His professional interests include the impact of new communication technologies on individuals and organizations, and the application of these technologies in the field of marketing. (email: etienne@fys.ruu.nl)

Lucien Hanssen (1960) is a staff member of the Foundation for Public Information on Science and Technology. He is involved in the areas of science broadcasting, opinion research and new communication technologies, particularly in the area of public debate. Further, he participates in a research programme at the University of Nijmegen concerned with virtual identities, cultures and communities. (email: lucien.hanssen@pwt.nl)

Bart van den Hooff (1967) is research associate at the Department of Communication, University of Amsterdam. His research interests include organizational use of computer-mediated communication and multimedia in general. More specifically, he is concerned with adoption, use and effects of electronic mail in organizations (the subject of his forthcoming dissertation), and organizational uses of the Internet. (email: vandenhooff@pscw.uva.nl)

Nicholas W. Jankowski (1943) is Associate Professor at the Department of Communication at the University of Nijmegen, the Netherlands. He has conducted empirical research on new communication technologies since the mid-1970s and has co-edited volumes on qualitative research methodology, local radio and television, interactive media and mass communication theory. Nick Jankowski is currently examining the development of virtual communities in cyberspace. (email: N.Jankowski@maw.kun.nl)

Anne de Jong (1970) received her degree from the Department of Communication at the University of Amsterdam, specializing in information science. Since 1994 she has been employed as a research executive for The Media Partnership Nederland. Research conducted by this agency concentrates on advertising effectiveness of different media as well as on specific advertising campaigns.

Cor van der Klauw (1932) is Professor in Educational Technology at the Erasmus University, Rotterdam, the Netherlands. Before his appointment in Rotterdam he was director of the Educational Research Centre of Twente University in Enschede, the Netherlands. He has conducted research on teaching and learning in higher education. During the last 15 years his interests have been mainly in the area of research and development of computer-assisted learning and the use of multimedia in education. Van der Klauw is co-author of a study on computers in medical education. (email: Klauw@otech.fgg.eru.nl)

Cees Leeuwis (1962) is a member of the academic staff at the Department of Communication and Innovation Studies at Wageningen Agricultural University in the Netherlands. He is involved in socio-anthropological research in the everyday use and development of communication technologies, especially in the field

of agriculture. One of his key interests is the development of methods for both user need assessment and participatory technology development. Also, he is studying the potential and limitations of new communications media for facilitating public debate and policy formation. (email: cees.leeuwis@alg.vlk.wau.nl)

Peter Linde (1955) is Head of the GIS and Multimedia Lab within the Department of Information Management and Data Communications of Wageningen Agricultural University. He is responsible for the initiation and management of innovative projects related to the introduction of multimedia and new communication technologies related to teaching and learning. Linde is coordinator of the AQUARIUS project (EU Telematics Applications Programme). He also is involved in STOAS, one of the projects affiliated with the Electronic Highway initiative of the Dutch government. (email: peter.linde@gismmlab.imdend.wau)

Rob Nadolski (1961) is employed as educational technologist at the Educational Technology Expertise Centre at the Open University of the Netherlands in Heerlen. He is involved in the educational design and development of various learning materials, particularly in the field of natural sciences and law. (email: rob.nadolski@ouh.nl)

Paul Nelissen (1959) is Associate Professor at the Department of Communication at the University of Nijmegen in the Netherlands. His research interests include audience studies, public communication campaigns and information technologies. He has published both theoretical and empirical studies in these areas. (e-mail: u211792@vm.uci.kun.nl)

Karoline van den Reek (1966) studied computer science at the Eindhoven Polytechnic School. After contributing to development of control software for medical imaging equipment at Philips Medical Systems, she joined the Institute for Perception Research, Eindhoven, the Netherlands, to work in the field of multimedia. Her research activities involve qualitative and quantitative user evaluations of CD-i pointing devices.

Emely Spierenburg (1970) is currently working as a CAE (Computer Assisted Education) designer at Erasmus University in Rotterdam, the Netherlands. She holds a master's degree in Health Sciences from the University of Maastricht, the Netherlands. Between 1993 and 1995 she evaluated the CD-i programme *Het Station*, resulting in a new and thoroughly improved version of the programme. In July 1994 she started working as a designer of various CAE programmes (CD-i and CD-ROM) at Erasmus University. Her main interests are graphic and educational design. (email: spierenb@fgg.eur.nl)

Fred de Vries (1963) works as an educational technologist at the Educational Technology Expertise Centre at the Open University of the Netherlands in Heerlen.

In this capacity he is involved in the educational design and development of various electronic learning materials. (email: fred.devries@ouh.nl)

Joyce Westerink (1960) received her PhD from Eindhoven University of Technology and has been employed at the Institute for Perception Research (IPO) in Eindhoven, the Netherlands, since 1985. Her research interests include various topics in the domain of man-machine communication, such as perceived image quality and the modelling of user-system interactions. Presently, she is involved in the investigation of user interfaces of (multimedia) information systems around such aspects as user navigation through information structures and information representation. (e-mail: westerin@natlab.research.philips.com)

Marc van Wegberg (1957) is Assistant Professor at the Economics Faculty of the University of Limburg in Maastricht, the Netherlands. He received his PhD at that university in 1994 on a theoretical study about multi-market competition and has published several articles on the topic. His current research interest is development of new media, especially that of the Internet and multimedia. Points of departure for these studies are multi-market competition, standards competition, mergers and alliances, and the diffusion of these new technologies. (email: m.vanwegberg@mw.rulimburg.nl)

1 Introduction: Multimedia Come of Age

Nicholas W. Jankowski and Lucien Hanssen

The term multimedia has become something of a catch-all phrase for a large array of new communication technologies: CD-ROM, CD-i, interactive television, video-on-demand, virtual reality – to name a few. It qualifies without doubt as one of the buzz words of the 1990s, and has been the topic of popular magazine as well as serious journal articles. Along with similarly fashionable phrases like cyberspace and Internet, multimedia has whetted the appetites of computer and telecommunications industries, educational institutions, and professional and lay consumers.

Many references to multimedia have little more substance than marketing hype. Authors of some of the more popular literature speak in terms of the 'next millennium' and urge us 'to embrace this social change that promises to usher in a new pattern of communication' (Aston & Klein, 1994:44). These authors prophesize that, thanks to multimedia, 'the world will experience new levels of productivity and creativity' and they further admonish us to 'either go boldly into this next millennium or to be swept into oblivion.'

It would be naive, of course, to consider such expressions as any more than what they are: inflated exclamations by those with vested interests. That reservation having been stated, it would be equally short-sighted to dismiss all of what is associated with multimedia as bandwagon ballyhoo. On the contrary, the interests, the possibilities, and – to some extent – the accomplishments of multimedia are substantial and impressive. The institutional structures for monitoring these developments are rapidly emerging. Special research centres have been established for investigation of facets of multimedia, trade and scholarly publications review and critique developments, conferences are regularly being held for presentation of findings to professional and academic communities.

A wealth of literature is rapidly accumulating on these developments, particularly in popular and 'how to' genres (e.g. McGowan & McCullaugh, 1995; Willis, 1994; Kristof & Satram, 1995; Collin, 1994; Bowen, 1994). There is also much work available on technical aspects of multimedia (e.g. Burger, 1992; Nakajima & Ogawa., 1992). But critical examinations of multimedia from social science perspectives are poorly represented, although there are a few excellent compilations available (e.g. Latchem *et al.*, 1993; Katzen, 1982).

This book is meant as a contribution to that last category of serious literature. The volume is a collection of reflections on multimedia – its technical and theoretical basis, some of its educational and informational applications, and research approaches and considerations. Many of the contributions have their origins in two seminars held in the Netherlands for specialists from industry, government, journalism, and universities. In January 1993 the first of these seminars was held around use of CD-i technology in public information campaigns and in educational settings (Hanssen & Jankowski, 1993). The second was held in June 1994 and explored difficulties in designing multimedia titles (Hanssen & Jankowski, 1994). A number of other chapters were subsequently commissioned in order to broaden and strengthen the collection.

The contributors to this volume represent a wide range of social science disciplines: industrial economics, public communication practioners and theorists, social psychologists, educational technology specialists and (mass) communication scholars. Amid this diversity of specialisms is a collectively underwritten committment to examining the development of multimedia analytically with argumentation supported by empirical evidence.

The editors and a majority of contributors have professional ties to communication science, and one of the underlying objectives of the book is to contribute to understanding multimedia from theoretical perspectives grounded in that academic domain. Communication science has arrived rather late on the multimedia scene, and much theoretical and empirical work needs to be undertaken; this volume is meant as an effort to rectify that deficiency.

This introductory chapter begins with an almost impossible task: defining multimedia. Thereafter, broad sketches are given for each of the volume sections: technical and market developments, theoretical perspectives, applications and research considerations. Within these sketches the arguments of the respective chapters are profiled – and sometimes critiqued. Finally, suggestions are made for a multimedia research agenda – seen from the perspective of communication science.

Defining multimedia

It is not an easy undertaking to define multimedia. Some authors (e.g. Aston &

Klein, 1994) have dispensed with this definitional task, seemingly satisfied with observations about the wide diversity of new communication technologies associated with multimedia and the related vagueness of the term. Others (e.g. Bouwman, 1993) seem to find solace in a relatively technical definition emphasizing the presence of diverse media within a single system of electronics. It is not uncommon to see reference to 'interactive multimedia', (e.g. in Ambron & Hooper, 1988; Latchem *et al*., 1993), apparently to distinguish this form from multimedia lacking interactive possibilities. In contrast, other authors like Aston and Klein (1994:13) consider interactivity an essential component of all multimedia. As elaborated in detail in Chapter 5, we do not consider interactivity primarily a facet of media, but of persons and media brought together in a particular situation. Interactivity, then, is the result of related actions and reactions between media and users.

Before the widespread appearance of compact disc technology, definitions of multimedia were usually formulated simply as utilization of a variety of media for particular pedagogical objectives. Sometimes such combinations were advocated because particular kinds of content were deemed to be better or more suitable when presented via different media forms. Student interest and performance was also believed to improve through multimedia instruction. Since the arrival of laserdiscs, CD-ROM, CD-i and other such technologies, the term multimedia has been strongly associated with how different media forms are integrated within a single carrier of information. The other interpretation of multimedia – sometimes called hybrid multimedia – has receded from most discussions.

The editors of one of the earliest collections of CD-ROM applications, based on a conference Microsoft hosted in 1986, described multimedia in unsubdued emotion as: 'What is new and exciting is the innovation of mixing text, audio, and video with a computer....Users can browse, annotate, link, and elaborate on information in a rich, nonlinear, multimedia data base' (Ambron & Hooper, 1988:5). These authors identified three elements of multimedia: (1) media in forms such as text, sound and images, (2) computer and optical technology, and (3) multimedia products (software) such as talking books and teacher lecture aids.

More or less the same media are mentioned in contemporary descriptions of multimedia, although 'data' is sometimes mentioned separately as a media form, and images are specified as either still and moving. What is substantially different now is emphasis on the digital nature of all media types, giving all media the same fundamental structure. Prominent spokesmen such as Negroponte (1995) contend this is the central element of new communications technology developments, and as a consequence of multimedia, too. The manifestations of multimedia have expanded substantially since the Microsoft conference in 1986 and Ambron's and Hooper's summary list of examples noted above. Now, multimedia are associated with virtually all new communication technologies: CD-i and CD-ROM players, virtual

reality gear, video-on-demand, teleshopping, video conferencing – the list is almost endless.

One of the most extensive reviews of definitions of multimedia has been undertaken by a group of scholars at the University of Limburg in the Netherlands (Van Gurchom *et al.*, 1995). Although many of the definitions they review are based more on intuitive than systematic and explicit criteria, there seems to be general consensus that multimedia have to do with diverse representations of data, particularly sound and images (Van Gurchom *et al.*, 1995:7). Most of the contributors to this book who define multimedia do so in terms of its technical components: digital integration of media types within a single technological system. Most are primarily concerned with the nature of this interaction as related to two multimedia platforms: CD-ROM and CD-i. There are many other platforms, but these two currently dominate available applications. Further, these platforms are mainly found as stand-alone configurations, but an increasing amount of interest and experimentation is taking place with networks involving these technologies. Both stand-alone and network applications, then, figure highly in this volume. Other technologies associated with multimedia such as virtual reality and interactive television play a minor role in this collection. As for the concept interactivity, we consider it not a part of multimedia technology, but an element which may emerge in greater or lesser degree when the technology is employed in a particular setting (see discussion in Chapter 5).

One important exception to the above delineation is an effort by Cees Leeuwis to view multimedia entirely from the perspective of user functions (see Chapter 6). His approach provides fresh insights in differentiating multimedia systems seldom achieved when the technological perspective serves as the starting point for examination. It leads, in fact, to the central concern communication scholars have with multimedia: the nature of communicative interactions taking place between users and systems, and between users and other persons thanks to multimedia interventions.

Technical and market developments

Even when such a user perspective is embraced, it remains valuable to have an overview of the technologies involved in multimedia. Three chapters in this volume sketch facets of multimedia technology and their markets, and they are introduced below. Several observations can be made about the development in general, though. First, the history of multimedia technologies extend at least as far back as pioneering experiments combining laserdisc technology with computers in the late 1970s. One of the early large-scale pilot applications of this technology was the Doomsday project sponsored by Philips and BBC in British schools. This project was linked to the 900th anniversary of the Doomsday Book celebrated in 1986, and involved a

task of similar Herculean proportions as that of the original endeavour in 1086: compilation of as much information as possible about local communities and everyday life throughout Britain in the 1980s. It resulted in two laserdiscs containing 50,000 photographs, 250,000 pages of text and 60 minutes of video (see further Looms, 1993; Hodges & Sasnett, 1993:7).

Since those early initiatives multimedia projects and technologies have come a long way. The casual observer cannot help but be struck by the sense of constant change and apparent advances brought about by technological improvements. Computers are becoming ever faster and capable of storing and retrieving increasing amounts of data. At the same time, systems are rapidly considered dated and inadequate to current professional and personal requirements. It has been frequently suggested that the rate of technological change is far too fast for unproblematic absorbtion by organizations and society in general. This situation may be one of the most problematic aspects of new communication technologies.

There are, though, other concerns of importance. One is the matter of standardization – or lack of it – in areas such as data storage and system configuration. There are clearly advances towards uniformity, allowing programmes designed for different systems to be interchanged, but much still needs to be done before professional and lay consumers will be able to make sense of the array of the largely incompatible products and standards. Industrial strategies related to this issue are cogently analyzed in Chapter 3.

Another area of overall importance is what is commonly termed the convergence of telecommunications, cable television and computer technologies. This development is evident in many arenas, but most dramatically in the emergence of network infrastructures where multimedia applications – consultation, transaction and communication services – are developing. How convergence of these technologies is eventually going to develop is extremely difficult to predict. Still, educated guesses are possible, and the authors of all three chapters related to technical and market developments have a hand at such predictions. The first chapter in this section considers these developments, starting from the emergence of compact disc media.

Compact disc media
Looking at the development of multimedia platforms over the years, one is taken by the dazzling array of formats which have been introduced. Virtually every major electronics and computer industry has attempted to capture a 'piece of the action'. In Chapter 2, *Jak Boumans* from Electronic Media Reporting in Utrecht, the Netherlands, reflects on the first almost magical moments of that history when CD-ROM was formally introduced. Then – as now – Microsoft was one of the initial actors and promoters of multimedia technology, and emphasized its involvement

through hosting a conference on CD-ROM. That same year Microsoft sponsored another conference which focused on educational applications of multimedia, and the volume which resulted from that event (Ambron & Hooper, 1988) remains both a source of inspiration and object of critique for students of the technological development.

Should there have been any doubt, Boumans has demonstrated with persuasive data that multimedia players and titles have now gained a serious foothold in the marketplace. Still, it is far from clear which of the many competing formats will be with us after another ten years. Making predictions in the world of new communication technologies is risky – some (e.g. Hamelink, 1988) have suggested fortune-telling is more reliable – but it does seem that television-based formats such as CD-i are having and will continue to have difficulties matching the actual and potential possibilities of computer-based systems such as CD-ROM. Both of these systems in their stand-alone configuration may, however, be replaced by systems making use of on-line network connections. Internet, or one of its more commercially-oriented contenders, may cast a shadow over the future of stand-alone systems as we know them today. A potentially redeeming development, though, may be data compression technologies such as Digital Video Disc (DVD) which allow far greater amounts of data on a compact disc than now possible.

Architectural battles
It is quite common for market research about new communication technologies to lean towards optimistic scenarios regarding the success of a particular development. As for multimedia, the press is saturated with such claims, some of which make their way into more permanent forms of book-based literature (e.g. Ambron & Hooper, 1988). One of the frequent omissions in this work is explicit presentation of the investigative procedures followed in generating such claims.

Given this practice, Chapter 3 by *Marc van Wegberg* from the University of Limburg in the Netherlands is a refreshing welcome. He clearly explicates the basis of his particular assessments of the activities of multimedia companies. Moreover, he grounds them in economic game theory and generates hypotheses which he tests as best can be done with limited data. In his concluding remarks he comments on the importance of company size and strategic alliances in securing and maintaining architectural control. Many uncertainties remain, as Boumans also mentions, regarding what developments will gain market acceptance: Internet, high storage formats such as Digital Video Disc, or set-top boxes for television-based environments. With the help of five hypotheses as to how companies react in such a volatile arena as multimedia, Van Wegberg cautiously suggests the overall rating of Apple and Microsoft give them a 'leading edge' over their competitors. Whichever companies are the 'winners' or 'losers' is less important in the long run, though, than develop-

ment of explicit empirical procedures – guided by a theoretical perspective – for making such assessments.

Electronic pathways

As mentioned in the previous two chapters, Internet and similar networks may have far-reaching implications for how we experience multimedia in the future. In Chapter 4 by *Harry Bouwman* (Institute for Policy Studies) and *Bart van den Hooff* (University of Amsterdam) the argument is made that not a single 'Information Highway' will develop as sometimes is suggested, but a multitude of different dedicated paths for information and communication purposes. The authors consider telecommunications and multimedia interlocked innovations in terms of technology, applications and forms of usage.

One of the central issues in this development is to what extent a single glass fibre telecommunications infrastructure will emerge. The authors suggest differentiating three levels of such infrastructures: Fibre in the Loop, Fibre to the Home, and Fibre to the Curb. For each of these levels probable development and type of services are discussed. Another proposed differentiation relates to the nature of information technologies within the home environment. Most discussions in this regard focus on whether the television set or the personal computer will serve as delivery system of multimedia applications. Bouwman and Van den Hooff suggest this choice depends on the specific home environment, and compartments therein which they call the 'ten-foot space' and 'three-foot space'. The first, somewhat larger space refers to environments such as the traditional livingroom found in most homes and site of most communal activity. Here, a low-resolution display unit such as a conventional television set can suffice for playing primarily entertainment applications. The 'three-foot space' refers to the home-office found in an increasing number of residences. Here, much more interactivity is required from applications as well as higher resolution images than in the 'ten-foot space'. The multimedia PC is the technology expected to be dominant here, accompanied by a high-speed modem for network connections.

The authors conclude that, even with awareness of such differentiation in home use, it remains more difficult to calculate the added value of applications for residential than for business markets. Moreover, markets are becoming increasingly diverse in an era of growing segmentation and individual media use. These aspects, along with previously mentioned arguments, lead the authors to predict a constellation of different networks designed for specific functions and users.

Theoretical perspectives

One of the frequent points of discussion among communication scholars is whether

existing theoretical models and notions are adequate to the task of understanding and explaining new communication technology. Rice and his associates (1984) were perhaps the first group to undertake a systematic search for theoretical insights from communication studies relevant to the emerging new media. One of their 'discoveries' was the psychological concept social presence which thereafter served as inspiration for a wealth of subsequent investigations. About the same time Rogers (1986) considered theoretical groundings for the study of communication technologies and suggested his earlier work on the diffusion of innovations as a valuable theoretical reference. This suggestion was taken up yet again in a volume Williams, Rice and Rogers (1988) compiled on research theories and methodologies for examination of new media. And, in a seminal essay McQuail (1986) formulates the concern in almost exactly the manner as noted above. He concludes that existing (social) theory is, essentially, adequate to the job of understanding those phenomena known as new media.

There is, without doubt, much of value to be gained from already existing theories of (mass) communication, and it is only 'straw men' thrown up in the heat of argument which argue otherwise. This having been said, it remains the case that mass communication theories and models are almost inherently constrained by the dominant characteristics of mass media and, as such, generally fail to consider the distinct features of many new communication technologies – the demassified, individual and interactive nature of communication with these technologies. There are, of course, many models of communication which attempt to 'speak' for the communication process as a whole. But all too often these models focus empirically on mass media processes. A case in point is the 'media use as social action' model (Renckstorf *et al.*, 1996). On examination of the model and explanatory text, it is clear that a very broad notion of communication is proposed in which contextual influences and individual actions are seen as central to how the communication process operates. The empirical foundation for this model, however, comes almost exclusively from quantitative studies of mass media use. In spite of theoretical and methodological attention to interpretative conceptualizations and research strategies, the empirical evidence for the model is restricted to traditional approaches to the study of media use and, thus, lack basis for examing the special components of new media missing from traditional mass media.

This example is meant to suggest that even recent theoretical developments which take account of more or less accepted facets of new media such as demassification of audiences and individually-determined action may be captive to the inherent limitations in empirical data based on mass media use studies. One way out of this situation is through examination of concepts and components central to new media, and rather than attempting to 'fit' these elements into already existing theoretical models to explore alternative models and constructs. That is what the three chapters in this section of the book have in common: fresh theoretical examination, unham-

pered by allegiance to dominant models or theoretical paradigms. The work is, obviously, preliminary. It represents, though, serious consideration of concepts and theories relevant to current multimedia developments.

Interactivity

Interactivity is widely considered (e.g. Rice, 1984; Rogers, 1986); Williams *et al.*, 1988; McQuail, 1994) one of the core concepts in theorizing about new communication technology. It plays a prominent role in virtually all definitions and descriptions of new media. It has also played a central role in conceptualizations of multimedia, particularly in those considerations of multimedia applications for educational settings. One of the classic formulations of interactivity in this area, stemming from work performed in the early 1980s by the Nebraska Videodisc Design Group is that known as the 'Nebraska Scale'. It assigns levels of interactivity based on configurations of technology. It is now antiquated, in part because of technological advances but also because it provides insufficient insight into the forms of interactions possible between users and machines (Looms, 1993).

A more recent elaboration of the term from an educational perspective is proposed by Romiszowski (1993) who suggests interactivity can be best considered as the degree or depth of processing required from student users. He formulates a continuum of four levels or scenarios, extending from what he terms surface-level interactivity (where simple responses are observed and commented upon) through so-called deep-level conversational dialogues where both learner and teacher gain insights into each other's thinking. 'This dimension (surface-processing to deep-processing) may be one of the most useful ways of evaluating the nature of interactivity that has been built into a given instructional product.' (Romiszowski, 1993:60). How such evaluation of these suggested levels of interactivity should take place is not elaborated on, however.

A small coterie of communication scholars have also been concerned with the concept, and their work has served as the basic for *Lucien Hanssen* (Foundation for Public Information on Science and Technology), *Rienier Etienne* and *Nicholas Jankowski* (University of Nijmegen) discussion in Chapter 5. They point out, first of all, that all too often the assumption is made that media are responsible for the degree or level of interactivity which may potentially develop during communication. On the basis of this assumption, face-to-face communication then becomes the model or 'ideal type' from which all other – by definition inferior – forms of mediated communication are measured. This perhaps explains why some of the more simplistic scenarios in early multimedia educational titles typically resembled the conventional prompting classroom teachers employ in soliciting responses from students (Romiszowski, 1993).

The authors of Chapter 5 criticize this assumption by reminding readers of the central – and changing – role played by users in mediated communication situations. Users are sometimes senders and at other times receivers of communication; in both roles, though, they remain central constituitents of the communication process. Other elements or components of an interactive communicative situation include the medium, message content, and finally the environment in which communication transpires.

Hanssen, Etienne and Jankowski develop a relational model for distinguishing face-to-face from face-to-interface communication forms. This model illuminates the possibility of multiple mediated environments, i.e. symbolic agreements and rituals (implicitly) agreed upon by the communicators – senders and receivers in traditional terminology. This conceptualization of interactive communication leans on Carey's (1989) now classic notion of communication as ritual behaviour. This vision, as opposed to the traditional transmission notion of communication, provides more opportunity for understanding the place of interactivity in the communication process within these virtual, socially-constructed environments. Empirical research based on this perspective is just beginning to emerge, and much of the pioneering work is being done by anthropologists and folklore specialists concerned with generation of rituals and virtual communities in cyberspace; see in this regard several contributions in the volume edited by Jones (1995). This research is often interpretative in style and methodology, leaning more on a quest for understanding than on 'knowing' (Jankowski & Wester, 1992). The contributions communication scholars may make to this quest are substantial; the task ahead, then, is formulation and enactment of a research programme committed to this perspective – a topic addressed at the end of this chapter.

Public communication campaigns
Multimedia are often prescribed as the cure for what ails current educational practice. A close cousin of education is public communication and it, too, is considered for improvement through infusion of multimedia, particularly information campaigns designed to transform human behaviours deemed socially undesirable: excessive smoking and drinking, unsafe sex, environmental pollution. Much research has been conducted around public communication campaigns, and *Paul Nelissen* from the University of Nijmegen reminds us in his review of this literature in Chapter 6 that these campaigns are strikingly unsuccessful in changing human behaviour in the direction desired. One of the problems with traditional campaigns, he points out, is lack of consideration for the context and concerns of the intended audience of such campaigns. An audience-centred interpretive approach has been developed as an alternative, and Nelissen describes its contours and then considers to what extent multimedia may satisfy the requirements of this theoretical perspective.

He illustrates his argument with a case study of an information service designed for the visually impaired. His conclusions suggest that the general characteristics of multimedia – flexibility, diversity and interactivity – are by themselves inadequate to the task of changing human behaviour. Such changes, Nelissen argues, are less dependent on the chosen mode for distribution of messages – be they multimedia or traditional media – than the complex processes involved in transforming knowledge, attitudes and behaviours.

An interaction-centred communication model
The next chapter comes from a similar critique of communication theory, suggesting it has been all too long and incorrectly dominated by a media-centred approach. For the past couple of decades, however, resistance has been growing to this paradigm, and has led to the audience-centred approach. One of the most recent offshoots of this approach is the 'media use as social action' perspective (Renckstorf *et al.*, 1996). *Cees Leeuwis* from the University of Wageningen in the Netherlands traces this development in his contribution, Chapter 7, and indicates one of the limitations of this last perspective: its focus on the individual as opposed to groups or collectives involved in the communication process. Leeuwis proposes, therefore, an interaction-centred approach where emphasis is placed on processes of negotiation inherent in human communication.

With this theoretical grounding, Leeuwis proposes a functional classification for communication technologies which highlight elements of interaction. Here, he dispenses with the technological-based ordering strategy commonly employed by scholars of computer-mediated communication (e.g. Fulk & Steinfield, 1990). This reordering of communication technologies along the lines of his interaction-centred approach lends insight into why so many communication innovations fail to achieve the degree of adoption and use anticipated. Leeuwis suggests, among other things, that insufficient attention is given to what he terms the external design or social-organizational dimension of communication technologies. Others have made similar observations; Qvortrup (1986), for example, proposed the shape of an iceberg to describe the core elements of information technology, and that the submerged, invisible mass of the iceberg constitutes the organizational layer which all too often is overlooked during the introduction process (see further Jankowski & Mol, 1988).

Leeuwis goes a significant step further, however, and proposes a number of points for enhancing communication development. He recommends, first of all, that the development process should be participatory in nature. This is similar to the user-centred design approach outlined later in Chapter 12. Second, the process should be iterative in order to integrate experiences into both the internal and external design aspects. Research should accompany the process, and Leeuwis recommends qualitative or interpretative research strategies. Communication researchers, he says, can

play a number of additional roles in the development: as facilitators, participants, negotiators and even political activists. There is uncertainty, however, whether communication scientists are suitably trained and professionally capable of taking on such a politically-oriented action research stance (see further Jankowski, 1992). That matter aside, Leeuwis provides communication technology developers with recommendations which can improve chances for successful introductions.

Applications

As Boumans mentions in Chapter 2, there has been a proliferation of multimedia titles in the past few years, and inventories are almost out-of-date by the time they are published. There are also informative historical overviews of multimedia projects in education where particular trends emerge (Looms, 1993). And, various compilations exist of descriptive case studies of multimedia applications (Ambron & Hooper, 1988). Perhaps the most noteworthy in this area is a volume providing a panorama of MIT's Project Athena (Hodges & Sasnett, 1993).

The chapters in this section of the book can best been seen as illustrations of recent multimedia developments in the broad field of education. They are not meant so much to represent as to suggest how multimedia developments can be both designed and subjected to empirical assessment. All three chapters, in other words, formulate initial theoretical concerns and reflect on these with the aid of case studies. Two of the three chapters are also substantiate with empirical research.

Teaching the learning disabled with multimedia
A commonly employed strategy for reducing the costs of education is to inject new communication technologies into the classroom. This is current policy at the level of higher education in the Netherlands, but is evident at other educational levels and in other countries. It is also evident in the sphere of special education, and *Cor van der Klauw* and *Emely Spierenburg* from Erasmus University in Rotterdam were involved in the design and evaluation of a CD-i programme targeted at remedial instruction described in Chapter 8. Many children and adults with learning difficulties experience train travel – and the skills prerequisite for such an undertaking – as difficult if not impossible. Additional training is required for these persons in tasks such as purchasing a ticket, decoding train schedules and navigating through complex station halls. The CD-i programme *The Station* was designed to provide practice with such tasks in order to assist learners in achieving the level of competence whereby they would be able to travel by train independently.

The programme was evaluated on the basis of an experimental research design, measuring both a control and experimental groups before and after use of the pro-

gramme. Although no clear set of results emerged regarding differences in learning effects between the control and experimental groups, the experimental groups did achieve significant improvement between the pre-test and post-test measures. Elsewhere, commentators (Clark, 1983; Reeves, 1986) have questioned the suitability of experimentally-oriented research for evaluating instructional designs. Quite often when 'no effect' is the result of such research, the problem, in fact, rests with contamination between the control and experimental groups, or failure to adequately isolate the element under investigation of the instructional design. For these and other reasons, Van der Klauw and Spierenburg tend to emphasize the positive aspects of the multimedia programme in improving skills and insights related to train travel among the learning disabled. They at the same time warn substituting the title for existing instructional materials and techniques. The Station is, in other words, a complement to — not a substitute for — the components of a well-conceived instructional design.

Distant learning

Multimedia production practice all too often lacks an empirical research component designed to provide feedback during the prototype phase and early period of market introduction. The strategy frequently seems to be based on fashionable technological appearance, which often results in products appropriately described as examples of multi-mediocrity.

There are, however, cases where multimedia titles are the result of careful theoretical considerations and empirical research. One such case is profiled in Chapter 9 by *Rob Nadolski* and *Fred de Vries* from the Open University in the Netherlands. They indicate the interest felt by the Open University in utilizing multimedia platforms such as interactive videodisc, CD-ROM and CD-i in its distant education programme, and trace how one CD-ROM title was developed based on a theoretical model for educational design. Nadolski and De Vries take full note of Clark's (1985) admonition that learning is more a function of instructional design than input from the latest media technology fashion. The authors correctly remark, however, that once an instructional design is settled on, some media work better than others in achieving learning objectives.

Nadolski and De Vries report findings from a field test of a CD-ROM title which suggest that the respondents generally appreciated opportunity to actively participate in the course through use of multimedia courseware. Although the research was limited in terms of number of respondents and characteristics of design, the findings have proved useful in further development of CD-ROM courseware at the Open University.

On-line instruction

The potential of the Internet for education has been widely sung, but seldom demonstrated. *Peter Linde* contributes to rectifying this imbalance through his report in Chapter 10 on the development of an on-line masters-level course at the University of Wageningen in the Netherlands. One of the objectives of this initiative was to transform the curriculum from a subject-based approach to that of problem-based learning. Further, individual student activity as well as various forms of social endeavour – collaboration, feedback, reflection – were considered components of an 'ideal' learning environment. Many of the instructional technologies developed to date have been, in part, unsuccessful because of their inability to support productive personal relations (Kraut *et al.*, 1988). The idea, then, was that some of the virtual environments available on the Internet, in particular so-called MOOs (Multi User Dimensions or Domain, Object Oriented) might provide the 'missing ingredients' for the desired learning environment.

With these notions in mind, a pilot project called Hortonomy (integration of horti-cultural, economics and education) was initiated in which multimedia and network technology were seen as supportive and complementary to each other. In the Hortonomy environment, students work both individually and collectively on solving – within the educational setting – horticultural problems. The multimedia and network technologies help create situations where resources can be consulted more extensively and where these materials can be shared more rapidly among group members.

One of the questions still unanswered by this pilot project is whether large groups of students will be able to manage the self-discipline required to make optimum use of this learning environment. It is also uncertain whether instructors will be able and willing to shed the traditional authoritive teaching role for one more egalitarian in style. In spite of these uncertainties, Linde feels the project has demonstrated how a combination of multimedia and network technology can be successfully utilized in an educational setting.

Research considerations

Suggestions for research questions and suitable methods are presented in almost all of the chapters of this book. Still, it seems appropriate to group three of the contributions together which consider aspects of particular concern to empirical research. The first of these contributions focuses on pointing devices and illustrates the kind of investigations multimedia industries engage in to determine the user-friendliness of a particular technology. The second contribution – again from industry – is enlightening inasmuch as it stresses the need for involvement of end-users in the design process of communication technologies. The third contribution warns us of

the disputable value of many predictions of technology penetration and user appreciation.

Pointing devices

Most computer users employ a mouse or other pointing device as a matter of routine action, particularly in task-oriented applications. With introduction of multimedia applications for a wider entertainment-oriented market, it is uncertain whether these users will experience pointing devices in the same manner. *Joyce Westerink* and *Karoline van den Reek* of the Institute for Perception Research at the University of Eindhoven in the Netherlands set up a laboratory experiment in which comparisons were made between user appreciation and pointing device efficiency based on experience with two CD-i titles. Described in Chapter 11, measures were recorded for time-to-target and relative-path-length, and for subjective appreciation of the six pointing devices included in the experiment.

Westerink and Van den Reek designed their experiment on the substantial research already conducted on pointing devices in task-oriented environments which has established consistent regularity between the time persons need to point to a target on a screen and the size of the initial distance to this target – a relation known as Fitts' Law. Still, Westerink and Van den Reek wondered whether this law would apply in an entertainment-oriented environment. It turned out that, although Fitts' Law was applicable for some of the pointing devices, other devices did not match expected results. The authors attribute the differences to less concern for efficiency on the part of users in a leisure-oriented environment. One possible consequence of this research, then, is that pointing devices for multimedia applications designed for entertainment purposes may not need to match the higher specifications and expectations of such devices used with multimedia applications for study or commerce.

User-centred design

Something of a movement developed about a decade ago in certain circles of telematics experts. These experts were concerned with the increasing development of new communication technologies with little input from the persons for whom they were intended. As a remedy, they advocated development of 'social experiments' in which users would play a central role from the early design phase to eventual implementation (see e.g. Qvortrup, 1984; 1986; Stappers *et al.*, 1989).

That movement has now, more or less, been institutionalized into what is known as the principles of user-centred design. *Maddy Brouwer-Janse* from the Institute for Perception Research at the University of Eindhoven reviews in Chapter 12 the development and content of user-centred design principles, and suggests their suitability for multimedia development. The core idea of user-centred design is that user

needs and requirements should be focused on from the very early stages of technology development. Once the intended users of a technology extend beyond those of rather homogeneous groups such as scientists and engineers, it is no longer valid for designers to base development on their own experiences or intuitions. Awareness of that fact has increased across time as an ever widening and diverse population of users becomes acquainted with new communication technologies.

The challenge of applying user-centred design principles to multimedia applications is even greater, given the possibility of user interaction and active participation in applications. This challenge is particularly complicated by differences in domain of use and the sometimes enormous cultural variations between users. Brouwer-Janse sketches some of the areas in which systematic empirical research are required, from the early conceptual phase, to repeated prototype development. The most important aspect in the development of multimedia applications, she asserts, is assessing the suitability of active behaviour of users for specific applications and – when appropriate – determining how to entice users into taking on such a stance.

Predicting adoption patterns
The history of new communication technologies could perhaps be described as a vast number of innovations, few of which reach a level of stable adoption and merit being called successful. Optimistic predictions, in contrast to these actual survival rates, are much more common – and consequently wrong, as history has frequently borne out.

Harry Bouwman (Institute of Policy Studies) and *Anne de Jong* (University of Amsterdam) in Chapter 13 examine the low 'hit rate' of new communication predictions and suggest a number of explanations for the limited performance. One of the definitional difficulties relates to the multitude of interpretations to 'success'. It can, depending on the purposes at hand, be defined in terms of technological, economical, political and socio-cultural aspects. Usually, as we have come to know, it is seen in terms of commercial marketing strategies whereby optimistic predictions are seen as necessary and functional. The authors term this strategy the *management of expectations* and see it as an effort to shape public and business opinion.

Few of such predictions, however, turn out to be accurate. One of the clearest cases in point is that of the introduction of videotex in various European countries during the 1980s. Predictions were consistently higher than the penetration figures actually achieved. It becomes questionable, then, whether such optimistic predictions serve the long-run interests of industries, even of those employing a 'management of expectations' strategy.

Predictions based on scientifically-based procedures, however, do not seem to achieve a substantially higher rate of success than those announced from the above

noted commercial strategy. One of the commonly used techniques in this regard is the Delphi method – collecting, in an iterative manner, the opinions from experts regarding a particular development. This technique is based, in part, on the erroneous assumption that these opinions are sufficiently independent of each other to be compared. In actuality, experts in a given field often constitute a community of persons who continually share information and opinions, consequently influencing each other in the process. Although some general trends may be possible with Delphi studies, the results are often dramatically wrong when it comes to specific predictions of communication technologies.

Summarizing, the authors repeat three guidelines formulated elsewhere for producing and assessing predictions: avoid technological wonders, ask fundamental questions about markets, and stress cost benefit analysis. Although application of these guidelines to researchers engaged in communication studies may seem baffling, Bouwman and De Jong also make a recommendation suitable for all social science researches: avoid Delphi methods in favour of methods stemming from conceptual models as found in scenario studies and longitudinal research practices.

Proposals for a multimedia research agenda

There are probably as many research agendas for multimedia as there are researchers. The contributions in this book are evidence of the multiplicity of questions and methodologies which may be proposed, even by investigators from the same discipline. There is, in other words, no single agenda or paradigm for investigation of a phenomenon so recent as multimedia.[1] The suggestions made here are meant as contributions from the field of communication to a much broader spectrum of disciplines, theoretical visions and methodological approaches concerned with multimedia.

One area in which communication scholars have been active for many years is shifts in media attention or use as new media are introduced and institutionalized. This is an area of particular concern among scholars monitoring new communication technologies, and an excellent collection of cross-national studies related to this area was compiled by Becker and Schoenbach (1989). Most of the contributions to that volume are concerned with the influence of increasing amounts of conventional television programming made available through cable-delivery systems, along with limited initiatives for information-delivery via teletext and videotex systems.

A similar situation of programming abundance to that involving cable-delivery systems is now emerging with the introduction and acceptance of multimedia systems by both professional and lay audiences. One major difference, however, is the poten-

1 No single agenda exists, but some very attractive agendas have been formulated for particular disciplines, in particular education; see especially Reeves (1993) and Romiszowski (1993).

tial for interactivity these media provide. It is unclear what shifts in media use may transpire once multimedia become more commonplace. It is, for example, not at all certain that new media will simply become part of an ever-increasing plethora of media, the one complementing the other. Lerg (1984) formalized this and other possibilities as hypotheses regarding substitution and compensation of audience media use. Some analysis (e.g. Olderaan & Jankowski, 1989) does suggest that media tend to complement rather than replace each other. Still, time allotment to different media does change, sometimes drastically when new media are introduced. How this will develop with the introduction of various multimedia is quite uncertain.

As noted above and elsewhere in this chapter, a central component in multimedia as well as new communication technologies generally is its potential for interactive use. In Chapter 5 the many conditions and moments in the communication process where interactivity may transpire are outlined. Very little is known, however, about the exact nature of these conditions and moments; empirical research around the concept interactivity in multimedia settings is virtually nonexistent. It should be evident, then, that we place the need for such investigations high on the list of communication research priorities. Perhaps less evident, though, is our recommendation that these investigations be undertaken from an interpretative or qualitative methodological approach. Qualitative research along the lines conducted by the contributors to Silverstone's and Hirsch's (1992) anthology on communication technologies in the home environment – investigations in natural settings, data collection through participant observation and informal interviewing, analysis directed at 'discovering' theory rather than testing hypotheses – provides much more opportunity to explore the nature of interactivity involved in multimedia use, and the place of this concept within the overall process of communication (see further Jensen & Jankowski, 1992).

The third and final suggestion for a multimedia research agenda has to do with a special facet of network-based multimedia developments: virtual communities. This development is briefly alluded to in one of the chapters in this collection – Peter Linde's contribution about on-line learning environments – but constitutes, in fact, one of the most fascinating features of network developments like the Internet. Rheingold (1994) has sketched this phenomenon in a highly readable personal account, and Jones (1995) has compiled the first collection of empirically-based studies on virtual communities. For communication scholars it is of particular interest how such interest groups in cyberspace may complement – if not supplant – face-to-face interactions commonly considered essential for the creation of community. Moreover, development of special codes of communication and identity in these virtual communities is an area only a few scholars (e.g. Reid, 1995; Baym, 1995) have yet explored, and these investigations are grounded more in anthropology and folklore than communication studies. The nature of the relation between communication and culture as emerging in these virtual communities, in other words, is yet to be

explored in detail by communication scholars. Preliminary work in this area (Jankowski, 1995) deserves expansion, and we are eager to benefit by insights and contributions from other researchers active in the field of communication.

References

Aston, R. and Klein, S. (1994) Multimedia will carry the flag, in: R. Aston and J. Schwarz (eds.) *Multimedia; Gateway to the next millennium*, Boston: AP Professional.

Baym, N.K. (1995) The emergence of community in computer-mediated communication, in: S.K. Jones (ed.) *CyberSociety; Computer-mediated communication and community*, London: Sage.

Becker, L. and Schoenbach, K. (eds.) (1989) Audience responses to media diversification; *Coping with plenty*, Hillsdale, NJ: Lawrence Erlbaum.

Bouwman, H. (1993) De doos van Pandora, in: H. Bouwman and S. Propper (eds.) *Multimedia tussen hope en hype*, Amsterdam: Otto Cramwinckel.

Bowen, D. (1994) *Multimedia now and down the line*, London: Bowerdean Publishing.

Burger, J. (1992) *The multimedia bible*, Reading, MA: Addison Westley.

Carey, J.W. (1989) *Communication as culture; Essays on media and society*, Boston: Unwin Hyman.

Clark, R. (1983) Reconsidering research on learning from media, *Review of educational research*, 53, 445–459.

Clark, R.E. (1985) Evidence for confounding in computer-based instruction studies: Analysing the meta-analyses, *Educational communications and technology journal*, 33,4: 249–262.

Collon, S. (1994) *The way multimedia works*, New York: Microsoft Press.

Gurchom, M.M. van, Rijssen E.H. van, Teeuw, W.B., Velthausz, D.D. and Bakker, H. (1995) *Multimedia; van 'buzz' naar 'business'*, Alphen aan den Rijn, NL: Samsom.

Hamelink, C. 1988) *The technology gamble. Informatics and public policy; A study of technology choice*, Norwood, NJ: Ablex.

Hanssen, L. and Jankowski, N.W. (1993) *CD-i in voorlichting en educatie*, report, Foundation for Public Information on Science and Technology, Utrecht and Department of Communication, University of Nijmegen.

Hanssen, L. and Jankowski, N.W. (1994) *Kanttekeningen bij multimedia; verslag van een studiedag*, report, Foundation for Public Information on Science and Technology, Utrecht and Department of Communication, University of Nijmegen.

Fulk, J. & Steinfield, C. (eds.) (1990) *Organizations and communication technology*, Newbury Park, CA: Sage.

Jankowski, N.W. (1992) On qualitative research and community media, in: K.B. Jensen and N.W. Jankowski (eds.) *A handbook of qualitative methodologies for mass communication research*, London: Routledge.

Jankowski, N.W. (1995) From cable to cyberspace; The technological quest for community, in: E. Hollander, C. van der Linden and P. Rutten (eds.) *Communication, culture and community*, Houten, NL: Bohn Stafleu Van Loghum.

Jankowski, N.W. and Mol, A. (1988) Confused objectives and organizational difficulties: An experiment in home language instruction, in: F. van Rijn and R. Williams (eds.) *Concerning home telematics*, Amsterdam: Elsevier Science Publishers.

Jankowski, N.W. and Wester, F. (1992) The qualitative tradition in social science inquiry: Contributions to mass communication research, in: K.B. Jensen and N.W. Jankowski (eds.) *A handbook of qualitative methodologies for mass communication research*, London: Routledge.

Katzen, M. (1982) *Multi-media communications*, Westport, CT: Greenwood Press.

Kraut, R., Galagher, J., Egido, C. (1988) 'Relationships and tasks in scientific research collaborations,' *Human computer interaction*, 3,1: 31–58.

Kristof, R. and Satran, A. (1995) *Interactivity by design; Creating & communicating with new media*, Mountain View, CA: Adobe Press.

Olderaan, F. and Jankowski, N.W. (1989) The Netherlands: The cable replaces the antenna, in: L. Becker and K. Schoenbach (eds.) *Audience responses to media diversification; coping with plenty*, Hillsdale, NJ: Lawrence Erlbaum.

Jones, S.G. (ed.) (1995) *CyberSociety; Computer-mediated communication and community*, London: Sage.

Latchem, C., J. Williamson, J. and Henderson-Lancett, L. (eds.) (1993) *Interactive multimedia; Practice and promise*, London: Kogan Page.

Looms, P.O. (1993) Interactive multimedia in education, in: C. Latchem, J. Williamson and L. Henderson-Lancett (eds.) *Interactive multimedia; Practice and promise*, London: Kogan Page.

Hodges, M.E and Sasnett, R.M. (1993) *Multimedia computing: Case studies from MIT Project Athena*, Reading, MA: Addison-Wesley.

Lerg, W. (1984) Rundfunk im Kommunikationssssystem – Fremdliniën für ein publizistisches Erklärungsmodel, *Studienkreis Rundfunk und Geschichte Mitteilungen*, 2.

McGowan, C. and McCullaugh, J. (1995) *Entertainment in the cyber zone; Exploring the interactive universe of multimedia*, New York: Random House.

McQuail (1986) Is media theory adequate to the challenge of the new communications technologies? in: M. Ferguson (ed.) *New communcation technologies and the public interest*, London: Sage.

McQuail (1994) *Mass communication theory: An introduction*, London: Sage.

Silverstone, R. and Hirsch, E. (eds.) (1992) *Consuming technologies; Media and information in domestic spaces*, London: Routledge.

Nakajima, H. and Ogawa, H. (1992) *Compact disc technology*, Tokyo: Ohmsha; Amsterdam: IOS.

Negroponte, N. (1995) *Being digital*, London: Hodder & Stoughton.

Qvortruop, L. (1984) *Social significance of telematics*, Amsterdam: John Benjamins

Qvortrup, L. (1986) Social experiments with information technology: Conclusions and recommendations, in: C. Ancelin, J. Frawley, J. Hartley, F. Pichault, P. Pop, L. Qvortrup (eds.) *Social experiments with information technology*, proceedings Odense, Denmark conference, Brussels: Fast.

Reeves, T.C. (1986) research and evaluation models for the study of interactive video, *Journal of computer-based instruction*, 13: 102–106.

Reeves, T.C. (1993) Research support for interactive multimedia: Existing foundations and new directions, in: C. Latchem, J. Williamson and L. Henderson-Lancett (eds.) *Interactive multimedia; Practice and promise*, London: Kogan Page.

Reid, E. (1995) Virtual worlds: culture and imagination, in: S.G. Jones (ed.), *CyberSociety; Computer-mediated communication and community*, London: Sage.

Renckstorf, K., McQuail, D. and Jankowski, N.W. (eds.) (1996) *Media use as social action; A European perspective for audience research*, London: Libbey.

Rheingold, H. (1994) *The virtual community; Finding connection in a computerized world*, London: Minerva.

Rice, R. (1994) *The new media; communication, research and technology*, London: Sage.

Rogers, E. (1986) *Communication technology; The new media in society*, New York: Free Press.

Romiszowski, A.J. (1993) Developing interactive multimedia: Existing foundations and new directions, in: C. Latchem, J. Williamson and L. Henderson-Lancett (eds.) *Interactive multimedia; Practice and promise*, London: Kogan Page.

Stappers, J.G., Jankowski, N.J. and Olderaan, F.J. (1989) *Interactief op inactief. Een onderzoek naar de ontwikkeling van experimenten met het kabelnet in het kader van het kabelkommunikatieproject in Zaltbommel*, research report, Institute for Mass Communication, University of Nijmegen.

Willis, J. (1994) *The age of multimedia and turbonews*, Westport, CT: Praeger.

2 A Decade of Compact Disc Media

Jak Boumans

In 1985 the first two commercial CD-ROMs were published. Ten years later, 50 million readers and more than 15.000 Compact Disc (CD) format titles were available worldwide. Although the growth curve cannot be likened to that of audio-CD, the percentages have nevertheless been spectacular in the last four years. Will this rate of growth continue? A new generation of CD media (including readers) has been recently announced, and this might create insecurity in the market. Moreover, the question is frequently heard whether on-line services like CompuServe and Internet may become competitors of CD media.

The first two CD-ROM titles, published in 1985, were intended for distinctly different target groups and almost instantaneously marked out the core areas for market applications: BiblioFile was designed for the professional market, in this case librarians, and Grolier's Academic American Encyclopedia for the consumer market. Over the ensuing years, professional products grew as in-house or commercially available titles, while consumer products were treated like best-seller books and targeted at the general public.

In 1986 CD-ROM captured much attention, when Microsoft organized the First Microsoft Conference on CD-ROM. Two conference items explicated the potential of the medium. The book entitled *CD-ROM: The New Papyrus* sketched the potential impact of the technology and described the production process and the infrastructure of this young industrial branch. In addition to the book, every conference delegate received a CD-ROM, entitled *Microsoft Bookshelf*, a collection of reference works for daily use at the office, school and home. Although the disc often found more use as a frisbee because of the prohibitively high price tag of CD-ROM readers then (ca. $2000), the title clearly demonstrated the commercial and in-house publishing potential of CD-ROM.

Despite all the publicity which followed, CD-ROM developed slowly during the following year. This was mainly due to the proprietary interface between reader and disc software, and the emerging industrial conflict over different CD media formats. The proprietary interface meant that CD-ROM publications were bound to particular brands of CD-ROM readers. At record speed – previously unknown among circles which determine standards – the industry produced an industry-wide standard, High Sierra (named after the hotel in Utah where the experts met), within half a year. This was soon followed by the official international standard: ISO 9660. Through such standardization a disc could be read by readers of various brands, and this eliminated a major obstacle for publishers, active in scientific, business and in-house publications.

Since 1985 a constant procession of CD media formats, consisting of a particular combination of disc, operating system, reader and delivery screen, has passed. Some 20 of these formats are listed in Table 1. They were all in their time attempts to secure a share of the market, either by way of computer-based or television-based technological approaches. Looking back over the decade, formats based on DOS and multimedia PC norms have come to dominate the CD media formats, particularly since these readers can be built into personal computers. The total number of television-based formats such as CD-i consist of no more than two million readers, and these are mainly concentrated in just a few geographical regions.

Statistical data

Since 1985 little statistical data have been gathered concerning readers, discs and turn-over. One of the few marketing research agencies to compile such information is the American company InfoTech, which has been publishing the OPIA report (Optical Publishing Industry Assessment) since 1986.[1] Since 1990 other companies such as Dataquest, Freeman Associates, Inteco and Euromonitor have taken an interest in the field and been reporting regularly on CD-ROM.

Examination of the data from such reports indicates a division between conservative and progressive estimates. One problem in this regard is uncertainty about distinctions employed in categories of CD media, such as replication and writable and erasable media, and also distinctions in market segments such as consumers, professional and in-house.

1 The author has leaned extensively on publications of the American market research bureau InfoTech and the UK market research bureau and publisher TFP for the statistical data presented here.

Table 1: CD media formats

Type	PC or TV	Developer	Introduction	Since
CD-ROM	PC	Philips/Sony	Worldwide	1985
CD-ROM XA	PC	Philips/Sony	Worldwide	1988
Electronic Book	Portable	Sony	Japan, USA (91)	
			Europe (92)	1990
CDTV	PC	Commodore	USA, Europe	1991
CD-i	TV	Philips/Sony	USA (91)	
			Eur., Jap. (92)	1991
MPC	PC	MPC Council	Worldwide	1991
Photo-CD	TV/PC	Philips/Kodak	Worldwide	1992
VIS	TV	Tandy/Microsoft	USA	1992
MMCD	Portable	Sony	Japan, USA (92)	
			Europe (93)	1992
Mega CD	TV	Sega	USA (92)	
			Europe (93)	1992
MPC2	PC	MPC Council	Worldwide	1993
3DO	TV	Electronic Arts	USA	1993
Amiga CD32	TV	Commodore	USA	1993
Atari Jaguar	TV	Atari	USA	1993
X-Eye	TV	JVC	USA	1994
Video-CD	TV/PC	Philips/Sony	Worldwide	1994
Play Station	TV	Sony	Japan (94)	
			USA (95)	1994
Sega Saturn	TV	Sega	USA	1995
MPC3	PC	MPC Council	Worldwide	1995
DVD	PC/TV	Toshiba, Sony & Philips	Worldwide	1995

Source: Electronic Media Reporting, 1995

The main figures are determined at various points of the production cycle. The number of readers manufactured is checked at production plants as well as at retail outlets. Production of discs is measured at the factories where master discs are replicated. Title production is determined by reference to directories describing the products (e.g. TFPL, 1995a). Ascertainment of the volume of discs intended for sale is partly performed by the Software Publishing Association, while other sales are monitored by research agencies such as Nielsen.

Table 2: Manufacture and sale of commercial CD media worldwide

	1994	1995	1996
Readers	21,697,000	40,699,000	70,143,000
Titles	7,407	10,786	14,470
CDs commercially sold	85,399,000	195,520,000	369,656,000

Note: data do not include in-house CD media. Source: OPIA (1995)

The figures indicate how commonplace CD media readers have become. The built-in readers in multimedia personal computers have contributed significantly to the popularity of CD media discs. The number of discs sold per reader has also increased substantially. In 1986 only one title was sold per reader; by 1995 the number had risen to almost five. Also, the production run of a commercial title has increased to an average of 18.000 copies in 1995. A small number of titles, however, far outsells the rest, generally at a 1:4 ratio. The top five titles sell in the region of a million copies, while the rest scrambles for a small segment of the market.

Acceptance

Acceptance of new media has taken on a distinct pattern over the years. There are generally two ways in which diffusion develops: the business-to-consumer model and the French Minitel model. With CD media a two-fold strategy has been followed since the introduction of the technology.

After the audio-CD had become a market success, companies began to consider the disc as a potential storage system for computer data. As such, the medium was particularly of interest to computing companies such as Digital, Apple and Microsoft who focused on the business market to carry the burden of the introduction. Other electronic firms like Philips, however, opted for a different introduction strategy in which the television set and home entertainment were central components.

By late 1986 Philips had decided not to follow the computer-oriented CD-ROM route, but to develop CD-interactive (CD-i), a mixture of text, still images, video and audio made available through conventional television sets. CD-i in this period of development was seen as a consumer product intended for home use. From that point in time another five years were required before CD-i was suitable for market introduction – primarily as an initiative by Philips but with some involvement from Sony. Other companies such as Commodore and 3DO Corporation also eventually developed products based on this television-oriented approach.

When CD-i was finally introduced in New York on October 16, 1991, the personal computer world had moved on and the computer hardware and software manufacturers, united in the Multimedia Personal Computing Marketing Council, had established the Multimedia PC norm, known by the acronym MPC. This industry standard assured the consumer that any multimedia title could be played on equipment consisting of a personal computer, CD-ROM reader and computer screen. The MPC norm eventually lead consumers into the world of multimedia and computing.

Television-oriented readers are popular in specific geographical regions of the world. For example, CD-i is more popular in Europe (403.000 units) than in the USA (350.000 units); it is especially popular in the Netherlands, the homeland of

Philips, where in 1994 no less than 10% of all CD-i readers worldwide (778.000 units) were located. 3DO is popular in Japan (225.000 units) and the USA (185.000 units) and hardly known in Europe (15.000 units) (see CD-Info, 1995).

Looking at market figures across time, professional CD media titles, mainly text-based products, had higher sales figures until the early 1990s when the price of personal computers with built-in CD-ROM readers became acceptable for a large segment of the consumer market. Since 1991 multimedia have made major inroads into the general consumer market. In that year alone 193 multimedia titles were available; in 1995 no less than 3,496 titles were on sale. In less than three years consumer titles took one-third of the total number of titles (TFPL, 1995b). Although at present more professional-oriented titles are produced than any other type, consumer-oriented titles are expected to equal this category by the end of 1996.

Video-CD

Multimedia in 1991 was a basic combination of text, sound, data, still images and video of little more than postage stamp size. On CD-ROM video was played through software such as QuickTime. CD-i also supported small windows video by software. In 1993, however, the White Book standard with MPEG1 compression was set, which led to full screen, full motion video then supported by hardware such as play-back add-ons for CD-ROM and video cartridges for CD-i.

More important was the cross platform play-back facility. A Video-CD, produced according to the White Book, became playable on CD-ROM, CD-i, 3DO and other platforms. It then became commercially attractive to transfer movies to CD media, independent of specific reader characteristics. However, inasmuch as Video-CD was only capable of holding 74 minutes of video per disc, a full-length movie had to be transferred to two discs, which was seen as a drawback by the film industry. And although MPEG1 compression was considered state-of-the-art technology, the film industry continued to demand a format which would allow presentation of a full-length film on a single disc.

By late 1994 two industrial alliances had produced commercially-viable alternatives. One alliance was formed by Philips and Sony, which hoped to dictate the new format much as they had done with CD audio, CD media and Video-CD. The other alliance included Toshiba and Time Warner. Philips and Sony proposed the Multimedia CD (MMCD) as industry format, and mustered much support in the computer world. Toshiba and Time Warner advocated the Super Density (SD) format, and this alliance was largely supported by the movie industry. Both camps launched a publicity war, and for almost a year it looked as if the earlier video war between VHS, Betamax and V2000 would be replayed. By October 1995 both

camps had negotiated a truce in order to avoid what all sides felt would otherwise be a costly conflict over technical standards.

Table 3: Characteristics of CD-ROM and Digital Video Disc (DVD)

Characteristics	CD-ROM	Digital Video Disc (DVD)
Disc diameter	120 mm	120 mm
Disc thickness	1.2 mm	1.2 mm (0.6 thick disc x 2)
Memory capacity	680 Mb	4,7Gb/single side
Track pitch	1,6 micrometer	0,74 micrometer
Wave length of laser diode	780 nanometer	650/635 nanometer
Numerical aperture	0,45	0,6
Error correction	CIRC	RS-PC
Data transfer rate	1.15 Mb/s	4.69 Mb/s
File management	ISO 9660	Micro UDF or ISO 9660
Image compression	MPEG1	MPEG2
Running time movies	74 min	133 min

Source: Electronic Media Reporting, 1995

By December 1995 specifications for the Digital Video Disc (DVD) had been established and accepted by nine electronics and amusement companies. Capacity is the most remarkable aspect of the DVD. Basically, there is a two-pronged technology approach. There will be a single-sided, single-layer technology providing a storage capacity of 4,7Gb, enough for 133 minutes of MPEG2 quality video. The format also leaves a migration path to future formats using a double layering technology facilitating 8.5Gb of storage on one side. Both layers will be read by a double-focus laser from one side of the CD disc. Besides this new 'two-layers-on-one-side' technology, two sides can be seamed together either back to back or on top of each other, thus doubling the 8,5Gb storage. As yet this technology is not included in DVD specifications.

CD media was basically a spin-off from CD audio. It was relatively easy to fund and build the technological infrastructure on the existing replication facilities of CD audio. The new DVD technology uses the same infrastructure, although with some adaptations. Changes in the replication infrastructure are inconsequential and additional costs to the consumer are anticipated to be minimal.

This technological development has yet another important implication for the existing CD media industry: it provides backward compatibility with existing conventional density formats. This means present discs in CD-ROM, CD-i, 3DO and Video-CD formats can still be read by the new readers. In this manner publishers need not fear loss of investment capital, and can pick the appropriate commercial moment for changing to the new format.

DVD technology implies that current CD media users will eventually have to change over to the new generation of readers. Inasmuch as a format consists of a disc, reader and a delivery machine, transformations are also expected in current

applications. As the CD-i format is based on a Motorola 68000 chip in the present reader, the new format discs will require a thorough upgrade or replacement by a new set-top box.

Implications of DVD technology

Three main applications of DVD technology can be defined in the areas of: multimedia PCs, linear TV set-top boxes, and interactive TV set-top units. Regarding *multimedia PCs*, the industry is accustomed to building CD-ROM readers into personal computers. Reader performance has been rapidly improving. Double-speed readers have been replaced by quad-speed readers and a new generation of readers with a speed factor of six is now emerging. In order to attain the next level of performance, however, more research and development will be required to achieve effective data decoding throughout, and tighter pit control by laser units. By switching to the new DVD readers, manufacturers will be able to leap-frog into the next CD media generation.

Regarding *linear TV set-top boxes*, Digital Video Disc is becoming a competitor with the analog laser videodisc, first introduced in 1979. Thanks to MPEG1 compression technique, the Digital Video Disc did not become a real threat to the market, but with the single standard, MPEG2 compression and backing from Hollywood, linear set-top boxes are expected to become a serious competitor of the analog video disc. However DVD technology will not replace the VCR because it does not have recording features and, as a consequence, does not allow users the benefit of time-shifting in programme viewing. However, the quality of the linear DVD products will be superior to present-day VCR tapes. As such, a quality war might ensue. In addition, the new linear DVD products will have to compete with video-on-demand and perhaps digital compact cassette tapes. Introduction of linear TV set-top units will be more difficult than the replacement of the reader in the multimedia PCs, inasmuch as the units constitute at best a partial replacement, playing for a change in quality.

Interactive TV set-top boxes, are expected to replace CD-i, 3DO and Play Station as these are constrained by the characteristics of the readers. CD-i of Philips/Sony is a 16-bit machine; 3DO of the 3DO Corporation is 32 bit. Play Station of Sony Corporation has advanced to 64 bit. Nintendo and Sega are caught up in a 32/64-bit transformation. It is expected that 64-bit machines will dominate the market for some time and not entice manufacturers to launch new interactive TV set-top boxes. Only Philips may react to the opportunity by dumping its CD-i machines in a couple of years and then entering the era of interactive TV set-top boxes.

The conversion process

A commonly heard expression in innovation circles is that the first city on gas will be the last on electricity. An initial technological advantage, in other words, may result in an eventual market disadvantage. The life cycle of a technology may, in fact, dictate the time required for conversion to another technological base. This phenomenon has been observed repeatedly in the history of computing. Minitel in France, it can be argued, reduced the rate of the introduction of personal computers in that country, and consequently to slower rates of introduction for both CD-ROM and Internet. The operating system Windows, another example, proved to be a serious market competitor for IBM's OS/2, despite the higher quality of the latter operating system. The presently installed base of personal computers and television set-top boxes may, indeed, determine the rate of technological conversion.

The American market research bureau InfoTech (1995) predicts that multimedia PC will drive the DVD market. In 1997 around 3% of the total worldwide CD-ROM readers will be sold, equivalent to some 1.2 million readers. By the turn of the century, no less than 39 million units, almost a third of the worldwide CD-ROM readers, will have been installed in personal computers.

By comparison, linear TV set-top boxes will follow at a slower pace of market acceptance due to competition from other technologies such as VCR tapes, digital video tapes and video-on-demand. Despite such delays, linear TV set-top boxes will score on par with CD audio with 1.1 million readers in 1997 and an expected 10 million by 2000. This is anticipated to be one of the most successful introductions of consumer electronics in history.

As already indicated, interactive TV set-top boxes will be introduced slowly due to the current change-over to 32/64-bit machines. Manufactures might well hold back until 1998 before considering DVD readers seriously for inclusion in their game computers. The sale of DVD units in 1997 is expected to be no more than 250.000, eventually increasing to 6 million units by the year 2000.

At the announcement of the DVD specifications, Toshiba predicted sales of 120 million readers by the end of the century. Although this prognosis is three times higher than those of InfoTech, Toshiba also agrees that the DVD format will be driven by the personal computer industry.

Both forecasts indicate that the business and high-end consumer market will initiate the conversion process. It is only when there is sufficient critical mass that the price of DVD readers will be driven down. So, the faster the personal computer market takes up DVD readers, the sooner linear and interactive TV set-top boxes will become commonplace.

Internet and CD media

The new format is not the only factor influencing the CD media market. Developments of services on networks such as Internet and interactive cable services are often mentioned as a threat to optical media. From this perspective, CD media are only a temporary phase bridging the period of the early 1980s with its videotex services and ASCII databases, and the late 1990s with Internet and interactive cable services. Media substitution may emerge, it is argued, instead of media differentiation.

The notion of substitution is based on the proposition that network services will be so inexpensive that they can easily surpass CD media on the basis of megabytes per second. This argument is comparable with that made regarding videotape recordings and video-on-demand (VOD). Once movies are available at any time during the day at a price comparable or lower than that charged for renting tapes at videoshops, VOD will appear more attractive for consumers. But VOD must still demonstrate its inherent value, and substitution of CD media by telecommunication services still has to take place.

Looking at media developments across history, a wide differentiation of print media products have emerged. Currency and quantity have lead to a broad spectrum of newsletters, daily and weekly newspapers, magazines and books. When radio and television were introduced, print media were forced to adapt their editorial formulas and marketing strategies. Although print media underwent much change, they have come to co-exist with electronic media. A similar form of differentiation is foreseen whereby digital media will concentrate on more current events presented on-line and CD media will be reserved for stable data and information.

This supposition caters to the idea that the free-for-all policy on Internet will end within the next years or be seriously curtailed as Internet becomes more commercial and financial transactions become secure on the Net. At that moment, the price/performance ratio will dictate the channel of distribution: the Net or the CD. The high capacity of DVD might well prove to be a viable complement to the Net.

Conclusion

A communication technology, initially conceived as a library reference tool has emerged into a full-fledged multimedia facility with widespread educational and entertainment applications. Readers are becoming commonplace and titles are being introduced along a strategy similar to that followed by traditional book publishers. The new DVD format will propel this development further and stimulate film recording on CD discs. The high data capacity of DVD may prove to become a low-cost complement to information storage and delivery via Internet.

References

CD-Info (1995) *CD-Info*, London.

OPIA (1995) *Optical Publishing Industry Assessment*, Woodstock VT: InfoTech Inc.

TFPL (1995a) *CD-ROM Directory*. London: TFPL Ltd.

TFPL (1995b) *CD-ROM Facts & Figures*, London: TFPL Ltd.

3 Architectural Battles in the Multimedia Market

Marc van Wegberg

Competition in the emerging multimedia market currently focuses on setting standards for storing, retrieving, processing, (de)compressing, and transmitting information. Each multimedia system or architecture combines several standards, some of which are proprietary. This chapter draws on a number of insights from industrial economics to analyze the strengths and weaknesses of the architectural companies by means of five hypotheses. These hypotheses may also serve as a guide for further research.

This chapter develops a case study of the emerging multimedia market. The multimedia market is at the intersection of several information technology industries. The importance of standards (for storing, retrieving and transmitting information) gives rise to architectures (a consistent, complementary set of standards). Business strategies (should) evolve around these architectures. The core concept here is the architectural control a firm has when it determines who has access to the architecture. The basic premise is that architectural control is the major source of a sustainable competitive advantage in multimedia. The next section demonstrates the importance of architectures. The subsequent four sections explain the strength of firms in the architectural competition. Each section uses an industrial economics theory to highlight one particular aspect of competitive strength. These insights form a cognitive model to explain the viability of architectures, that is, their prospects of diffusion. I apply the model to an examination of the multimedia market. The aim is to give a preliminary evaluation of the viability of the existing multimedia standards. It concludes with a ranking of the architectural companies in terms of strength to sustain their respective architectures. This entails a prediction about the viability of these standards. The concluding section discusses events in 1995 which begin to indicate whether the standards' battle is unfolding along the lines expressed in this chapter.

The data used in this chapter come from various business journals, such as the *Economist*, the *Wall Street Journal Europe* and *Business Week*. They include announcements of alliances, product introductions, standards supported by firms, and statements about the installed base of selected multimedia standards. The source material used from journals applies to the period 1985 to 1994. These data are, it should be stressed, extremely limited. Moreover, many relevant data are somewhat judgemental, such as the quality of an operating system, hardware, or software. Some quantitative data, such as sales, are not always reliable inasmuch as firms use them in competition for signalling purposes. The conclusions in this chapter are, therefore, tentative. The chapter identifies variables that are relevant in predicting the diffusion of a multimedia standard. This should stimulate further effort in collecting and analysing the necessary data.

Architectural control and multimedia strategies

Business strategies in information technology evolve around architectures (Ferguson & Morris, 1994). A system consists of several components which must work together. An information system consisting of many components requires several standards to govern the intricate flows of information. There are standards about how to store, (de)compress, retrieve, and transmit information. Ferguson and Morris (1994:120) call the complex of standards and rules that governs a system its *architecture*. An important aspect of an architecture is who owns the standards. Some standards are public, and have been selected by joint bodies or governments. The television standard PAL employed in Europe is an example. A privately funded committee, the Motion Picture Experts Group (MPEG), developed Video-CD, a standard for (de)compressing moving images and associated sound onto a CD. Other standards, such as computer operating systems, belong to individual firms. A company that owns and controls a standard has *architectural control*: it sets the conditions and prices by which other companies can access its architecture. For example, software makers pay royalties to video game system owners (such as Nintendo and Sega) for the right to release software for their machines.

Ferguson and Morris make two claims about architectural control. First, it is both more costly but also (potentially) more profitable to have architectural control. Second, since their control is profitable, rivals will launch improved systems. Hence, privately controlled architectures are more dynamic and offer higher quality than publicly controlled standards. They cite the slow advance and low quality of the television and fax standards as examples of public standards.

The operating system of a multimedia system is the key to its architectural control. Within an architecture, however, there can be standards for certain components or links that are controlled by separate companies, or that are world standards.

Microsoft owns the Windows operating system, but not the Soundblaster, the *de facto* standard for sound in Multimedia PCs. Most architectures pledge support to world standards such as audio-CD, Photo-CD and Video-CD. Because of the complexity of multimedia products, they involve many standards. Innovations keep adding new functions and thus new standards. Interactive TV is an example where an innovation has unleashed a new standards battle. Companies that own one or more standards exert (some) architectural control.

Consistent with Ferguson and Morris's second claim, the advantage of proprietary standards induces a spate of systems. Multimedia has become a fragmented market with incompatible systems by Sega, Nintendo, CD-i, 3DO, Atari, Commodore, as well as Windows and Macintosh multimedia PCs. Tandy uses Modular Windows from Microsoft for its system, called Video Information System (VIS). Commodore's CDTV has already failed on the market, but the company bounced back with its CD32. The various multimedia architectures target different market segments and types of use. The multimedia computer systems (Macintosh and Windows) and CD-i target all market segments, that is, business (e.g., training and point of sales), consumers and education. Most other systems, including those of Atari, Commodore and 3DO, Sega (the Saturn), Sony (PlayStation), and Nintendo (Ultra 64), are primarily targeted at video game applications.

Explanatory Model

The next sections piece together a model intended to explain the evolution of multimedia architectures. The dependent variable, so to speak, is the chance that an architecture survives into the next period. Or, alternatively, the variable indicates the evolution of market shares of architectures (diffusion). In order to identify explanatory variables, I turn to the existing literature in game-theoretical industrial economics. This perspective contains many useful theories which have deepened our insight into how markets function.

Four theoretical perspectives within industrial economics will be discussed. Each presents some explanatory variables for the survival and market share of multimedia architectures. To some extent, firms can manipulate these variables, that is, use them as instruments in competition. Together, these theories provide a model accounting for the evolution of standards. The first is the standards perspective with emphasis on the importance of an installed base and compatibility. The next one is the commitment perspective which focuses on the need to make irreversible decisions in an uncertain environment. The multi-market perspective focuses on entry by related firms, and finally, the network perspective compares the pros and cons of alliances and mergers. Each perspective suggests one or more hypotheses that indicate the strength of the companies involved in the

architectural battles. The final section summarizes the overall strength of these multimedia firms.

Standards perspective

The cumulative number of machines or systems sold, the installed base, provides an estimate of the potential market for a software programme. Hence, the larger the installed base, the more and better the software which will be made available. This in turn is important for potential consumers' buying decisions. First movers build up an installed base, which is their prime competitive advantage (and entry barrier) to later movers (Farrell & Saloner, 1986; Matutes & Regibeau, 1988). A new architecture may attempt to overcome the disadvantage of a small installed base by seeking compatibility with existing standards. This theory suggests the following hypothesis:

> *Hypothesis 1: The size of the installed base (1a) and degree of compatibility with accepted standards (1b) have a positive effect on the viability of an architecture.*

What does this imply for multimedia architectures? Table 1 provides estimates of the installed base of a large number of systems. In this respect, multimedia PCs lead, with Windows PCs having by far the largest installed base and largest catalogue of software titles. The Apple Macintosh PC ranks second in this regard. Both systems also accept

Table 1: Multimedia architectures

Multimedia standard	Estimated installed base (date of est.)		Standards supported		
	Players sold	Consumer titles	Audio-CD	Photo-CD	Video-CD
CD-i	850-900,000 (end 1994)	200 (Oct. 1994)	x	x	x
Multimedia PC & windows (MPC)	3.5m (US, end 1994)	1,700 (est. end 1994)	x	x	—
Multimedia PC/ Macintosh			x	x	—
Tandy's VIS			x	?	?
Commodore CDTV			x	—	—
Commodore CD32			x	—	x
3DO	250,000 (Oct. 1994)	100	x	x	—
Sega Mega (CD or cartridges)	13m. (US, May 1994)		?	?	?
Sega Saturn	introduced 1995/96				
Sony PlayStation	idem				
Nintendo Ultra 64	idem			Expected to use cartridges and not CD	

several CD-based standards, such as Photo-CD.[1] The installed base of Nintendo and Sega videogame sets is also very large: a third of American homes have a game player, and two-thirds of the children between 6 and 14 are regular players (*Business Week*, 22 Nov. 1993, 54–60). Most of these are not, however, CD-based, and can only play game software. Sega has already moved up to a CD version of its videogame set. New systems introduced in 1995 (Sony's PlayStation and Sega's Saturn) and in 1996 (Nintendo's Ultra 64-bit computer) did not have any installed base nor software as of 1994. Among the new systems introduced by or before 1994, CD-i appears to have the largest installed base, and the largest catalogue of titles.

Penetration of multimedia in the home is still small, probably even in the United States. This suggests that the installed base advantage of early movers may not be sufficiently large to deter new entries. This is, at least, the assumption made by late movers (such as Sony). One strategy to overcome the problem of a small installed base is to seek compatibility with an established standard. In this regard, the three computer systems have upgraded their existing operating systems into multimedia systems. The MPC standard for Windows was built on the CD-ROM standard, introduced in 1985. It has, therefore, the oldest roots, which allowed it to build up a large installed base. The new systems introduced by consumer electronics firms seek compatibility with emerging world standards, notably, Photo-CD and Video-CD. If the pieces of available evidence are brought together, it appears, in accordance with hypothesis 1, that the viability of multimedia standards ranges from High (Microsoft, Apple, as well as Nintendo and Sega's 16-bit standards), via Medium (Philips and 3DO/Matsushita), and Low (Atari, Commodore, and Tandy) to Absent (Sony's PlayStation, Sega's Saturn, Nintendo's Ultra 64). See scores for each of the hypotheses in Table 6.

The viability (future diffusion possibilities) of multimedia standards, however, depends on more factors than just the installed base. The next sections discuss three other factors which consider why some firms, such as Sony, take the risk of entering the market at such a late stage in technology development.

Commitment perspective

The existence of many incompatible standards leads to uncertainty. Neither consumers nor software suppliers know which standard offers the best future prospects. This is a problem since investments in multimedia are durable and it is costly to switch from one standard to another. To attract both consumers and software suppliers, architectural companies must build confidence in their product. Confidence that the architecture will continue to be available worldwide for many years to come, and that it will participate in new developments that consumers consider important.

[1] Both accepted Video-CD as of 1995.

The main instrument to build this confidence is to make irreversible investments in it. These irreversible investments, or *commitments*, display beyond doubt that the firm itself believes in its own architecture. No firm invests massive sums in an architecture if it is uncertain about its future existence.

An early move represents a greater commitment than a later move, since a first mover commits itself to certain choices, whereas a later mover waits in order to keep options open. Later comers may integrate new technologies into their systems, and may learn from mistakes made by early movers. If commitments dominate, first movers have an advantage over later movers. If technological uncertainty and imitation dominate, then second movers will win the competition for standards. As a result, firms should strategically over-invest in commitments (if the advantages are most important) or under-invest (if the disadvantages are thought to be the most important). Industrial economists emphasise the importance of these strategic over- or under-investments (Fudenberg & Tirole, 1984; Bulow *et al.*, 1985). But their approach is not yet sufficiently operational to be able to identify in advance what is the appropriate strategy for the multimedia market. It comes as no surprise, then, that firms have made very different choices in their commitments. The commitment theory therefore suggests the following hypothesis:

> *Hypothesis 2: The extent of a firm's commitment has a positive effect on the viability of its architecture.*

There are quantitative aspects to the extent of commitment (the firm's sunk investments) as well as qualitative aspects. In the context of multimedia, I approximate the extent of a commitment with the time of entry and the qualitative breadth of the firm's commitment. These data are more readily available and also more relevant than financial size of investments.

Table 2 lists firms and the types of commitments in which they have engaged. It shows two dimensions for commitment: in terms of timing and in terms of the breadth and nature of investments. It does not record the absolute size of investments in standards, nor the quality of resources and policy execution that a firm brings to bear. Introduction of a system in 1991 (in at least one country) is considered an early move; later dates identify later movers. Learning is an example of a later mover advantage. For example, Philips's early investments in software for CD-i were largely educational. It later found that most consumer demand was for videogames. CD-i is not, however, primarily designed for videogames. Building a game for CD-i is certainly possible, but requires special programming software that is costly to develop (Multimedia Computing Magazine, Jan. 1995, 39-41). Later movers learned from this by designing their interactive machines with videogames as the primary objective.

Table 2: Multimedia companies and commitments

Firm/ Commitment	Entry	Investments in: OS	Hard- ware	APP	OS new (N) or upgraded (U)	Number of incompatible OS supported	Size of commitment
Microsoft (MPC)	1991	x	—	x	U	1	High
Apple (Macintosh)	?	x	x	—	U	0	Medium
Philips (CD-i)	1991	x	x	x	N	1	Medium
Commodore (CDTV)	1991	x	x	—	U	1	Medium
Tandy (VIS)	1992	—	x	—	U	1	Low
Sega (Mega CD)	1992	x	x	x	U	0	High
3DO (3DO)	1993/4	x	—	—	N	0	Low
Matsushita			x			2	Low
Atari (Jaguar)	1994	x	x	—	N	1	Low
Sega Saturn	1994/5	x	x	x	N	1	Low
Sony (PlayStation)	1994/5	x	x	x	N	3	Low
Nintendo (64-bit)	1996	x	x	x	?	0	Low

The breadth of investments refers to the objective of developments: an operating system (OS), hardware, application software (APP), or combination thereof (which represents a greater commitment). If a firm upgrades an existing standard (a computer operating system or videogame system), it deepens its commitment to that standard. If it develops a new system from the ground up, it has no prior commitments or does not need to honour them. If a firm bets on two horses, so to speak, it has a lower commitment to any particular standard, than if it focuses on a single standard. For example, some firms supported both multimedia computers as well as television-based multimedia systems (Atari, Philips, and Tandy). Matsushita supports the 3DO standard, so the two companies are complementary, each having a low commitment. Matsushita can easily switch to another standard. Initially, for instance, it cooperated with Philips in the development of CD-i. Commitments range from low (late entry, development of only one component of a multimedia system, introduction of a new platform, betting on several standards) to high (early entry, development of all three components of a system, upgrading existing system, focusing on a single standard).

Considering the breadth of the commitment, hypothesis 2 implies that the viability of multimedia standards ranges from High (Microsoft), via Medium (Apple, Commodore, and Philips), to Low (Atari, Nintendo, Sony, Tandy, and 3DO); see Table 2. Microsoft has a high degree of commitment to its system, as shown by its early entry, its investments in, especially, application software, and its upgrading of existing operating systems (from Dos to Windows to the MPC standard). It should not weigh heavily that it does not invest in hardware (given that PC manufacturers perform this task), nor that it also supplies multimedia software to the Macintosh (as

these are the same programmes also developed for Windows). Apple fails to get a 'High' score for not investing in application multimedia software. Philips comes close to a 'High' score, but loses from having developed a new system, while simultaneously having supported the introduction of incompatible CD-ROM based multimedia systems. Commodore does not invest in multimedia application software, and it developed two (slightly) incompatible standards, the CDTV and the CD32. Sega scores 'High' on its Mega, but this one will be replaced by the Saturn, where it scores low.

Multi-market perspective

The multimedia market is colonized from existing markets whose products or technologies are related. Most participants in the multimedia market are multi-market firms with vested interests in these related markets. The advantages that these firms may have upon entry in multimedia are based on *shared resources* (Baumol *et al.*, 1982). A shared resource is an asset that can be utilized in several markets simultaneously, without use in one market impairing use in another market. That is, it represents a 'public good' in the company's research, production, or marketing process. A brand name, for example, can be used to market different products. Other examples of shared resources are know-how and reputation. Once a firm owns a shared resource, it can enter a market at lower costs than a new firm, as the latter still needs to acquire the resource. That is, the shared resource leads to an economy of scope (Bulow *et al.*, 1985). If firms own shared resources, the associated economies of scope induce them to become multi-market in scope. By *related markets* I refer to markets that are linked by economies of scope due to shared resources. *Relatedness* indicates the extent to which a firm that enters the multimedia market can exploit economies of scope with its home market. The larger a firm, the more such shared resources may have accumulated. This perspective suggests the following two hypotheses:

> *Hypothesis 3: Company size, as a proxy for the potential for economies of scale and scope, has a positive effect on the viability of an architecture.*

> *Hypothesis 4: The degree of relatedness (with multimedia) has a positive effect on the viability of (multimedia) architectures.*

What do these hypotheses suggest for multimedia? Considering hypothesis 3 on company size, the viability of multimedia standards ranges from High (Matsushita, Sony, and Philips), to Medium (Apple, Microsoft, Nintendo and Sega) to Low (Atari, Commodore, and 3DO); see Table 6 for an overview of these scores for the hypotheses. The 3DO company is difficult to judge, as 3DO is a small upstart with mounting losses, but some of its backers are powerful companies, notably

Matsushita. Because of their (nearly complete) exit from the computer industry, Atari and Commodore cannot exploit economies of scope resulting from the relatedness between the computer and multimedia markets. Table 3 provides an indication of recent sales for the major multimedia companies as an indicator of size.

Table 3: Total Sales in 1993 & 1994

Company	Sales in $ million
Apple	7,977.00 *
Matsushita	69,946.70
Microsoft	3,753.00 *
Nintendo	4,825.00
Philips	33,516.70
Sega	3,432.00
Sony	40,101.10

Source: Time Inc., Pathfinder, Internet (Nov. 21, 1995). Note: figures with asterisk are for 1993; rest for 1994.

The architectural companies in multimedia come from different industries, and are able to bring with them different kinds of resources. Table 4 reviews the architectural companies, their origin, their resources and possible weaknesses. The entries are admittedly somewhat judgemental. Relatedness of a home market with the multimedia market is difficult to measure. It is reasonable to argue that relatedness increases if the firm already sells to consumers, has a brand name that appeals to the targeted audience, has experience with user-friendly operating systems, and already sells some type of content. It also needs to be experienced in markets as fast moving and volatile as multimedia. This suggests that companies in (1) computers, software, (2) videogames, and in (3) consumer electronics have decreasing relatedness between their home base and multimedia. Computer companies score High on relatedness because of their experience with software, their experience with rapid innovation, and because they sell machines that can be upgraded to multimedia. Videogame suppliers score Medium by their experience in selling games consoles to a volatile and highly critical audience (youngsters). Their focus on videogames limits both their consumer segments and their experience with multimedia content. Consumer electronics firms Matsushita (Panasonic's 3DO), Philips and Sony score Low, as they did not have an operating system before entering into multimedia, nor did they develop operating or application software.

These arguments imply that, considering the degree of relatedness with multimedia (hypothesis 4), the viability of multimedia standards ranges from High (Apple, Atari, Commodore and Microsoft), via Medium (Nintendo, Sega and 3DO) to Low (Matsushita, Philips and Sony). See Table 4.

Table 4: Degrees of relatedness with multimedia

Firm	Main market	Shared resources used in its multimedia effort	Disadvantages and weaknesses
Apple	Computers	Macintosh OS Installed base (++) Design skills Brand name	No activities in multimedia application software
Atari	Computers	Design skills	Small size
Commodore	Computers	Amiga OS Installed base (+) Design skills	Small size
Matsushita	Consumer electronics	Panasonic brand name and manufacturing MCA film library	Focus on hardware may underutilize software (such as its MCA film library)
Microsoft	Computers	Windows OS Installed base (+++) Design skill	
Nintendo	Videogames	OS Installed base (+++) Design skill Brand name	Late entry New machines may not even be CD-based
Philips	Consumer electronics	Brand name Manufacturing Integration in cons. elec. products R&D and design skill	Delays from R&D to the market still a problem
Sega	Videogames	OS Installed base (+++) Design skill Brand name	
Sony	Consumer electronics	R&D, Design skill Brand name Columbia film library Manufacturing skill	Late entry
3DO	[New]	Design skill	Small size

Networking perspective

The network literature suggests that network centrality is an important asset, although no conclusive evidence seems to exist (Duysters, 1995). Why do firms create a network through alliances or mergers in the first place? Investments in, for instance, R&D have direct effects on other firms. They have positive effects as know-how is passed on to them. There are also indirect effects as know-how may improve one's competitive position relative to rivals. These (in)direct effects induce firms to cooperate, which may take the form of a merger or alliance (De Bondt & Veugelers, 1991). Both mergers and alliances are instruments in improving one's competitiveness (market positioning). They have some different (dis)advantages.

An alliance allows firms to share costs and to pool risks. It also allows firms to specialise to the benefit of the overall quality of joint projects. A firm can enter into numerous alliances (thus creating a network), while it can acquire only so many firms. An alliance usually has an objective which is focused and specified ex ante. It may, for example, entail a project with a given time schedule, budget and partners' contributions. A merger or acquisition instead allows firms to coordinate a wide variety of decisions, without specifying them *ex ante*. A merger tends to coordinate both R&D and other investment decisions, as well as product market decisions. The latter allows the merged firm to exploit market power. Mergers are more costly to realise than alliances, as a merger or takeover may have far-reaching implications for shareholders and the equity markets. A merger, therefore, provides more commitment to a project or technology than an alliance. The higher costs of a merger imply that large firms will be more 'acquisition-active' than smaller firms. The following hypothesis emerges from this perspective:

> *Hypothesis 5: The centrality in networks has a positive effect on the viability of a multimedia architecture.*

Table 5 and journal reports suggest that the following firms are very active in multimedia mergers and alliances: the computer companies Apple and Microsoft, the consumer electronics companies Matsushita, Philips and Sony, and the videogame maker Sega. The firm 3DO appears to have created a network with numerous hardware and software firms. Nintendo has few reported alliances, and broke off its alliance with Sony. Sony then developed its own system, the PlayStation. Since the number of mergers and alliances recorded in this chapter is but a small segment of the total, the following conclusion may be put forward: considering the centrality in networks, the viability of multimedia standards ranges from High (Apple, Microsoft, Matsushita, Philips, Sony, Sega and 3DO) to Low (Atari, Commodore, Nintendo and Tandy).

Overall strength of multimedia firms

Combining the five hypotheses implies that the viability of a firm's architecture increases with the:
(1a) installed base and (1b) compatibility with established standards,
(2) timing and breadth of commitment,
(3) company size,
(4) relatedness between home market and multimedia, and
(5) firm's centrality in networks.

Table 5: Multimedia architectures and alliances

Standard	Open*	Acquirer (Acquired firm)	Alliances
Audio CD	Yes		Philips/Sony
CD-i	Yes	Polygram's film acquisitions (Propaganda Films; Working Title Films; A&M films; Island Pictures) Philips (Superclub videorentals)	MPDC (Philips/ Motorola) PCD-i (Philips/IBM) Interactive TV (Philips/Compression Labs)
CD32	No		
Jaguar			Atari/IBM
Macintosh	Yes		Apple/IBM (Kaleida)
Nintendo (NES)	No		
Nintendo (Ultra 64)	No?		Nintendo/Silicon Graphics
Photo-CD	Yes		Kodak/ Philips
PlayStation	No	Sony (Columbia Pictures; Guber-Peters Productions)	
Powerplayer	Yes		Apple/Bandai
Sega	No		Sega Channel (TCI, Time Warner)
Sega Saturn			Hitachi; Nvidia (licensing)
Video-CD	Yes		MPEG; JVC, Matsushita, Philips, Sony
VIS	No		Tandy / Microsoft
Windows	Yes	Microsoft (Dorling Kindersley, 26%, 1991)	1991 Multimedia PC Marketing Council (AT&T Computer Systems, CompuAdd Corp, Creative Labs Inc., Media Vision, NEC Technologies, Olivetti, Philips, Tandy Corp., Video Seven, Zenith Data Systems, and Microsoft)
3DO	Yes	Matsushita (MCA Universal)	3DO (alliance of Time Warner) Matsushita, AT&T, Electronic Arts)

* for a license

Table 6 lists the overall conclusions in this chapter regarding the strength of the companies in supporting their multimedia architectures. Given the firms' ranking on these five dimensions, I computed for each firm the number of High scores minus the number of Low scores, the Hi-LO score. I then suggest the following overall score. Firms with a Hi-Lo score of two or more score High overall. Firms with a Hi-Lo score of minus two or less score Low. Others score Medium. Apple and Microsoft score high, for they have no low scores. All the others score low on at least one dimension and consequently have overall scores of either Medium or Low.

Table 6: Overall assessment of multimedia architectural strategies

Firm	Installed base/ Compatibility*	Commitment	Size	Related-ness	Network Centrality	Overall score
Hypothesis & Table	1	2	3	4	5	
Apple	High	Medium	Medium	High	High	High
Atari	Low	Low	Low	High	Low	Low
Commodore	Low	Medium	Low	High	Low	Low
Matsushita	Medium	Low	High	Low	High	Medium
Microsoft	High	High	Medium	High	High	High
Nintendo (Ultra)	Low	Low	Medium	Medium	Low	Low
Philips	Medium	Medium	High	Low	High	Medium
Sega (Saturn)	Low	Low	Medium	Medium	High	Medium
Sony	Low	Low	High	Low	High	Medium
Tandy	Low	Low	?	?	Low	Low
3DO	Medium	Low	Low	Medium	High	Medium

* 'Low' also refers to absence of an installed base (new system).

Do these overall scores suggest any surprises? They suggests that the best prospects, as far as architectural companies are concerned, exist for Microsoft and Apple (High). This result indicates the strength of these firms as leaders in multimedia architecture. Apple's high score may be somewhat of a surprise. It does not produce multimedia application software itself. And, Microsoft is the largest supplier of multimedia Macintosh programmes. The videogame giants Sega and Nintendo score medium largely because they introduce new systems (the Saturn and the Ultra 64, respectively) that entered the market very late, and that have no installed base of software at the outset. Sega scores higher than Nintendo in networking ability. The consumer electronics companies have multimedia systems with medium or small-sized installed bases. Their relatedness to multimedia is Low, as they had to develop ability to write an operating system from scratch, as well as skill to write and publish application software. Atari, Commodore and Tandy score Low in several dimensions. Tandy's system appears to have collapsed for lack of sales. In 1993 Tandy sold its hardware PC activities to AST Research, and withdrew to retailing activities.

Concluding remarks

The data in the source tables stem from the period 1985 to 1994. In 1995 several new developments occurred which suggest how the architectural battle is about to unfold. Two developments stand out. The first is that small firms face great difficulties in supporting a multimedia architecture. This development shows the importance of company size (hypothesis 3). Commodore has been declared bankrupt (*Automatisering Gids*, Dec. 16, 1994), and its assets have been acquired by the

German computer manufacturer and retailer ESCOM. ESCOM plans to re-introduce Amiga technology upon which Commodore's multimedia standard was based. For the time being, Commodore is out of the race.

In October 1995 the 3DO Company and Matsushita Electrical Industrial Co. announced that Matsushita will pay 3DO a $100 million license fee plus additional royalties in exchange for the exclusive rights to use the M2 technology to power next-generation consumer and commercial products including 64-bit videogames, Digital Video Disc players, and interactive television set-top boxes. The M2 technology defines 3DO's second generation, 64-bit, multimedia standard. Matsushita will also receive the sub-license rights from 3DO that will allow Matsushita to sub-license M2 technology to hardware companies and software developers. This alliance comes very close to the equivalent of acquisition of 3DO by Matsushita. Without this cash-infusion 3DO was unlikely to survive. Matsushita seems intent on increasing its commitment to multimedia.

The second development is that new battlefields appear where the architectural companies have yet to prove themselves. These new battlefields show the importance of commitment (hypothesis 2). Only by renewing its commitment in every new battlefield can a company continue to spread its architecture. Since the beginning of 1995, the PC multimedia systems have been giving access to the Internet. The Internet has become the hype of the year. In October 1995, Philips followed in the same direction by announcing it will introduce a modem and software (a 'browser') for access to the Internet via its CD-i player. The Internet opens up a new battle for multimedia systems. Suppliers who fail to upgrade their multimedia systems to provide this capability may fall behind, and further diffusion of their systems may be halted.

A worldwide alliance of firms, including Toshiba, Sony and Philips, agreed to introduce a new standard for CD formats, called Digital Video Disc (DVD). The new global standard provides a higher storage capacity than current CD formats. This will force existing standards to upgrade their systems. That is, the audio-CD, Photo-CD, Video-CD, CD-ROM, CD-i, and all other CD-based formats will have to be redefined to use these higher-capacity CDs. Any supplier who fails to upgrade his system is likely to loose the race for market acceptance.

Interactive television needs set-top boxes to control the interaction between TV users and broadcasting organisations. Some multimedia architectures may evolve into these set-top boxes. This new development means that economies of scope emerge, when an architecture is used for several distinct products. The alliance between 3DO and Matsushita is an example: Matsushita is going to use 3DO's 64-bit technology for a variety of purposes, including 64-bit videogames, Digital Video Disc players (Digital Video is Video-CD upgraded to the new CD format), and interactive television set-top boxes. These economies of scope show that hypothesis 4 is gaining in force.

New technological battlefields have a contradictory effect on the multimedia market. On the one hand, they may increase the number of players in the market. New products, such as interactive television, mean that new economies of scope emerge. These may attract new entrants into multimedia. It is possible that, while existing multimedia standards may evolve into set-top boxes, some dark horses may enter the race, too. Cable companies are possible entrants. On the other hand, new battlefields may also raise entry barriers, while reducing the number of existing standards. The architectures have to face new survival tests almost every year: access to the Internet, a new CD format, virtual reality, interactive television, etc. Since no multimedia architecture is as yet entrenched, other than those from Apple and Microsoft, some existing systems are likely to fail.

Uncertainty will continue to exist, therefore, before clear indication of the 'winner(s)' and 'losers' is evident. Commitment (hypothesis 2), installed base (hypothesis 1), and the ability to develop new applications for one's multimedia standard become more and more pressing demands to keep an architecture alive. These new applications, in turn, may come forward when the architectural company has sufficient size (hypothesis 3), when it owns enough related resources and products that can be combined with the multimedia standard (hypothesis 4), and when it engages in the appropriate alliances to combine the resources it needs to develop new applications (hypothesis 5).

References

Baumol, W.J., Panzar, J.C. and Willig, R.D. (1982) *Contestable markets and the theory of industry structure*, New York: Harcourt Brace Jovanovich.

Bondt, R. de, and Veugelers, R. (1991) Strategic investment with spillovers, *European journal of political economy*, 7: 345-366.

Bulow, J.I., Geanakoplos, J.D. and Klemperer, P.D. (1985) Multimarket oligopoly: Strategic substitutes and complements, *Journal of political economy*, 93,3: 488–511.

Duysters, G. (1995) *The evolution of complex industrial systems: The dynamics of major IT sectors*, Maastricht: Datawyse.

Farrell, J. and Saloner, G. (1986) Installed base and compatibility: Innovation, product preannouncements, and predation, *American economic review*, 76,5: 940–955.

Ferguson, C.H. and Morris, C.R. (1994) *Computer wars: The fall of IBM and the future of global technology*, New York: Times Books.

Fudenberg, D. and Tirole, J. (1984) The fat-cat effect, the puppy-dog ploy, and the lean and hungry look, *American economic review*, papers and proceedings, 74,2: 361–366.

Matutes, C. and Regibeau, P. (1989) Standardization across markets and entry, *Journal of industrial economics*, 37,4: 359–371.

4 Electronic Pathways for Professional and Domestic Use

Harry Bouwman & Bart van den Hooff

This chapter considers the convergence of technologies in the field of telecommunications and multimedia. The central thesis is that there will be no Electronic Highway, but rather a large number of different paths dedicated to specific use functions. Technology allows different networks and applications which are suited to the demands and needs of individual users. For some applications narrowband twisted pair wires will suffice, even for multimedia. Other applications require gigabit networks. The discussion in this chapter focuses on networks, services and user demands.

The Electronic Highway is upon us. If we are to believe the protagonists (such as American Vice-President Al Gore and representatives of the telecommunication and computer industries), the 21st century will see the emergence of an integrated system of publicly accessible communication networks without limits as to transmission speeds and capacities. The discussions surrounding this subject have turned into a full-blown hype, both in the United States and Europe. It is, however, not the first hype of this sort to which we have been witness.

In the 1970s, there was concern among telecom operators about saturation of the telephone market and limited use of the infrastructure. Usage of telephone lines was – and still is – mostly limited to only several minutes a day. The emergence of video-tex systems seemed to provide an opportunity to achieve a more intensive and cost effective usage of the network. When the first concept of interactive television was introduced, either in the form of broadcast viewdata or videotex, a hype similar to that of the current Electronic Highway appeared in the mass media and focused on both videotex and emergence of the 'information society.' Another hype accompanied the first ideas on ISDN in the 1980s. In both cases, these hypes created high expectations, but eventually the results of the innovations were disappointing.

Videotex still has not been successful outside France, and ISDN is, although widely available, hardly used. Nevertheless, technology hypes do have their functions.

In addition to contribution to technology development, hypes can generally be considered to have an agenda-setting function. The current hype surrounding the Electronic Highway assists in this development becoming a relevant issue for policy makers, practioners and service providers. Technology, however, is not the only factor affecting the successful introduction of networks and services. A lot of actors and other factors – economic, political and social – play a crucial role in this process (Bouwman & Latzer, 1994; Latzer & Thomas, 1994). Telecommunications and multimedia applications, therefore, can be considered *interlocked innovations*. Interlocked innovations are not only innovations in the field of technology, but also innovations in service and applications themselves, and in usage.

A central concept in our perspective is 'contingency'. This means that users both in business as in consumer markets will select the service that fits best their interests; users aim to achieve an optimal 'fit' between their needs and the services they select (Daft *et al.*, 1990). Originally, contingency theory, with a basis in more general organization theory, was founded on the premise that, in order for an organization to be optimally effective with regard to its goals, the organization must be designed according to the requirements that situational factors place on organizational design (Galbraith, 1973). his premise has also served as the basis for models of media choice for individuals. In order to communicate effectively, a person has to achieve an optimal 'fit' between the information requirements of his task and the characteristics of the media used to communicate for that task (Daft *et al.*, 1990; Fulk *et al.*, 1990).

Such a contingency approach can also be applied to developments concerning the Electronic Highway. The central thesis here is that the communication infrastructure of the future will not be a single Electronic Highway, but rather a large number of different paths dedicated to specific user functions. Depending on their tasks and needs, either in professional or household surroundings, users will choose the medium with the appropriate bandwidth and interface for these tasks and needs.

The main technological developments with regard to information infrastructures are:
- increased capacity, intelligence and mobility in telephone networks;
- increased capacity and interactivity of cable networks;
- development of advanced peripheral equipment;
- designing interfaces from a user-centered approach.

Telephone network

Compared to just a few years ago, most public telephone networks in Western Europe and North America have changed radically. Transmission capacity has

increased considerably because of the use of optical fibre and compression techniques. 'Intelligence' has been built into networks; more functions which used to be performed by (software in) peripherals are now an integral part of these networks. Finally, there is a growing degree of mobility; interconnections with mobile networks make usage less dependent on fixed lines.

The issue of capacity is primarily related the growing use of optical fibre in telephone networks. Optical fibre allows higher transmission speeds than any other infrastructure material, providing a basis for a rich array of telecommunication services. It is important to distinguish between *Fibre in the Loop, Fibre to the Home* and *Fibre to the Curb*. Each of these concepts relates to a different degree of penetration of fibre in telephone networks.

Fibre in the Loop (FITL) relates to the usage of optical fibre for the connections between the trunk network and the primary and secondary access networks, the rest of the network consisting of either twisted pairs or coaxial cable. *Fibre to the Home* (FTTH) relates to the situation where every household is directly connected to the fibre network – even the trajectory from the home to the local switch is composed of optical fibre. *Fibre to the Curb* (FTTC) relates to a situation where the connection between the local switch and the home is based on both twisted pairs and coaxial cable. From an economical point of view, FTTC is much more attractive than FTTH. But, as long as it is unclear what kind of broadband services will be offered, it is hard to assess the economical viability of both concepts, especially for the consumer market. Further reduction in equipment and installation costs are necessary before FTTH or even the more cost-effective FTTC will become common practice.

Increasing transmission capacity is one way to achieve an increase in data exchange, but *compression* of the data to be sent is yet another. Compression techniques are also necessary in optical fibre networks. Digital television, for instance, requires 1.8 Gigabit/s, which is more than fibre itself can offer. It is clear, then, that compression techniques are important for the further development of services. Transmission of images over twisted pairs becomes possible due to techniques like JPEG and MPEG. Fractal compression even promises to make higher compression ratio's possible (Hoogeveen & Peeters, 1994).

Another development increasing the telephone network's capacity is the use of *protocols* like Asymmetric Digital Subscriber Line (ADSL), which increases the bandwidth of telephone networks from 30 Kbps to 1.5 Mbps and thus enables the transport of television signals over telephone networks. At the moment, capacity is still limited to one channel, but it is expected that eventually capacity will expand and serve multiple stations and programs. Experiments with this technology are going on in the United Kingdom, Australia and the United States. Some believe that the use of ADSL will make the concept of Fibre to the Home obsolete. Others believe that developments with regard to compression and communication protocols

are approaching the bounds of possibilities. Most likely, both developments will support each other.

In the business area Local Area Network (LAN) capacity can be increased through the usage of the Asynchronous Transfer Mode (ATM) technology (for [unshielded] twisted pairs) or Fibre Distributed Data Interfaces. For business LANs, optical fibre is only interesting for very demanding multimedia applications. Broadband ISDN (see next section) seems to offer sufficient bandwidth, certainly when used in combination with compression techniques.

The issue of 'intelligence' in a network relates to the question where additional functionalities are located: should these all be taken care of by the user's peripheral equipment (telephone, PC, television, etc.), or should part of them be located in the network itself? The traditional function of the telephone network is to establish a *connection*, but more and more 'intelligent support' functions are being built into networks: transmission control, signaling functions, charging functions, call forwarding, identification of communication partners, etc. The more intelligence being built into networks, the more advanced the services that can be offered over these networks.

Users want more individually tailored and mobile communication facilities: they want their communication to take place whenever required, i.e. communication should be independent of place and time (Llana, 1991). Developments in mobile communications serve this need: mobile telephony is developing to a stage where anybody is able to send and receive any kind of data, anywhere and at any chosen moment. Cellular telephony, the European GSM standard, mobile data communications, and the interconnection of these mobile networks with the fixed network, are important developments in this field. In the future, Personal Communication Networks (or sometimes called Personal Communication Systems) (PCN/PCS), based on smaller cells than GSM, will become available. PCN/PCS is expected to meet consumer demands even better (Acker *et al.*, 1993).

Integrated Services Digital Network

Having discussed the technological developments which will advance the level of service to be offered on the telephone network, we now turn to the successor of this network: ISDN, the Integrated Services Digital Network. ISDN is not a service in itself but a new type of service level, the digital successor of the analogue network. Improvements regarding networks mainly relate to digital switching and multiplexing techniques which allow faster and more sturdy transmission. One of the characteristics of ISDN which leads to such improvements is the usage of one channel for routing information. ISDN combines circuit switching with high transmission speeds and reliability of digital leased lines.

ISDN offers the following general services:
- *bearer service*, consisting of simple data transmission;
- *teleservices:* telephony, telex, facsimile;
- *additional services* such as call forwarding, video conferencing, Group 4 fax, and video telephony.

Most of these services are enabled by the technical separation of transmission and signalling which is the core of the Intelligent Network concept.

ISDN is commercially available in most European countries. In six European Union member states, more than 300,000 subscribers were anticipated on the ISDN network in 1993. In January 1994, there was a 70% availability of ISDN in the Netherlands, but there were only 850 known users. The main problems within Europe with regard to diffusion of 'Euro-ISDN' are the lack of full inter-operability between national networks and the lack of fully Euro-ISDN compatible terminals. Some consider ISDN as an alternative to the optical fibre scenario, especially those parties who have an interest in cable television systems and advocates of broadcast networks.

Two-way cable

Another existing large-scale communication infrastructure is cable television networks. Capacity is not a main issue with regard to cable television systems, but because of design factors these systems are only suited for distribution of signals from a central point in a particular network to its dispersed end connections. Signalling in the reverse direction is not possible. But ability to return data is a necessary condition for the advanced applications cable operators want to provide.

At the moment, some hybrid applications are available. One type of hybrid application uses telephone networks as a return channel. An example of such an application is Spirit: a 'freenet' experiment in Rotterdam, applying videotex via cable television and the telephone network. Many of the proposed experiments with interactive television in the Netherlands are, in fact, experiments with such hybrid applications.

The breakthrough of interactive television and cable is not expected to come from information services, but from entertainment developments such as pay-per-view and video-on-demand. An interactive video-on-demand system ideally requires data compression in the MPEG format, an ATM network connecting the video servers, and an access network of either copper, fibre or coax, with necessary network access multiplexers (Deloderre *et al.*, 1994).

Because of the technology required, the emergence of commercially viable interactive television will be a long-term process; it is not expected to be profitable before the end of the century. Therefore, cable providers are also interested in other ways

of capitalizing on the new infrastructures such as providing (mobile) telephony, interactive services and data communication capacity. The problem cable providers encounter in their wish to supply 'regular' telephony is that, under EU regulation, this service is still under concession of the national Telecom operators. Besides, it is to be doubted whether such service will be the most profitable for cable operators. Pay-television, for instance, has been available for 10 years in the Netherlands and thus far, no more than 200,000 households subscribed. With regard to mobile telephony, the traditional telecom operator has a very big lead in securing the market.

Currently, a number of Dutch cable operators are experimenting with tele-surveillance, telephony and distance education by cable. In the short run, the next five-year period, providing data transmission capacity might become a more profitable activity for cable operators. In the Dutch city of Leeuwarden, the cable operator is experimenting with broadband data transmission for the business market, enabling video conferencing, tele-surveillance, data retrieval and data transmission. For the consumer market, primitive forms of electronic mail are also offered. There is, however, a certain wariness among cable operators to actually implement these services, because they might interfere with their core business: provision of cable television programming.

Peripheral equipment

Not only the networks which carry the new services are developing rapidly, but also the peripheral equipment users apply to actually use these services is expanding. The trend is towards smaller, more mobile and sophisticated equipment, enabling a more flexible usage of advanced (multimedia) services.

With regard to the trend towards mobility, developments in the field of portable personal computers are of interest. Modern laptop computers have internal and external memory sizes which, only a few years ago, were not to be found in even large desktop PC's. Given this development, such laptops are able to carry sophisticated software for communication and document presentation. These laptops can also easily contain a (radio) modem, enabling them to communicate over both fixed and mobile networks. The trend towards smaller computers offering more possibilities has now led to the stage where 'palmtop' or 'pocket' computers have been introduced. The computer company Apple, for instance, has taken a leading role in this field with the Personal Digital Assistant (PDA) based on so-called Newton technology. This palmtop offers a wide array of applications, including a host of communications options (fax, mail, and 'beam' notes). There is also the possibility to connect with PC's and other PDA devices. Sharp, Siemens, Motorola and Matsushita have also entered this market. Whether these PDA's provide a real opportunity for multimedia applications is as yet uncertain, since market penetration thus far has been

rather disappointing, and the display facilities of these terminals are not – yet – adequate for most multimedia applications.

With regard to peripheral equipment for cable networks, the development of digital television will make the medium even more interactive thanks to the rapid evolvement of digital set-top boxes. The set-top box for digital interactive television is one of the potential multimedia terminals in the private domain. These terminals provide access control functions, features such as on-screen display, pay-per-view capability, reception of Direct Broadcasting Satellite (DBS) services and video-on-demand (Puissochet, 1994).

In the United States, General Instruments, Scientific Atlanta, Pioneer and Zenith are the main providers of the 32-bits set-top boxes. In Europe, Philips developed a set-top box based on the CD-i processor, using the relatively slow Motorola 16-bit 68000 chip. The addition of a CD-i drive to the set-top box facilitates use of CD-i. This technological development, however, is not supported by the alliance between General Instruments and Intel, currently the major developers of set-top boxes. In general, set-top boxes only facilitate addressability and do not imply interactivity. Set-top boxes do not provide for a return route on cable systems.

An example of a fully interactive digital set-top box is Mundi. Mundi (Multiplexed Network for Distributed and Interactive services) allows for a full-duplex, switched transparent connection over optical fibre with a capacity of some gigabits-per-second for the consumers market. Mundi is being developed by British Telecom, Deutsche Bundes post, Philips and a number of universities, and is not expected to be commercially available before the year 2000.

With regard to multimedia platforms, there seems to be a battle around different systems such as CD-i, CD-ROM, CD-ROM-XA, Electronic Book, CDTV, 3DO and game machines (Hietink & Bouwman, 1994; see also Chapter 3). There is a lot of uncertainty here, the latest market results suggest that Electronic Book, CDTV and 3DO are on the brink of extinction (Hietink & Bouwman, 1994), and CD-i sales seem to be disappointing. In the segment of game machines, many new systems are being introduced by Sony, Atari, JVC and Commodore.

It is striking that Sony and the 3DO-consortium are marketing their equipment through initial emphasis on games and entertainment applications, and from that perspective they have been developing and introducing other applications. Philips, on the other hand, has primarily positioned its CD-i player on the market as an edutainment tool, but also as an application for point-of-sale and point-of-information.

CD-i, based on television as a display platform, has to compete with multimedia PC's connected to CD-ROM drives and multimedia extension. Philips aims to take advantage of the relatively successful introduction of CD-ROM by offering a PC-board, which enables PC users to play CD-i discs on CD-ROM drives. Multimedia

PC's, incidently, are mainly found in professional environments. In combination with ISDN, these developments make video conferening a feasible option (Adamson & Males, 1994).

Interfaces

So, developments in the areas of infrastructure and peripherals have increased opportunity for faster provision of more advanced services, and faster and more flexible consumption of these services. For the ultimate presentation of a service to users, however, there is also another very important factor: the interface.

In the design of interfaces, an important factor is the relationship between text, (moving) images and sound in relation to the way people process information (Petty & Cacciopo, 1986). A strong asset of multimedia is that moving images attract the attention of the user, but that in itself does not constitute effective communication. According to Petty and Cacciopo, images appeal to the peripheral route of information processing, while the actual content of the information will be better processed on the basis of written text, which appeals to the central route. Wember's (1976) now classic studies demonstrated that the effect of images and text can oppose each other. This suggests that a careful balance between images and text is essential in the design of multimedia interfaces.

Some initiatives for the development of standards for multimedia interfaces are currently underway (Hodges & Sasnett, 1993). Voice processed interfaces will become available, but this development depends on the success that will be attained with voice recognition and voice synthesis, success which thus far has been rather disappointing. No voice processed interfaces are anticipated for general consumer applications before the end of the century.

User friendliness is crucial for the success of a particular service. Experiments with interactive television also suggest that users seldom read the manuals which accompany installed equipment: 40% of the manuals in one case remained unpacked. Learning to use such services is a process which consists of trial and error, vicarious learning and learning from children.

Work and profession

Organizational information infrastructures are changing from separate clusters of stand-alone systems to networked systems, not only local area networks (LANs) but also networks which span many organizations and geographical distances. Networks can cover local areas, metropolitan areas (MANs), or even larger areas (WANs). The most important trend in networking is the interconnection of networks, with Internet as the ultimate example of a 'network of networks.'

The interconnection of all types of systems within networks creates a need to rede-fine organizational processes. Relations within value chains are changing: electron-ic markets and hierarchies are developing (Malone *et al.*, 1994). There is also a trend towards integration within value chains in every economic sector, affecting relations between organizations and changing production and distribution processes. Information technology supports and facilitates these developments (Miller & Porter, 1985). Information exchange, either formalized (e.g. EDI) or based on a free format (e.g. E-mail), is crucial. Exchanges are not limited to mere information; the new technologies also enable electronic funds transfers (EFT) and other financial transactions (Digi-cash).

The strategic application of telecommunications and information technology affects organizational structures and strategies. The ultimate consequence of the introduc-tion of such technologies is a restructuring of existing relations between organiza-tions, even a restructuring of whole industries. In general, information technology and telecommunications assist organizations to overcome coordination and control problems and contribute to an increasing efficiency by standardizing products and processes (Bradley, 1993).

Communication services such as e-mail improve coordination and management of organizational processes, and are central within but also between organizations. One of the factors influencing the choice for a specific service is the complexity of the task to communicate (Daft *et al.*, 1990; Fulk *et al.*, 1990). According to this posi-tion, communication is effective when the capacity of the medium to convey 'rich information,' i.e., information which provides more cues as to the interpretation of the message, is in accordance with the complexity of the task.

Following this argument, when a message needs much of clarification, a medium with a lot of bandwidth (capacity to convey multiple cues) and direct feedback pos-sibilities is appropriate. Fax or electronic mail do not have the bandwith required for really complex tasks; video conferencing does offers possibilities in this case. However, it is not very plausible that traditional face-to-face conversations and meetings will be replaced in the case of complex managerial tasks.

Another important factor is the degree of structure a task requires; when standard-ized procedures are followed, EDI may be an appropriate medium. Management tasks, however, often require less structured formats such as e-mail or video confer-encing. Still, the appropriation of computer mediated media has led to a situation where group decision support systems and computer supported collaborative work are used in management tasks as well.

Information services primarily concern the reduction of uncertainty. With regard to the Electronic Highway, information services relate to services like on-line databases and news services. Internet is one very large collection of information, the retrieval of

which can be difficult, but is strongly improved by navigational services like Gopher, World Wide Web and user friendly interfaces such as Mosaic and its commercial counterpart Netscape. Increasing network capacity, together with more advanced peripheral equipment and interfaces now allows for the easy access of databases containing all kinds of formats: full text, images – still and moving. There is also a public interest in information services: both the American Vice-President Al Gore (1993) and the Bangemann *et al.* (1994) state that public administration information should be an important incentive for the development of national information infrastructures.

There is a strong information need on the part of managers. And, there is an important trend (facilitated by new communication technologies) towards a blurring of formal organizational boundaries, emergence of more inter-organizational networks and temporary alliances. This causes an increasing need to gather and access information about the external organizational environment (Nouwens, 1994). The fact that the boundaries between organization and environment are becoming increasingly unclear, and that these environments are in themselves vague, intangible and complex, makes the exact nature of this information need equally unclear. Because of these aspects, empirical investigations are required regarding the exact information needs managers have about such strategically important subjects.

Education and training programs within organizations tend to be stand-alone, tutorial drill-and-practice applications. However, people learn by discussing and evaluating the information offered, which means these traditional programs do not really correspond with user needs. Networks offer the possibility for people not only to work together on specific issues, but also to learn together. An excellent example of this is a program developed at Ohio State University called 'Meeting of the Minds'. This application contains not only the possibility to store and retrieve information, but also the possibility to discuss relevant topics in formal and informal settings (Acker, 1993). The program is used in a collaborative project between Ohio State University and the University of Amsterdam. Comparable applications are anticipated for human resource activities such as education and training programs within organizations.

Such beneficial effects do not occur automatically – the technologies have to be used in a way which corresponds with user needs. Van den Hooff (1994) found support for this in that persons who use the relatively lean medium of electronic mail predominantly for routine communication tasks, report more positive effects, both on an operational (increased efficiency) and strategic (new communication patterns) level. This underlines the importance of 'fitting' services to user needs.

Information technology at home

New communication technologies are entering not only the professional, but also the residential market at an increasing pace. An important issue is raised by the plat-

forms which will be used to deliver services to the consumer: the television set or the personal computer. Services for the consumer market can be divided in these two delivery platforms, which correspond with two defined spaces in a household: the *ten-foot space* where people watch television and the *three-foot space* of the home-office or study.

The ten-foot space is dominated by a low resolution display fit for entertainment-like services such as sports, games and movies. The amount of television channels available to the consumer is ever increasing, but there is also a tendency towards more channels offering more of the same. So, the question emerges as to whether there is really an increase of choice in the television market. In Europe, the same sport games are broadcast by various national channels, both commercial and public service stations. The only difference between the programs is the commentator's language. Although the number of channels is increasing, really new options are rare.

Yet, suppliers of interactive television expect viewers to be active and consciously select services offered by interactive television. The degree of activity actually required for services such as video-on-demand and home shopping is very low, and therefore these services can be expected to be attractive to any viewer – regardless of the validity of the so-called 'couch potato' image. With these services, there is no need to leave the house, and services and goods can be ordered directly from home thanks to lenient credit arrangements.

More 'active' services, such as participation in game shows and other programs, can be expected to increase viewer involvement. These services do not require very much in terms of technological functionality and interactivity; they can be delivered by means of the set-top boxes described earlier. Currently, experiments with interactive television are being conducted in the United States (in Orlando, Chicago, Manassas and Castro Valley) and in Japan (Digital City). Most of these experiments focus on the technological capabilities and market expectations, with a risk of overlooking the role of user needs. The primarily technology oriented experiments AT&T conducted among 50 Chicago households indicate that a 'killer-application' is hard to define: entertainment, even in information services is a very important aspect of any service with regard to attracting viewers (Mulder, 1994). So, for new services it appears to be important to integrate different functions; such services should contain aspects of information, communication, and transaction (home shopping), but especially entertainment. Another striking result of the AT&T experiment was that people tend to watch television socially; viewers want to watch and play games in a family setting, where personal computers tend to stimulate individual behavior. The actual 'interactivity' of interactive television is rather limited – yet viewers, strangely enough, are asking for communication facilities. This happened, for instance, in the AT&T two-way cable experiments in Chicago, and also in France, where videotex users in the first experiments with Télétel asked for such facilities as well (Charon, 1987).

In the three-foot space, users seem to demand a higher degree of interactivity. Because of the more active and individually oriented tasks which the usage of a personal computer implies, there will be a higher need for active participation, as opposed to the relatively passive entertainment in the ten-foot space.

The central equipment employed here is the personal computer, connected to a network by means of a high-speed modem and to a CD-ROM player, both enabling distance learning and working. The functional requirements of the equipment are more extensive than in the case of interactive television configurations. Different tasks can be performed: learning will become edutainment and communication becomes more independent of time and place (while at the same time communication with the user's direct environment is reduced). Gradually, images will become more easily accessible, both an addition to and a possible replacement for text information. All in all, the three-foot space is an environment for more serious attention to information retrieval and communication than it is for entertainment.

Conclusions

Networked multimedia services can be considered 'interlocked innovations', innovations characterized by an interdependence between different areas of innovation. These are not merely technological innovations, but also innovations with regard to organizational processes, professional tasks, social activities and policy aspects.

Technologically speaking, the development of networked multimedia services is strongly dependent on further increases in network capacity or bandwith and more advanced methods of data compression. An important issue here is where to locate the 'intelligence' required for the provision of these services: in the equipment of the end user, or – at least partly – in the network itself.

Users are not really interested in knowing about the technology. They do not care about how things travel through which wires. The central issue is the applicability of the technology with regard to certain tasks and needs, for a reasonable price. Therefore, developments in the field of peripherals and interfaces are very important, for these determine how the service is presented to the end user. Particular care must be taken in adjusting the interface to the user's needs, because the interface is the only direct connection between user and technology.

The 'added value' of such services, is more easily determined in the business market than in the residential market. This comes from the fact that tasks in organizational/professional settings are stated much more in terms of performance than needs and activities in residential settings, and therefore the demands such tasks place on new services are more clearly defined.

In spite of the enthusiasm that surrounds the Electronic Highway hype, the market

for services on this 'network of networks' is primarily a potential market. The intended user is confused as to the fulfillment of the technology's promises: there is a high degree of uncertainty and lack of clarity in the market, and the market does not seem to be ready for really radical changes. The current demand for networked multimedia services, especially in the residential market, is not well known. This is an important problem with new services: their adoption is difficult to study other than on a 'seeing is believing' basis.

User needs and tasks are important determinants of the success of new services such as networked multimedia applications. But these needs are not only hard to determine, they are also very diverse: in an age of growing segmentation and individuality, each person selects his/her own set of needs and interests in different areas, not necessarily mutually consistent. Because of this high degree of diversity and because the process of change of these needs is certainly no faster than the process of technological development, it is very likely that existing networks, with different rates of development regarding capacity, compression, intelligence and other technological factors determining the level of sophistication of services offered, will adequately cater to these needs. Therefore, it is more likely that the Electronic Highway of the future will consist of a constellation of different networks, each with its own traditions and specific functions with regard to user needs. This scenario seems more probably than the emergence of a truly integrated single network, offering services for each individual task and need on a single infrastructure.

References

Acker, S.R. (1993) Multimedia voor groepen: Educatieve toepassing, in: H. Bouwman and S. Pröpper (eds.) *Multimedia tussen hope en hype*, Amsterdam: Otto Cramwinckel.

Acker, S., Bouwman, H., Cuilenburg, J. van and Slaa, P. (1993) *PCN in perspective*, Columbus, OH: Ohio State University, Department of Communication and Amsterdam: University of Amsterdam, Department of Communication.

Adamson, M. and Males, E. (1994) *European multimedia. Business perspectives and potential for growth,* London: Financial Times Business Information.

Bangemann, M. *et. al.* (1994) *Europe and the global information society; Recommendations to the European Council*, Strausbourg: European Council.

Bouwman, H. and Latzer, M. (1994) Telecommunication network-based services in Europe, in: C. Steinfield, J. Bauer, and L. Caby (eds.) *Telecommunications in transition. Policies, services and technologies in the European Community*. Thousand Oaks, CA: Sage.

Bradley, S. (1993) The role of IT networking in sustaining competitive advantage, in: S. Bradley, J. Hausman, and R. Nolan, (eds.) *Globalization, technology and competition. The fusion of computers and telecommunications in the 1990s*, Boston: Harvard Business School Press.

Charon, J.M. (1987) Télétel, de l'interactivite homme/machine à la communication mediatisée, in: M. Marchand (ed.) *Les paradis informationnels*, Paris: Masson.

Daft, R.L., Lengel, R.H. and Trevino, L.K. (1990) Understanding managers' media choices: A symbolic interactionist perspective, in: J. Fulk and C. Steinfield (eds.) *Organizations and communication technology*, Newbury Park, CA: Sage.

Deloderre, D., Verbiest, W. and H. Verhille (1994) Interactive video on demand, *IEEE communications magazine*. May, 82–88.

Fulk, J., Schmitz, J. and Steinfield, C. (1990) A social influence model of technology use, in: J. Fulk, J. and C. Steinfield (eds.) *Organizations and communication technology*, Newbury Park, CA: Sage.

Galbraith, J. (1973) *Designing complex organisations*. Reading, MA: Addison Westley.

Gore, A. (1993) The administration's agenda for action. Internet-version.

Hietink, A.J. and Bouwman, H. (1994) CD-i versus 3DO, *Informatie and informatiebeleid*, 12,1: 7–10.

Hodges, M. and Sasnett, R. (1993) *Multimedia computing. Case studies from MIT Project Athena*, Reading, MA: Addison Westley.

Hooff, B.J. van den (1994) Incorporating electronic mail. Paper proposed for the 46th ICA conference, Albuquerque, NM, May 1995, Amsterdam: Department of Communication.

Hoogeveen, M. and Peeters, M. (1994). De elektronische superhighway, *Multimedia computing*, July/August, 7–9.

Latzer, M. and Thomas, G. (1994) Cash lines. *The development and regulation of audiotex in Europe and the United States*, Amsterdam: Het Spinhuis.

Llana, A, (1991) The prospect for personal communications, in: *Telecommunications*, September.

Malone, T., Yates, J. and Benjamin, R. (1994) Electronic markets and electronic hierarchies, in: T. Allen and M. Scott Morton (eds.) *Information technology and the corporation of the 1990s*, New York: Oxford University Press.

Miller, V. E. and Porter, M.E. (1985) How information gives you competitive advantage, *Harvard business review*, July-August, 149–160.

Mulder, A. (1994) Bells Labs ziet toekomst in multi-media, *PC+*, 6, 17.

Nouwens, J.C. (1994) Electronic consultation media for business applications, research proposal, Amsterdam: Department of Communication.

Petty, R.E. and Cacioppo, J.T. (1986) The elaboration likelihood model of persuasion, in: Berkowitz (ed.) *Advances in experimental social psychology*, New York: Academic Press.

Puissochet, A. (1994) Set-top boxes in the US: A gate to information highways? *Communications and strategies*, 14,2: 97–104.

Wember, B. (1976). *Wie Informiert das Fernsehen?* Munchen: Lis Verlag.

5 Interactivity from the Perspective of Communication Studies

Lucien Hanssen, Nicholas W. Jankowski and Reinier Etienne

Interactivity seems like a familiar concept, and that partially explains the common and frequent use of the term in discussions about new communication technologies. The attraction and familiarity of the term are at the same time barriers for fundamental consideration of its meaning. Examination of the literature reveals various classifications and typologies have been proposed. Many of these efforts tend to focus on the media – especially new communication technologies – and what they allegedly bring to communication settings. Interest by scholars is often directed at levels of interaction these media introduce into the process of communication. Less attention is given to the changing role of senders and receivers in the communication process itself. New communication technologies make possible creation of virtual environments in which the traditional roles of senders and receivers no longer apply. These aspects are presented here in a relational model where communication processes in more traditional settings are compared to those in virtual environments.

Various classifications and typologies of the concept of interactivity have been constructed during the past years (Bretz, 1983; Durlak, 1987; Williams et al., 1988; Rafaeli, 1988; Heeter, 1989; Suchman, 1991). In most definitions the communication process is explicitly mentioned, apparently because some aspects of communication are seen as interactive. In this section of the chapter several descriptions of interactivity are presented as well as the place allotted to them within the communication process.

Williams, Rice and Rogers (1988:10) define interactivity as the degree to which participants in a communication process have control over, and can exchange roles in, their mutual discourse. By mutual discourse they mean the degree to which a given

communication act is based on a prior series of communication acts. Using the concepts mutual discourse, exchange, control and participants it is possible to compare the degree of interactivity within systems. They distinguish three levels of interactivity. Face-to-face conversations are generally felt to have the greatest degree of interactivity. To a lesser degree, interactivity is possible between people and a medium, and between people and systems where the content can be retrieved and manipulated (e.g. videotex systems). The least amount of interactivity is experienced with information-retrieval systems such as teletext which allow no degree of influence or change in system content by users.

Williams *et al.* (1988) base their definition of interactivity on earlier work by Bretz (1983) who suggests that three actions are required in order for a system to be characterized as interactive. First, a message must be conveyed from communicator A to another communicator B; second, there must be a response from B intended for A and based on what A already said. Finally, there there must be a response or reaction from A to B, based on B's earlier response. Of these three actions, the second and third are always required for interaction to transpire. The first action is necessary only at the beginning of an exchange or at the start of a new subject of discussion. At other moments, communicators engage in responses to each other's statements (Bretz, 1983:13). During an interactive situation senders and receivers change roles. A learning system that poses a question which a user subsequently answers can best be considered quasi-interactive. The situation is interactive because there is, in any event, limited interaction between the learning machine and the user. Moreover, there is not an equal position between participants. The human user has a relatively passive role in the communication process and lacks control over the form of interaction; without the help of some question formulated from the learning system, the user is unable to proceed further with the programme.

Rafaeli (1988) suggests consideration of social interaction theories for clarifying the relation between interactivity and communication. Social interaction has been an object of research in the social sciences for decades, particularly regarding how individuals perform in group settings and how this performance relates to interaction. Nevertheless, seldom is interactivity treated as an isolated or variable dimension in work on social interaction. In this tradition, interaction subsumes communication; it is not a part or subdimension of it. Communication from this perspective is viewed as one vehicle through which interaction is achieved. People engage in interactions, and exchange is what they were considered to be doing. But, with communication as a primary focus of interest, interaction itself becomes a variable outcome, and exchange is no longer a given. With a focus on media and what is brought by new technologies to communication settings, the interest is directed at communication with varying levels of interaction (Rafaeli, 1988:114–115). This starting point offers the possibility of placing interactivity in a framework based on a model of communication.

Rafaeli (1988:111) defines interactivity as an expression of the extent that, in a given series of communication exchanges, any subsequent transmission (or message) is related to the degree to which previous exchanges refer to earlier exchanges. Interactivity is generally assumed to be a natural attribute of face-to-face conversation, but has been proposed to occur in mediated communication settings as well. Interactivity is seen as an event involving users, media and messages – and particularly how messages refer to earlier messages, i.e. their *responsive character*. Rafaeli distinguishes three levels of communication: (1) two-way (non-interactive) communication, (2) reactive (or quasi-interactieve) communication, and (3) fully interactive communication. The last two levels differ from the first in that role exchange is central to each subsequent message. The difference between quasi and complete interactivity is dependent on the nature of the given response. Interactivity demands both sides react to each other. The content of the response can have two forms: a reaction to a previous message or a response on which some account must be given regarding previous reactions. Quasi-interactivity is present when the second type of response is missing (Rafaeli, 1988:118–119).

The three levels of interactivity that Williams *et al.* and Rafaeli differentiate can be termed *bidirectionality* (lowest level of interactivity), *reactiveness*, and *responsiveness* (highest level). Examples of the first level include electronic data interchange (EDI) and teletext; examples of the second level are videotex and CD-i; and the third level can be achieved with technologies such as electronic mail and expert systems. It is important to realize that with human computer interaction, the interaction is asymmetrical. There is, at best, an illusion of role exchange; taking initiatives, changes in the discourse and the formulation of questions from the computer are only to a limited degree achieved. In the following section aspects of this topic – human computer interaction – are considered further.

Situated action

'We are made aware that interactivity is not a medium characteristic. Media may set upper bounds, remove barriers, or provide necessary conditions for interactivity levels. But potential does not compel actuality,' states Rafaeli (1988:120). In addition to media, users and messages play a role in the nature of interactivity. Further, a component not yet mentioned – but equally important – is the context or the environment in which communicative activitities take place. Suchman (1991) considers the relation of knowledge and action to the particular circumstances in which knowing and acting emerge. An important difference between face-to-face communication and human computer interaction is that conversation partners are much better able to react in unexpected situations and are also able to solve communication problems. Suchman examines interaction between humans and computers in terms of the nature of their respective situations. Evidence of successful interaction

appears not so much when each participant in a concrete situation is able to antici-pate the actions of the other, but when responses are occassioned by and related to unanticipated actions of the other (Suchman, 1991:120).

In spite of the fact that software applications are often developed for specific objec-tives and used in particular contexts, they are also to a certain extent meant to func-tion independent of specific contexts. Programmes are designed according to formal models of knowledge and action. Suchman suggests that people do not operate as systematically with these systems as designers assume. The models of human think-ing and action do not, in other words, correspond to the reality of *situated action*. Situated action contains all the means an actor has at her/his disposal in order to relate the meaning of action to others, and to interpret the actions of others. Situated action is an emergent property of interactions between actors from moment to moment, and between actors and the environments of their action (Suchman, 1991: 178–179).

Interaction between people and machines implies for Suchman (1991:6) mutual intelligibility or shared understanding. But how can a system react appropriately to the actions of (individual) users? As long as designers operate from previously made representations of users and their situations, there is asymmetric communication between partners (Suchman, 1991:181). Interaction between humans and computers remains limited to the intention of the designer, while it is in fact the user's situa-tion, the environment in which actions take place which are crucial for their inter-pretation. Consideration of environment as a component of interactivity provides for a greater degree of interactivity. This level goes fundamentally further than respon-siveness which is limited to a specific topic in a concrete situation. Mutual intelligi-bility is much broader and assumes a shared understanding of each other's knowledge and social *environment*.

The importance of the above argumentation suggests incorporation of environment into the list of central components of interactivity as presented by Rafaeli (1988). These items – user, medium, message, and environment – when brought into con-tact with each other in a particular fashion may result in an aspect of communica-tion that can be identified as interactive.

New communication technologies

An increasingly larger amount of human communication and interaction takes place via electronic or multimedia.[1] The growth of stand-alone devices and on-line ser-vices in professional, educational and entertainment settings is an indication of this development (see further Chapters 2 and 3). The explosive growth in the number of

[1] Chapter 1 of this volume provides a short review of multimedia definitions. Presently, multimedia are associated with virtually all new communication technologies.

Internet users and particularly of the Internet resource World Wide Web suggests the same development. Face-to-interface communication is becoming increasingly important and commonplace. By face-to-interface communication we mean both computer-mediated communication (CMC) as well as human computer interaction (HCI). The component media mentioned in the previous section should therefore be considered broadly: as the carrier of information, as the information product, as well as information services on networks.

New media generally offer only limited possibilities for the development and maintenance of social relations. An exception are computer networks. Networks change not only our manner of communication, but also social structures. Audience members in conceptions of traditonal mass media are uniformly and impersonally approached. Networks, in contrast, allow more individual media use. Users become the editors of their own virtual environments. In this manner the communities in which they participate no longer become geographically determined, but are based on specific information search strategies or shared interests (e.g. newsgroups, MUDs and MOOs).[2] This development brings localness into the domain of globalization, and individualization into the sphere of socialization.

These new forms of community are called virtual, but such communities are in every sense real; there is, to name a few of the characteristics, involvement, gossip and conflict. New meanings, values, rites and identities are being developed. As Van Dijk (1996) expresses this development, 'There appears to be an entirely new type of community emerging from network communication. New forms of language, interaction and identity are created. Virtual communities seem to be a perfect compromise between individuality and sociability in modern (network) society.' Jones (1995:19) makes a similar observation: 'The important element in cyberspatial social relations is the sharing of information. It is not sharing in the sense of the transmission of information that binds communities in cyberspace. It is the *ritual sharing* of information that pulls it together.'

Even while taking the above into account, networks can contribute to further fragmentation through creation of disparate subcultures. Network media offer individuals the possibility to determine for themselves in which virtual environments they wish to remain. Individuals can, in this manner, easily isolate themselves from the opinions of others. Differences between these virtual communities can only be resolved, just as in real-life communities, through a form of mutual intelligibility. But, it is not only in, but also between subcultures where shared understanding is necessary in order to work towards resolution of differences.

2 MOO: MUD Object Oriented (MUD: Multi User Dungeon, Multi User Dimensions or Multi User Domain). MOOs are text-based, although experiments are taking place with MOO Web sites. In such situations fantasy worlds are created in colour with hyperlinks and – it is anticipated – with simulation of three dimensional spaces.

Face-to-face and face-to-interface communication

A *conditio sine qua non* required to achieve any degree of interactivity is that both sides undertake and maintain communicative activities. Each side may be human or machine. Stappers (1983:44–50) emphasizes in his model of communication[3] the dual roles participants can have in a communication event. One role is that of the sender of a message, and the other is the receiver of the message content offered. The two roles are quite distinct, and they need not necessarily be connected to each other. In computer-mediated communication situations, users can take on both roles. With human computer interaction, the sender role is limited to the possibilities designer have already built into the systems.

With an increase in technological possibilities (e.g. wider bandwidth to carry more complex signals simultaneously, user-friendly and graphical interfaces), 'face-to-interface communication' (FIC) has also developed further. FIC developments, interestingly, are coming more and more to resemble 'face-to-face communication' (FFC) forms. Designers seem to be trying to emulate the information richness of unmediated interpersonal communication. This is apparent, for example, through use of simple but necessary symbols such as 'smileys' in computer-mediated communication, and in references to sensory cues in multimedia applications.

Van Dijk (1994:218) suggests that communication and interaction with and in data-banks, videotex and computer networks is to a large degree technically formed – if not deformed. This applies to all of the components of communication, including the sender and receiver. In the case of videotex, the sender is a computer system, and in the case of electronic data interchange the computer is both sender and receiver. 'Although the human actions and reactions of the machine may appear like a dia-logue, the change between user and computer is fictive. Initiatives, changes in top-ics and considered questioning from the side of the machine does not exist. Communication with the machine is, in fact, asymmetrical' (Zoeppritz, cited in Van Dijk, 1994:219). This is the same asymmetry to which Suchman is referring, as dis-cussed in an earlier section.

Jones (1995) is of the opinion that creating software and hardware for computer-medi-ated communication – or, for that matter, for human computer interaction – has become a race to provide the most 'lifelike' interaction possible, a race characterized by extreme attentiveness to information richness and simulation. This is done in order to come as close as possible to the 'conversational ideal'. But, postulates Jones, much of what is most valuable in face-to-face interaction is actually the absence of infor-mation, the silence and pauses between words and phrases. Thereby, one must realize that face-to-face interaction does not necessarily break down boundaries between peo-ple, and to adopt it as an ideal will likewise not necessarily facilitate communication, community building or (shared) understanding among people (Jones, 1995:28–29).

3 Stappers model is inspired by Newcomb's (1953) co-orientation model of communication.

Interactivity and new communication technologies

Potential interactivity in communication settings is best understood in terms of the components which contribute to its presence: users, media, messages and environments. Figure 1 represents a model which suggests how these components interrelate in both unmediated (face-to-face communication, FFC) and mediated (face-to-interface communication, FIC) communication settings, and – especially – how the relationships differ between these two forms of communication. To simplify the presentation, only these four structural features of interactivity – user, message, medium and environment – are presented in both representations of the communication process.

The top half of the figure, Part I, is based upon traditional models of communication from sender to receiver, and presents a *relational model* of face-to-face communication. Relation A has to do with the link between sender and message. Relation B involves the link between message content and receiver. In principle, it is possible – but not necessary – that senders and receivers change roles after each expression (see the arrows with broken lines in the figure). Reciprocity is not a naturally occuring element in communication settings. Stappers suggests that when both senders and receivers are active, it is the sender who sends and the receiver who receives. Receivers do not, by definition, engage in sending messages. Of course, it is possible for these roles to be changed, but that is not necessary. All too often, however, this assumption is made which Stappers calls the myth of communicative exchange (Stappers, 1993:67). Although reciprocity or role exchange may not be self-evident in communication settings, it is a condition for achieving interactivity.

Part I of the figure incorporates the feedback view on interactivity in terms similar to those formulated by Rafaeli (1988:120): 'Interactivity is feedback that relates both to previous messages and to the way previous messages related to those preceding them.' In addition, the message and environment are related in the sense that the content of a message takes on meaning in a specific social and cognitive context. In this model the environment (real world) is shown as a closed box. Within that area, within that particular setting, the relation between sender and receiver transpires. This relation determines the degree of equality between participants in terms of knowledge, behaviour, and social status, and determines the nature of a particular form of feedback. The possibility of providing a response (reciprocity) and the nature of the given responses determines the degree of interactivity, bidirectionality, reactiveness, responsiveness and shared understanding. The medium component is in this part of the model not included, but messages can naturally be transported via a medium from a sender to a receiver.

Steuer (1992; 1995) focuses attention on the relationship between an individual who is both a sender and a receiver, and on the mediated environment with which he or she interacts in face-to-interface communication. Here, he draws attention to a fun-

damental difference with conventional media. Traditionally, the process of communication is described in terms of transmission of information, as a process linking sender and receiver (see Part I of the figure). Media are therefore important only as a channel, as a means of connecting sender and receiver, and are only interesting to the extent that they contribute to or otherwise interfere with transmission of the message from sender to receiver. Steuer suggests an alternative view of mediated communication: information is not transmitted from sender to receiver; rather, mediated environments are created and then experienced (Steuer, 1995:37–38).

In Part II of the figure of the relational model we have tried to indicate the fundamental difference with the transmission notion of communication. Relations C en D in Part II of the figure both are associated with the link between an individual and mediated environment. Relation C suggests that a user can contribute information to a system. Relation D suggests that a user can request or retrieve information. Individuals can fulfill both roles (see the dashed arrows). Dependent on which communication technologies are used, communicative activities can lead to a degree of interactivity between, on the one hand, users and a multimedia system (e.g. CD-i) and, on the other hand, between users among themselves (e.g. e-mail). The essential difference between Parts I and II of the figure is that in second part information is no longer transmitted from sender to receiver. In this alternative view *mediated environments* are created and then experienced through the sharing of information.

Part 1: face-to-face communication process

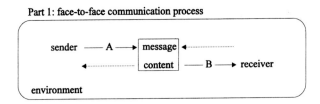

Part 2: face-to-interface communication process

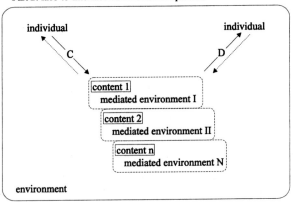

Figure 1: Relational model for face-to-face and face-to-interface communication

Here, the characteristics of the mediated environment and the relationship of individuals to that environment are central.

In Part II of the figure a series of mediated environments are noted with boxes drawn with broken lines. An individual can add information to the system in different contexts. At the same time, the person can extract information from other contexts, and do so outside the physical reality within which the user is situated (the solid line box). In the case of FIC, the content situated in another environment can take on another meaning.

Changes and consequences

For each of the four distinguished relations – A through D – it is possible that technical or psychological constraints inhibit the degree of interactivity which can be achieved. If equality between the participants in a face-to-face form of communication is absent, it then becomes difficult to achieve any substantial degree of responsiveness. In the case of face-to-interface communication, interactivity is often absent due to the limitations of the hardware or software. This is the case with one-way cable networks and with systems that operate with programmes which are relatively unsuited for particular users or exceptional environments. New communication technologies have been, up until recently, relatively insensitive to contextual situations. These systems are not so flexible, creative and associative as their human users. Moreover, these systems are not always meant for the creation and maintenance of social relations. Here, direct human contact, in the form of face-to-face communication, remains necessary.

In CMC and HCI the interface relates to hard and software used to faciltate and optimise the coupling of man and machine. The interface can be a limiting factor. Working with computers is, for some persons, psychologically and physically difficult given the keyboards and pointing devices often used to transmit information to computers.

Developments involving touch screens, speech recognition and 'goggles and gloves' environments – as in virtual reality – are intended to increase the user-friendliness of computer systems. Computer graphics and animations are increasingly being incorporated into software for the same reason. Further, use of metaphors and icons are valuable in helping users identify structures in and navigate through programmes, but it is clarity which ultimately counts. Books, in this regard, have the advantage that they are now considered products of *low technology*, and that most people understand the ordering systems employed. With many new media this is not the case, which results in users feeling uncertain and 'lost'. Increasingly, some degree of competence in a visually-based language is required.

From the perspective of functionality, it is certainly not necessary to always strive for a high degree of interactivity. Transaction and consultation systems, such as pay-per-view or videotex, can function with what was earlier termed reactiveness. The functionality of systems can be described in terms of the accessability for users (interface) and the degree to which a problem is solved within everyday practice of users; see also Chapters 6 and 7.

The content of a message gains meaning within a specific context. In face-to-face communication that context can be relatively straight-forward; see Part I of Figure 1. In face-to-interface communication the number of possible virtual contexts increases, and meaning or interpretation of messages also increases; see Part II of the figure. The coding process is, in other words, conditional on time and place.

The question which arises here is whether in such virtual environments a 'story' can be told in the conventional sense of the word. It seems as if the story, the message, is influenced – if not replaced – by the environment. The story-teller establishes conditions, it is true, but the user has a large degree of freedom for interpretation at his/her disposal. The difference with reading a book is that the writer generalizes his/her personal experiences for a wider audience. The reader must then translate and relate these experiences to his/her own situation. In a virtual environment, in contrast, this transposition from general to personal does not take place. The elements of multimedia – the texts, videos, sounds and data – can be modified and – with some systems – updated. So, rather than a story, multimedia experiences appear rather as fragmented, very personalized experiences.

One development in this direction is what is known as MOOs. Van den Boomen (1995:142–144) describes these contexts as virtual theater and *avant garde* in the classical sense of the word: no distinction between public and actor; between actor, director and author; between script writer and stage designer. In the fantasy world of MOOs little is certain, and previously fixed identities and positions are uprooted. MOOs are not only employed in game-like settings, but also have numerous educational possibilities; see Chapter 10 for an example.

Van den Hoven (1995) refers to the problem of *narrow embeddedness* which may emerge. He suggests people may become more and more dependent for knowledge on net sites, information providers, information systems and databases. But what does this mean for the ability to assess the accuracy, adequacy and relevancy of the expertise, knowledge and information offered? This problem can become serious when users of a system are curtailed in their intellectual freedom of movement. At the moment a system is being used it is not possible to gain insight into the manner in which it was designed (see also Chapter 7). It is a black box, and when users have limited possibilities to avoid a system or examine it from outside its context, then their situation can be described as a form of cognitive submission. For this reason, Van den Hoven (1995:3–7) feels designers should

ensure users are able to maintain a measure of distinction between virtual and real environments.

Preliminary investigation of CD-i use

In the previous section changes and consequences were considered regarding face-to-interface communication. It is important, of course, to empirically test these theoretical considerations, particularly whether specific levels of interactivity are achieved and experienced as such by users of new communication technologies.

We conducted an exploratory investigation in 1994 with CD-i technology as a form of human computer interaction. Participants examined a number of CD-i titles and completed an extensive questionnaire afterwards. They also formulated open-ended essays in which they were asked to reflect on their experiences. For development of the questionnaire, an overview was constructed from classifications and typologies of the concept interactivity culled from relevant literature (Bretz, 1983; Durlak, 1987; Williams *et al*. 1988; Rafaeli, 1988; Heeter, 1989; Suchman, 1991). With the help of this overview, aspects of interactivity were clustered around three terms: *equality* (containing aspects such as participants, mutual activity, role exchange, controle), *responsiveness* (e.g. mutual discourse, nature of feedback, response time) and *functional communicative environment* (e.g. bandwidth, transparancy, social presence, artificial intelligence). Although this clustering was provisionary and somewhat arbitrary in nature, it nevertheless provided opportunity to explore the meaning of interactivity for users.

One of the commonly made observations by participants was is that they considered a title interactive when they seemed to have control over the further sequence of scenes or steps in the programme. The greater the number of choices, the greater the amount of interactivity experienced. However, too much control on the side of one of the communication partners (for CD-i, the user as well as the programme were seen as communication partners) is experienced negatively. Equal positions of control seemed to be valued. In addition, participants indicated that many decision-making moments functioned as obstacles for development of a dialogue or mutual discourse to be generated. When the roles of 'sender' and 'receiver' changed without a substantial degree of relation between messages, there was no evidence of responsiveness, but only reactiveness. Such situations were experienced negatively by participants. Further, they appreciated a seemingly personal approach during use of the titles and a degree of transparency. Both of these elements, personalness and transparency, seemed to contribute to a sense of interactivity.

One of the more interesting findings was that users indicated need for a certain degree of linearity within a programme in order to be able to orient themselves. Without editorial structure it appeared as if unexperienced users easily lost their way

within a programme. This appeared to be the case for each of the three categories of CD-i titles examined – educational, informational and recreational.

Two questions emerged from the essays composed by participants. The first concerns the degree to which improved navigational information at various decision moments within a programme can improve the level of interaction. This concern relates to the cognitive asymmetry between programme (designer) and user. Both can, in principle, change roles, but the programme has, as yet, few possibilities to interpret the actions of the user. Higher levels of interactivity – responsiveness or shared understanding – are consequently still beyond the range of possibilities of such multimedia.

A second concern relates to the degree and manner moments of decision are incorporated within a programme. Such decisions contribute to the interactivity experienced, but at the same time they can impede development of mutual discourse, and can contribute to irritation and frustration among users. This may be related to notions of narrativity as formulated in film theory (see, e.g., Chapter 4, Hodges & Sasnett, 1993) and it may be that interactivity as experienced with multimedia inhibits such conventional, narrative approaches to story-telling.

Communication research and interactivity

An increasing degree of human experience is achieved through mediated rather than direct sources. Regardless of the particular medium used (CD-i, video conferencing, on-line chat systems) mediated interactions fall within the concerns of communication research. Communication studies, in other words, may be well suited to address the cognitive, social and perceptual issues surrounding new communication technologies by building on lessons learned through the study of traditional media. Further investigations conducted from an interpretative, qualitative approach may help us better understand the communicative experiences of multimedia users, and the nature of interactivity therein.

The relational model presented in this chapter is an initial effort to take into account the fundamentally changed role of individuals who make use of multimedia. The model is provisionary and, as such, subject to revision. Whatever changes may be made, however, it seems to offer space for an alternative view of mediated communication. Information is not, we believe, simply transmitted from sender to receiver, but mediated environments are created and then experienced through the sharing of information. Carey (1989:15–23) also distinguishes these two visions of communication – communication as transmission versus communication as ritual behaviour. In the latter, communication is seen as a symbolic process whereby reality is produced, maintained, repaired and transformed. The ritual vision of communication offers a possible frame of reference for further investigation. The challenge for com-

munication studies, then, is to define problems within this framework as clearly as possible in order to increase understanding of the workings of multimedia. The relational model is, we suggest, a step in this direction.

References

Bretz, R. (1983) *Media for interactive communication*, Beverly Hills (CA): Sage.

Boomen, M. van den (1995) *Internet ABC voor vrouwen; Een inleiding voor datadames en modemmeiden*, Amsterdam: Instituut voor Publiek en Politiek.

Carey, J. W. (1989) *Communication as culture; Essays on media and society*, Boston, MA: Unwin-Hyman.

Dijk, J.A.G.M. van (1994) *De netwerkmaatschappij; Sociale aspecten van nieuwe media*, Houten, NL: Bohn Stafleu Van Loghum.

Dijk, J.A.G.M. van (1996) The reality of virtual community, *Trends in Communication*, 1,1.

Durlak, J.T. (1987) A typology for interactive media, in: M.L. McLaughlin (ed.) *Communication Yearbook* 10, Newbury Park, CA: Sage.

Heeter, C. (1989) Implications of new interactive technologies for conceptualizing communication, in: J.L. Salvaggio and J. Bryant (eds.) *Media in the information age; Emerging patterns of adaptation and consumer use*, Hillsdale, NJ: Lawrence Erlbaum.

Hodges, M.E and Sasnett, R.M. (1993) *Multimedia computing: Case studies from MIT Project Athena*, Reading, MA: Addison-Wesley.

Hoven, van den (1995) De moraal van het virtuele verhaal; Over schijn en werkelijkheid in het digitale tijdperk, lecture, Studium Generale, Erasmus University Rotterdam.

Jones, S.G. (1995) Understanding community in the information age, in: S.G. Jones (ed.) *Cybersociety; Computer-mediated communication and community*, Thousand Oaks, CA: Sage.

Newcomb,T.M. (1953) An approach to the study of communicative acts, *Psychological Review*, 60: 393–404.

Rafaeli, S. (1988) Interactivity. From new media to communication, in: R.P. Hawkins, J. Wiemann and S. Pingree (eds.) *Advancing communication science; Merging mass and interpersonal processes*, Newbury Park, Ca: Sage.

Stappers, J.G. (1993) De mythen van communicatie, in: J. Willems and E. Woudstra (eds.) *Handboek wetenschaps- & technologievoorlichting*, Groningen: Martinus Nijhoff Uitgevers.

Stappers, J.G (1983) *Massacommunicatie; Een inleiding*, Amsterdam: De Arbeiderspers.

Steuer, J. (1992) Defining virtual realitiy; Dimensions determining telepresence, in: *Journal of communication*, 42,4: 73–93.

Steuer, (1995) Defining virtual realitiy; Dimensions determining telepresence, in: F. Biocca and M.R. Levy (eds.) *Communication in the age of virtual reality*, Hillsdale NJ: Lawrence Erlbaum.

Suchman, L.A. (1991) *Plans and situated action; The problem of human-machine communication*, Cambridge: Cambridge University Press.

Williams, F., Rice, R.E., and Rogers, E. (1988) *Research methods and the new media*, New York: Free Press.

6 Public Communication Campaigns and Multimedia

Paul Nelissen

Designers of multimedia are seldom modest in expressing the expecta-tions they anticipate through use of the technology. Ambron and Hooper (1988:3), for example, compare multimedia with Galileo's invention of the telescope. The new image of reality provided by this technological development, they claim, will cause major transforma-tions in different social and cultural arenas – in politics, architecture, literature, music, science and the arts. The question, however, is whether and in what manner objectives of communication campaigns can be realized with the assistance of multimedia. Public communica-tion campaigns, although initiated and conducted in virtually all devel-oped countries, are seldom successful. To determine whether this situation may change through use of multimedia, a theoretical per-spective is required which takes into account the possibilities and con-ditions for effective and efficient communication campaigns. On the basis of such a perspective it should be possible to explain the general lack of success of campaigns and then predict whether employment of multimedia in such campaigns increases the degree of effectiveness. This chapter outlines a theory in which public communications cam-paigns are considered instruments with which problems or discrepan-cies can be exposed and solutions offered. The possibilities of multimedia within public communication campaigns are considered from the user's perspective.

In virtually every country in the world governments and public organisations have been trying to improve people's well being by persuading them to, for example, adopt healthier lifestyles, pollute the environment less or practice safe sex. But many of these campaigns, especially those aimed at changing people's behaviour, have not been very successful in achieving their stated goals.

Communication researchers have been dealing with this problem for decades. One of the first scientific studies in this area was conducted by Hyman and Sheatsley (1947), entitled 'Some reasons why information campaigns fail.' It was followed by Mendelsohn's (1973) study 'Some reasons why information campaigns can succeed,' which contributed additional theoretical and empirical support for effective public communication campaigns (see also Rice & Paisley, 1981; Rice & Atkin, 1989).

Communication science has not been the only field which has investigated the conditions for successful campaigns. Psychology, for example, has a long research tradition regarding changes in attitudes and behaviour; for an overview, see McGuire (1989). The accumulated scientific knowledge has led to different explanations for the lack of success of large-scale public communication campaigns, particularly those involving the media. These explanations often make reference to problems in the planning of the campaigns, inadequate preliminary research and – especially – lack of insight into the fundamental processes involved in influencing people through the media. Public communication campaigns often are concerned with very complex themes, and there is frequently a conflict between individual and social interests. The campaigns, in any event, have to do with interventions in the everyday life of people and are directed at changing awareness, attitude and behaviour – or a combination of these aspects – in directions desired by communicators.

This chapter deals with campaigns which are planned and conducted by governmental bodies or commissions. These campaigns have to do especially with the legitimation and implementation of policy objectives of government. This means that public communication campaigns are employed as policy instruments, for example, to make citizens aware of regulations and laws. Policy objectives may have to do with improving individual awareness and concern for education, housing, health care, employment and education. But the objectives may also be directed at improving the functioning of society as a whole (e.g. emancipation of deprived groups, equal treatment, environmental protection, cultural development). Generally, these objectives result in campaigns which employ techniques such as public service announcements on television, newspaper advertisements and publication of brochures and leaflets.

One of the misconceptions in campaign practice is the misplaced belief that these traditional media are capable of bringing about change on a large scale. Campaign planners generally employ a rather mechanical model regarding the effects of media use. There is an expectation that exposure to media messages automatically leads to change in knowledge, attitude and behaviour. Such a sender-oriented model and the related notion of the audience as passive and dependent has long been discarded in mass communication studies (see, for example, Katz, 1959;

Bauer, 1964). The alternatives to this mechanical model of influence in which analysis of audiences is involved, although generally not convincing for campaign practioners, do provide opportunity to consider possibilities of effective and efficient production of changes. On the basis of these insights, for example, it is evident that mass media play only a marginal role in behavioral change; the influence of people in the direction intended by communicators is anything but self-evident. Given this situation, it is interesting to examine the degree to which the limited possibilities of mass media are possibly compensated by utilization of multimedia.

First of all, the conditions inherent in effective and efficient campaigns are elaborated. These conditions are especially related to creation of insight and understanding of campaign target groups. Desired changes must be considered from the background and situations of the persons with whom changes are desired. Generally, the difficulties and bottlenecks related to these situations are such that public communication campaigns have little chance of success (Nelissen, 1991a; 1991b). Further, it is necessary on the basis of this knowledge of the situation to develop means for generating change. It is in this domain that the possibilities of multimedia will be explored. The following characteristics of multimedia use are particularly considered important:
- multiple and diverse information sources
- flexibility in information production
- interactivity
- routine use.

Audience-centred interpretative approach

As noted above, the history of mass communication research – including studies regarding public communication campaigns – is marked by an increase in the influence attributed to audiences on the outcome of communication processes. This influence, generally conceptualized as audience activity, causes campaigns to fail or at least not to provoke the desired behavioral changes. In order to explain the effects or consequences of campaigns and of other communication processes it is necessary to integrate this key concept into a broader theoretical perspective whereby using media – including the interpretation of campaign messages – is but one of many acts people perform in everyday life. When the intent is to change people's cognitions, attitudes and/or behaviour it is necessary to study the situations in which people develop and perform actions, and to then consider the importance of the desired changes from their, the actors', point of view. Once the process is seen from this perspective, it becomes obvious that a mechanistic, causal relation between communicator's intentions, messages and effects on people exposed to messages cannot realistically be expected. This is the value, in fact, of an interpretative rather than a mechanistic paradigm for the study of human action.[1]

1 Human action as used here also includes media use.

An interpretive paradigm for human action considers people's action as a manifestation of internal motives based on subjective meanings. It is not the environment which dominates and provokes people's behaviour; rather, it is the individual situated in the centre of a social world who acts in conformity with a subjective definition of the (social) situation. This *concept of man*, only briefly elaborated here, leans heavily on the ideas and views developed within the symbolic interactionist approach to social action. The influence of symbolic interactionism within mass communication research has been increasing gradually during the past decades (see Altheide, 1985; Evans, 1990; Hulett, 1966).

An important starting point for conceptualizing audience activity from an actor-perspective is Mead's (1938) theory of the 'social act'. This is a general model of human action in which three capacities of human beings regarding determination of a course of action are emphasized. One of these capacities is the ability to use symbols. The second is the capacity for reflexive action enabling persons to place themselves in an external environment along with other environmental objects. This capacity also allows persons to respond to themselves in somewhat the same fashion as they respond to other elements in the environment. Finally, humans possess an empathic capacity 'to take the role of the other' and thus to estimate more or less accurately the attitudes and characteristics of others and to see things from their point of view.

These three capacities are internalized in humans and enable them to cope with their situation. As Hulett (1966:12) expresses it, 'A socialized human individual uses these three capacities to perform a complex internalized analysis of any action intended with respect to any stimulus object (including other humans) before he acts, by creating in himself an aroused future act, thus making a prediction of the likely outcome.' The 'stimulus object' noted here may refer not only to other humans but also to the media and media messages. The significance of these notions is that people learn to act within their social world and that the objects within that social world are meaningful to them. Once objects – including other people, events and experiences – are interpreted, external acts can be planned, projected and performed. When (external) actions are evaluated as generally accurate and adequate, they are then gradually internalized and become routines. These routines enable people to act non-reflexively because they then *know* their social world.

Media and media content also belong to that social world and, as such, compete with other objects for attention. People do not react to the media as non-interpreting objects would react to external stimuli; people do not, in other words, simply reproduce a communicator's intentions. Rather, viewers, listeners and readers interpret messages taking their own motives, goals and beliefs into account: Media content, Evans (1990:147) reminds us 'is seen as open to individual interpretation by people creating meaning in the process of consumption.'

The consequences for mass communication research and communication theory based on this perspective of social action should be clear. Differences between people's uses of media and media messages can only be explained when people's motives and goals are taken into account. Using media may be only one of the many alternatives people have to solve a problem. A problem occurs when individual knowledge of the situation is insufficient to cope with a certain experience or event. This problem can be solved by seeking and using information in order to adjust the knowledge of the situation. When the problem is solved, future action will be non-problematic regarding this type of situation.

Consequences for public communication campaigns

It is in these types of situations in which campaigns are meant to intervene on topics felt important by governmental or other bodies. The first objective is thereby stated: *to convince people that the themes of a campaign are relevant for them*. In other words, people must be convinced, for example, that traffic safety is an important issue within their own situation. This task demands a degree of congruence between governmental and personal agendas, but an increasing individualization in society and the decline in social cohesion have resulted in greater diversity in individual concerns which increasingly differ from governmental concerns. Individual interests and needs are becoming more prominent than those of the collective for which government generally feels responsible. From the perspective of campaign planning, it is clear that uniform messages distributed via mass media are unable to accommodate such diversity.

Campaigns are concerned with more than attention for relevant themes. Another aspect is attention for the problematic character of themes. An important condition for changing knowledge, attitude and behaviour regarding a particular issue involves problematizing the issue for individuals. In other words, that which a communicator considers problematic – smoking, unsafe sex, environmental pollution – must also be seen in such a light by the relevant target groups. This, in fact, means that campaigns must offer observations which promote discussion regarding current positions on those issues. In this manner, a discrepancy can be created between that which is known and that which is experienced. In order to know which observations are necessary to create such discrepancies or problems it is necessary to gain insight into the situations in which people behave and in their own subjective definitions of the issues.

In addition to increasing the relevance of issues and creation of problems, there is a third important objective important to consider during the planning and execution of campaigns: proposal of viable solutions to the experienced problems. People need guidelines in order to change their behaviour. The knowledge people have used in the

past to act in a problem-free manner is no longer applicable. Campaigns should play an important role in providing new knowledge useful for acting in the desired direction. This requires an integrated approach: on the one hand, the creation of problems by questioning existing knowledge, and on the other hand the offering of useful and attainable solutions. Also here the situation determines whether and to what degree people are willing and able to achieve the desired change. And again, the diversity of situations and limited cohesion within the target group are factors causing problems for public communication campaigners. It is not possible to anticipate the relevance of campaign themes presented within a mass media campaign when the situations of target group members is so individually different and determined. This aspect is the primary reason, in fact, for the limited effectiveness of campaigns.

The question which now must be attended to is to what degree multimedia applications are in a position to compensate for these disadvantages of mass media oriented campaigns. In other words, are multimedia better able to:
- bring issues to the attention of target group members, particularly given the diversity in relevance;
- present messages in such a manner that existing knowledge, experience and evaluations come to be questioned, come to be seen as problematic;
- present usable and attainable solutions to experienced problems in order that undesired behaviour is modified and the campaign objectives are achieved.

Multimedia in campaigns

It is important to remember that informational campaigns designed to influence the actions of people must contend with the subjectively defined situations of those same people. With present knowledge people are able to interpret their environment and act accordingly. External actions come about, in other words, through an internal process of reflection whereby, on the basis of existing knowledge, possible external actions are designed, projected to the actual situation and ultimately chosen and enacted. This does not mean, however, that every action is prepared in the same fashion. Actions which are once developed and performed with satisfaction remain functional and are transformed into routines: the storage of knowledge is then in a position to allow external actions to be performed in a nonreflexive manner.

Many actions in everyday life which are the focus of campaigns have the character of routines — actions such as smoking, driving, sexual behaviour. Also, media use when seen as a form of social action can have a routine character. Media, but also informal information sources, play an important role in the determination of the importance of objects and the solving of problems. Also here is it the case that particular sources of information are routinely consulted because of proven value in the past.

This entire assortment of sources of information which are used in everyday life is referred to as the *media budget* of individuals (Nelissen, 1991a:129). In this manner

it is possible to differentiate between an objective media budget, consisting of media more or less regularly consulted, and a subjective media budget consisting of media content used to solve problems.

In general, it is not to be expected that new information and communication technologies are consulted to any great degree. Their functionality must first be demonstrated; only then will these media have serious opportunity to be included in the objective media budget. For multimedia to be able to play a role in the realization of campaign objectives they must constitute part of the media budgets of the target groups. A routine use of multimedia is a basic condition, then, before the desired changes can be realized among members of the target group.

The limited penetration of some new communication technologies among intended users is a serious obstacle, certainly in cases where societal groups are made attentive to the possibility of improving their social position. A characteristic of such positions is namely the limited access to usable sources of information, be they multimedia or traditional media sources.

Having stated these reservations regarding the possibilities of multimedia at this point in time, it may also be valuable to speculate on the possible value of multimedia in future campaigns. A number of characteristics of multimedia do make them attractive for initiating and conducting change processes. These characteristics have, in particular, consequences for the relation between the senders and users of information services.

McQuail (1994) sketches a number of characteristics of new electronic information services which also apply to multimedia. Two of these characteristics he mentions are abundance and diversity of information. In addition, it is possible to chose from these media offerings at a time and place of user's preference. Use of multimedia, then, becomes very much an individually-oriented activity with interactive possibilities. This is in contrast to traditional media such as television and radio where there is more of a collective attention to a relatively limited diversity of content.

Through computer technology it is possible for users of new information services to combine and integrate data bases. The influence of the communicator in these processes becomes increasingly less. The globalization of information brings with it that people are becoming less and less limited by their national languages and cultures (see McQuail, 1994:292).

The question now is whether these characteristics of multimedia are relevant during the realization of the main objectives of communication campaigns: thematizing, problematizing and solving of experienced problems. For example, the problem of environmental pollution must first take on a prominent place in the relevance structure of people before they will discuss it and seek possible solutions to it.

Regarding the task of bringing a topic to the attention of people, there is little reason to believe multimedia are necessarily better suited for this task than traditional media. This is all the more problematic inasmuch as use of multimedia cannot be considered a matter of routine for many persons. The condition for thematizing is not so much the presence of available information, but rather the interest and relevance for members of the campaign target group.

Where much more possibility exists for multimedia is in the strong individualization of interests and needs. Social changes have resulted in the situation that people are much less involved with social or ideologically based matters with strong collective values and norms. Because of this society-wide development, individual issues of persons are not often shared. The pluriformity of information made available on multimedia and the interactive use of this information provide opportunities to compensate for these societal tendencies.

Regarding the ability to problematize topics, multimedia offer, thanks to a pluriformity of content and flexibility in production processes, better possibilities to react to different situations in which a particular theme is relevant. Given individual agendas of problems and definitions of problems are no longer shared by large segments of the population, undifferentiated media content is no longer adequate for campaign objectives. This is even more the case when solutions are suggested for experienced problems. Providing adequate procedures are developed whereby the diversity of information can be channelled to individual needs, multimedia offer a serious alternative for traditional campaign communications like leaflets and brochures.

This requires that the information can be tailored to the specific situations in which a problem arises as well as presentation of alternatives for its solution. If energy conservation is considered, for example, it is conceivable that alternatives are presented which differ for families with and without children, and for persons who rent and own their homes. Through the interactive capability of multimedia use, it is possible to provide rapid solutions tailored to the individual user situation.

An immediate problem is the limited penetration of multimedia hardware among large segments of the population. Because of this it is necessary to temporarily consider 'upgrading' traditional analogue media. This necessitates transplanting the core characteristics of multimedia – interactivity, flexibility, pluriformity, and abundance of choice – to media already routinely used by target groups. Examples of these media include two-way teletext incorporating both television and telephone systems. Taking into account the substantial costs associated with developing a digitalized information highway, it seems appropriate to search for possibilities with existing networks. Here, too, it is important to stress that the creation of changes in human attitudes and behaviours through communication campaigns remains extremely difficult to achieve. The changes which may be attained are less the result of a particular campaign message or its mode of distribution, but based much more

on the complex character of the process involved in changing knowledge, attitudes and behaviours.

The functionality of multimedia – a case study

An application of multimedia outside the professional sphere is the telephone information service of the Centre for the Spoken Word (Centrum voor Gesproken Lectuur, CGL). This organization is financed by the Dutch Ministry of Health and Welfare. It provides a large variety of spoken materials intended for persons with impaired eyesight. In addition to magazines, newspapers and books, brochures and folders are available on audio tapes. The CGL is interested in providing its services on a larger scale than just to persons with sight impairments. Examples in this direction include the project 'Electronic Reading of the Newspaper' which makes use of personal computers and modems, and a telephone information service, the 'CGL-infoline'. For this last service, empirical research has been conducted; see Boekelder & Nelissen (1992).

The objective in the CGL-infoline was to rapidly provide concrete and practical information usually already available in print, but often incomplete. Through use of the buttons on modern telephones, users were able to select information. Four general topic areas were available: services of CGL itself, services for the visually handicapped, employment information, and general service-oriented information.

As is evident from the above four topic areas, the information provided had a strong instrumental character: practical information with an accent on referral to relevant organizations and institutions. After a number of initial start-up problems, the technique functioned very well. For this part of the experiment, most persons involved were satisfied. Soon after introduction of the service, though, use declined and eventually stopped altogether.

We conducted an inventory of the questions visually handicapped have in their everyday lives, and the information sources they consult to attend to these questions. Questions, in this manner, are seen as problems which must be solved in order to allow everyday actions to proceed as desired. Sources of information, then, become the functional 'problem solvers'.

The question was to what degree the CGL-infoline service could provide an adequate alternative to the manner in which information was collected. Interviews with visually handicapped provided awareness of how this group experiences information sources. In the first place, it became evident that the questions and problems experienced have a strongly individual character, both now and in the past. Nevertheless, a degree of similarity in questions and solutions was evident. This cor-

relation was explained by the context within which persons experienced information themes. Two groups of visually handicapped were identified: those who were blind from a relatively young age and those who became visually impaired later in life. Within these two broad categories differences were evident, but for assessment of the information service the division is illustrative.

Situation in which questions about everyday life arise have either an instrumental or a fundamental character. Questions with an instrumental character are those about practical matters – such matters as train schedules, availability of aids for the visually handicapped and sales at the supermarket. Fundamental questions for this group are those having to do with acceptance of being blind, the limitations they experience in society and living with the handicap.

Members of the group which became blind at a young age seem generally able to lead active lives. They have learned all kinds of solutions early in life for everyday problems related to being blind. The acceptation process of their physical condition is more or less complete, whereby the questions posed are mainly of an instrumental nature as opposed to the fundamental variety. The information service, composed mainly of instrumental-oriented information, failed to provide anything new to the already existing sources of information this group consulted.

Members of the group which became blind later in life, particularly those persons who were already quite old when blindness struck, were substantially more problematic. They experienced a form of social isolation which increasingly limited their ability to function in everyday life. Acceptation of the handicap and ability to function with it was far from achieved. Before questions regarding practical, instrumental matters, it was necessary for members of this group to raise other, fundamental problems. This group, too, had limited value for the CGL-infoline service; in some cases, though, it served as a surrogate for attention to the fundamental questions members of the group posed.

This case demonstrates that even a perfectly functioning information technology, directed at answering instrumental questions, requires support or incorporation into an already existing information system.

Conclusion

In this chapter the possibilities of multimedia in bringing about the objectives of public communication campaigns have been explored. The increasing belief among theorists and campaign designers, regarding the ineffectiveness of mass media in changing awareness, attitudes and behaviour (on a large scale), is simultaneously a demand for new concepts on persuasive communication. As mass media play a marginal role in behavioral change, it is valuable to examine possible utilization of

multimedia. This can only be done, however, after insight is gained into the fundamental processes involved in influencing people in everyday life – and the role of multimedia herein due to the special characteristics of multimedia – their flexibility, diversity and interactivity.

To understand the lack of success of mass media in influencing people the proposal has been made to examine campaign topics from the perspective of audience members. In order to achieve success, a topic requires relevancy for the target audience. This means, given the diversity in relevance, issues have to be brought to the attention of target group members.

Mostly, campaign issues refer to undesirable actions like smoking, ignoring speed limits and polluting the environment. But these actions are mainly undesirable from the government's point of view. People are generally unwilling to reflect on their actions once these have become routinized. Campaign messages should be presented in such a manner that existing knowledge, experience and evaluations come to be questioned or, in other words, come to be seen as problematic. Finally, usable and attainable solutions to experienced problems should be given, in order that undesired behaviour is modified and campaign objectives achieved.

For some time multimedia will not be very successful in bringing about the objectives of communication campaigns. Relevancy of issues by target groups can only be achieved once multimedia can be consulted on a routine base. The limited penetration of multi media among intended users is a serious obstacle, certainly in cases where societal groups are made attentive to the possibility of improving their social position. A characteristic of such positions is, namely, limited access to usable and functional sources of information (including traditional media). Multimedia are mainly useful for business-oriented purposes, and are certainly not accepted – yet – by consumers (see De Vuijst, 1994).

Once communication technologies become widely penetrated or accessible in society they could be helpful because of the diversity of content and flexibility of information production and consumption. The processes of individualization within modern societies result in individual agendas, problem definitions and solutions. These developments favour the functionality of multimedia.

The creation of changes in human attitudes and behaviours through communication campaigns will remain – even with high penetration of equipment – extremely difficult to achieve. Such changes depend less on the chosen mode for distribution of messages, interactive or otherwise, but more on the understanding of the complex character of the process involved in changing knowledge, attitudes and behaviours. The results of the case study summarized in this chapter confirms this proposition. New information services are only useful when they provide information on issues

people really care about and which they cannot obtain elsewhere within sources routinely consulted. Multimedia, then, must first become a relevant and functional alternative to the means people have already developed to understand and to adjust to their (social) world before these forms of new communication technology will be valuable for public communication campaigns.

References

Altheide, D.L. (1985) Symbolic interaction and 'uses and gratification': Toward a theoretical integration, *Communications*, 11: 51–60.

Ambron, S and Hooper, K. (1988) *Interactive multimedia*. Redmond: Microsoft press.

Bauer, R.A. (1964) The obstinate audience, *American psychologist*, 19: 319–328.

Boekelder, J. and Nelissen, P. (1992) Is de vraag informatie? Een onderzoek naar de CLG infolijn benaderd vanuit de Sense Making Approach. Nijmegen: Institute of Mass Communication.

Evans, W. (1990) The interpretive turn in media research: innovation, iteration, or illusion? *Critical studies in mass communication*, 7: 147–168.

Hulett, J.E. (1966) A symbolic interactionist model of human communication. Part one: The general model of social behaviour; the message-generating Process. *AV communication review*, 14: 5–23.

Hyman, H.H., and Sheatsley, P.B. (1947) Some reasons why information campaigns fail. *Public opinion quarterly*, 11: 412–423.

Katz, E. (1959) Mass communication research and the study of popular culture. *Studies in public communication*, 2: 1–6.

McGuire, W.J. (1981) Theoretical foundations of campaigns, in R.E. Rice and W.J. Paisley (eds.) *Public communication campaigns*, Beverly Hills, CA: Sage.

McQuail, D. (1994) *Mass communication theory; An introduction*, London: Sage.

Mead, G.H. (1938/1972) The philosophy of the act, in: C.W. Morris (ed.) , *The philosophy of the act*, Chicago: University of Chicago.

Mendelsohn, H. (1973) Some reasons why information campaigns can succeed, *Public opinion quarterly*, 37: 50–61.

Nelissen, P. (1991a) *Het omgaan met kennis en de vraag naar voorlichting. Een communicatiewetenschappelijk perspectief voor empirisch onderzoek naar de vraag naar voorlichting*, Nijmegen: ITS.

Nelissen, P. (1991b) Public communication campaigns and the audience activity, in: K. Renckstorf, P. Hendriks Vettehen and L. van Snippenburg (eds.) *Communicatiewetenschappelijke bijdragen 1990–1991*, Nijmegen: ITS.

Rice R.E. and Paisley W.J. (eds.) (1983) *Public communication campaigns*. Beverly Hills, CA: Sage.

Rice R.E. and Atkin, C.K. (eds.) (1989) *Public communication campaigns*. Newbury Park, CA: Sage.

Vuijst, J. de (1994). *De behoefte aan informatie. Commentaar op de informatiemaatschappij*, Tilburg, NL: University Press.

7 Communication Technologies for Information-based Services: Experiences and Implications

Cees Leeuwis

In the field of information provision and advisory communication, expectations are high regarding the impact of computer-based communication technologies. Inasmuch as such technologies allow for interaction between software and user, they can reach a large audience, while maintaining a degree of message specificity (Hawkins et al., 1988; Blokker, 1984). Despite numerous experiments actual use of such communication technologies has remained far below original expectations. In this chapter I discuss various shortcomings in the manner adoption of communication technologies has been explained in communication studies. In relation to this I argue for moving away from technologically-based descriptions and analyses. I suggest a functional classification of communication technologies and discuss its relation with multimedia. I also identify a number of ways in which communication technologies may fail to anticipate the environment in which they are supposed to be used. Finally, I suggest how communication scholars may contribute to development of more appropriate communication technologies, in particular multimedia.

Historically, there has been a strong focus on traditional electronic and print media within communication studies. More recently, research efforts centre around 'new' media such as videotex, e-mail, expert systems, interactive television and multimedia. These media are distinguished largely along technological lines; labels are used to refer to a particular combination of technological packages. These distinctions may be 'functional' to the extent that they clarify, for example, the senses involved, or the speed and pattern of the communication process. This functionality, however, derives directly from the

technical characteristics of the medium, and has little relation with the specific functionality of the communication process itself.

Based on this technological orientation, several communication scholars have developed an interest in the field of computer-mediated communication (CMC) (e.g. Steinfield, 1991; Fulk & Steinfield, 1990). Authors within this area have shown a strong interest in explaining the (non-)adoption of particular computer-based media. Steinfield (1991) and Fulk & Steinfield (1990) identify a number of theoretical approaches in this respect which can be roughly described as rational choice models (e.g. Trevino *et al.*, 1990; Short *et al.*, 1976), critical mass approaches (e.g. Rogers, 1986; Markus, 1990) and social influence models (e.g. Fulk *et al.*, 1990). Despite significant differences between these approaches, they have in common the idea that specific *characteristics* of the medium – the technological package – plays an important role in the explanation of its use. These are termed *media-centred* approaches. In both the rational choice and social influence models media use is explained in terms of a more or less adequate match between the characteristics of the medium and the characteristics of the communicative task to be performed. Thereby, social influence writers (e.g. Fulk *et al.*, 1990) point out that such characteristics are to be seen merely as socially constructed attributions, and hence that they are not necessarily self-evident and/or agreed upon. From the perspective of critical mass theory, media characteristics that play a role in that interactive communication technologies are seen as radically different from those of other innovations. This implies that adoption must be understood in fundamentally different terms (Markus, 1990).

The media-centred approaches mentioned above can be criticized on several grounds. Basically, they tend to assume media behaviour can be adequately described and predicted in terms of media and user characteristics. Hence, these approaches tend to have deterministic implications and incorporate a passive view of the social actor (Leeuwis, 1993:29–55). Moreover, they tend to encompass a rather mechanical view of communication and information (Dervin, 1983:173; Bosman *et al.*, 1989:28; Leeuwis, 1993:57–58, 65–66). This is reflected in the fact that neither the communication process itself nor the specific content of what is being communicated plays a role in the explanation of media use, let alone the interpretative, normative and political connotations inherently connected to the process and content (see e.g. Giddens, 1984:29). Furthermore, these theoretical models (except the critical mass approach)[1] tend to focus on *individual* media choices, socially influenced or not. This is rather curious, inasmuch as communication inherently implies involvement of a minimum of two actors which means issues of interaction and coordination are always at stake.

1 In this approach a social group or 'community' of actors is usually taken as the unit of analysis.

In response to the shortcomings of media-centred approaches various *audience-centred* options have been developed (Van Woerkum, 1990; Dervin, 1983; Nelissen & Renckstorf, 1991; Renckstorf *et al.*, 1996). These are more interpretative approaches and incorporate a subjectivist view of information. In relation to this, media use – and especially non-use – is often explained in terms of content, for example, the extent to which the information offered through such media anticipates cultural diversity and can be placed in an adequate context (Dervin, 1991). Although audience-centred approaches provide a correction for some of the limitations of media-centred approaches, they share a focus on the *individual*. Political and normative dimensions of communication processes do not figure in the explanation of media use; it remains the individual who does the interpreting.

It makes sense to explain media use in terms of interaction between the actors involved. In this *interaction-centred* approach, communication processes are regarded as *processes of negotiation*. Media use in specific interactions must be understood against the background of interpretative, normative and political 'struggle', and cannot be looked at in isolation from other social interactions in time and space.[2] This implies, for example, that use of communication technologies must be understood in terms of interactions between the designers of the technology, those who use the technology for intervention purposes, intermediaries, end users and others related to the social networks of these actors.

A functional classification of communication technologies

It is easy to lose one's way in the jungle of terminologies referring to communication technologies. Some terms are mainly grounded on technological characteristics (e.g. videotex, knowledge-based systems, interactive television, multimedia). Others clearly have functional connotations (e.g. management-information systems, decision-support systems) whereas others incorporate both elements (e.g. expert systems, electronic mail, databases).

Starting from an interaction-centred approach, it seems plausible that use and development of communication technologies is always, in one way or another, connected with communicative intervention. That is, certain actors deliberately develop and apply such technologies in order to realize certain outcomes. For this reason, a classification is introduced here of communication technologies relevant to communicative intervention. The classification is rather pragmatic and is based on analyses

2 There is an on-going discussion about interactivity as a characteristic of communication technologies; see Chapter 5. Although differences of opinion exist regarding the precise definition of interactivity, it is commonly assumed that computer-based communication technologies are more interactive than traditional media. For the 'interaction-centred' approach, all communication technologies are highly interactive in that they are used in specific social interactions inherently connected with other social interactions.

of the types of systems developed for purposes of information provision and advisory communication.

From text databases to Search and Access Systems (SAS)

A number of communication technologies consist essentially of a collection of electronic text pages which can – after selection with the help of search procedures – be viewed on a computer monitor or television screen. In some cases, this collection of text pages is rather fixed, as with an electronic encyclopedia; in other cases, the content of the pages is changed regularly as with a text database of weather forecasts or market information. In order to permit rapid updating and service to a large audience, the latter type of flexible text database is often located within a central computer. In some cases the technology allows only for one-way transfer of messages; this is, for example, the case with teletext which allows persons to use television sets for accessing pages stored on a central computer which in turn is connected to broadcasting equipment. In other text databases (e.g. videotex) a central computer is accessed by means of a local computer and a cable network, like that of a telephone system which makes it possible to have two-way message exchange. This implies that the same equipment can be used for gaining access to altogether different types of communication technologies. Both teletext and videotex-like text databases often make use of hierarchically-organized and structured menus as search facilities. In hypertext-like text databases hierarchical menu structures are replaced by associatively linked networks between text pages.

From the viewpoint of communicative intervention, such text databases can be described as *Search and Access Systems*. In essence, such systems are aimed at allowing end users to search efficiently in a large amount of available information. A crucial element in Search and Access Systems is the searching procedure. It happens frequently that such procedures incorporate menu structures, search trees and keywords which, from the perspective of end users, are not very logical, transparent or adequate.

From Management Information Systems (MIS) to Feedback Systems (FS)

Management Information Systems are frequently used in business firms and refer to communication technologies designed to assist managers in decision-making. MIS consist of databases which may include all sorts of information: letters, contracts, forms, minutes, production figures, accounting and similar data. Although such systems can be used to store information originating from outside the organization, they are used primarily for storing internally-produced information. An important difference with Search and Access Systems is that end users themselves are 'filling' the system and providing information. Management Information Systems can be used

for storage and retrieval of information, but also to select, manipulate, represent and communicate information.

From the viewpoint of communicative intervention such communication technologies can be labelled as *Feedback Systems*. Such systems assist end users in registering, storing, manipulating and representing data related to their own actions. They are designed to give end users regular feedback on the consequences of their own routine-like activities. In addition, such systems provide end users an information pool to cope with unexpected situations. Registration of relevant data is a crucial prerequisite for the adequate functioning of such systems. This can be a very time-consuming activity, which is complicated by the fact that it is not always easy to assess what may be relevant data for future situations.

From Decision Support Systems (DSS) to Advisory Systems (AS)
Decision Support Systems often build on data which are collected with the aid of Feedback Systems. Usually, Feedback Systems only summarize and represent data. Decision Support Systems, in contrast, are geared towards generating specific advice or concrete guidance for future action. A crucial element in such a system is a model which supposedly contains predictive qualities. Many DSS systems involve complex calculation models. With the help of simulation models, it is possible to make projections on the basis of hypothetical interventions, whereby such simulations result in an evaluation or advice concerning the desirability of specific interventions. Other DSS systems encompass optimization models which generate advice on the 'optimal' allocation of means, given some previously defined set of objectives. A third type of model which frequently underlies DSS are diagnostic models; these attempt to arrive at a diagnosis of a specific problem situation with the help of an interactive 'dialogue' between user and the communication technology. In contrast to simulation and optimization models which merely carry out complex calculations, diagnostic models make use of 'reasoning' or artificial intelligence techniques.

Although the label 'Decision Support Systems' is often attached to such communication technologies, the convention is unfortunate. Communication technologies like Search and Access Systems and Feedback Systems perform decision-supporting functions as well. It is preferable, then, to speak of Advisory Systems. A fundamental problem with many Advisory Systems, however, is the limited validity of the complex models incorporated within them. An additional problem is their 'black-box' character. It is difficult for end users to verify and understand or correct the results of an Advisory System.

From computer networks to Networking Systems (NS)
Speaking about computer networks, the first images which come to mind are the physical infrastructures (glass-fibre cables, telephone lines, central computers,

servers) and the network software necessary to link computers. Logging onto a computer network users can not only access all sorts of systems – FS, SAS and AS – but can also utilize special network facilities called Networking Systems. Such systems purposefully capitalize on opportunities for fast and asynchronous communication within networks. A well-known example is electronic mail (e-mail). Other examples are bulletin boards, electronic conferencing systems, and electronic networks for exchange of rapidly changing information such as weather forecasts, market and stock exchange reports.

A special category of Networking Systems is Network Transaction Systems (NTS). The use of NTS initiates certain transactions concerning goods, services and money. Frequently, computer networks have not only a large number of end users, but also many providers of services. Via search procedures end users can find their way through the multitude of opportunities offered.

Additional remarks

The classification outlined above is functional in relation to communicative intervention which – as I have argued – is inherently implied in the development and use of communication technology. Little attention has been paid to all sorts of software techniques, technical devices and information carriers such as CD-ROM and CD-i. Each communication technology can be constructed with the help of a variety of software and hardware techniques. Moreover, such techniques are increasingly used together. Hence, the distinctive capacity of technological classifications is rapidly eroding.

For similar reasons, multimedia is not considered a separate category. All the main types of communication technology distinguished in this section can include facilities for auditive, visual, numerical and textual communication simultaneously. This means they can be designed in multimedia fashion. Nevertheless, it is clear that multimedia designs may be particularly suitable in certain Search and Access, and Advisory Systems. Systems which are dealing with the domain of crop protection may, for example, very well incorporate pictures of (stages) of pests and plagues in addition to textual information. Moreover, the results of simulation runs may be presented by means of graphs, text, spoken language and moving pictures. Furthermore, Networking Systems can be used for exchange of pictures and sound as well.

It is also important to realize that many communication technologies are, in fact, a form of cross-breeding between various categories. Videotex systems, for example, usually combine functional characteristics of Search and Access Systems and Networking Systems. Similarly, it is fairly easy to find examples of cross-breeding between Feedback Systems and Networking Systems, and between Feedback Systems and Advisory Systems (see various case studies described in Leeuwis, 1993).

Finally, different types of communication technology may play a role in different aspects of decision-making and problem-solving. Feedback Systems can play an important role in the evaluation of one's own behaviour, but can also be instrumental in problem identification and image formation. Search and Access Systems can be used very well for image formation, but also for uncovering specific information which is of direct relevance to the execution of activities. Similarly, certain Advisory Systems can be useful for comparing alternative solutions in a specific decision-making process, but can also be used for 'undirected' playing and experiments of thought, and hence contribute to image formation and problem identification. See Table 1.

Table 1: Functional characteristics of communication technology

	Search and Access Systems	Feedback Systems	Advisory Systems	Network (Transaction) Systems
common labels used in practice	.databases .teletext .videotex .hypertext	.management information systems	.decision support systems .expert systems .knowledge systems	.E-mail .electronic conferencing systems .videotex
underlying intervention goal	provide efficient access to information	provide adequate feedback	give specific support and advice	facilitate networking activities
means	search/selection procedures	registration, manipulation and representation of data	calculation, optimization, simulation and reasoning	message exchange, file-transfer (pictures, sound text, etc.)
source of information	information suppliers	end users	end users and 'experts'	end users and information suppliers
aspects of learning, decision-making and problem-solving	mainly image-formation and implementation	mainly evaluation, image-formation and problem-identification	mainly searching/ selecting alternatives and image-formation	variable: dependent on nature and content of messages
role of communicative intervener	supplier of information	discussion partner for the interpretation and processing of information	.discussion partner .co-user .corrector	user
typical substantive problems	search procedures are incompatible with knowledge and logic of end users	feedback does not (or no longer) meet the interest of the end users	validity of the underlying model is questionable complexity causes interpretation problems	users are confronted with superabundance of information

Non-use of communication technologies from a 'negotiation' perspective

Despite the potential of communication technologies, their actual use – in both quantitative and qualitative terms – often remains below expectation (Oonincx, 1982; Vonk, 1990). Often, these disappointing outcomes are attributed to inexperience and fear for computers or conservatism on the side of the prospective users. From an interaction-centred approach, such 'user-blame' explanations are unsatisfactory. Such explanations do not take into account social relations, interactions and negotiation processes inherently connected to communication technology use.

If communicative interventions which involve communication technologies imply a negotiation process, it needs to be clarified first what such a process involves. The exact nature of what is being negotiated varies from context to context. In general, it can be argued that both the *meaning of what is being communicated* and the *meaning of the communication* process itself are at stake. Developers of communication technologies usually incorporate a number of substantive or relational meanings. Such meanings are built in (often implicitly) in the form of various types of assumptions; see Table 2.

Assumptions that are incorporated in the technology may or may not adequately anticipate the context in which the communication technology is used. Users may wish to re-negotiate such underlying assumptions or may reject the technology altogether. Below, I identify various reasons why the use communication technologies often remains limited, and indicate how these relate to various types of inadequate assumptions.

The fuzzy nature of information needs
For a long time communication technology development has been characterized by a considerable degree of 'technology push'. User needs have only played a subordinate role in communication technology development. In recent years, however, there is an increased interest in thorough user-oriented research. It appears far from easy, however, to identify relatively stable information needs of potential users. In social interaction, people continuously identify and solve certain problems, so that new problems and information needs replace previous ones. Hence, it is no surprise that users rapidly become 'bored' with certain communication technologies (Leeuwis, 1993; Blokker, 1984). Moreover, the wider context in which users operate is subject to continuous change. There is a danger that assumed information needs have become obsolete when they are eventually implemented in communication technologies.

Table 2: Assumptions implicitly found in communication technologies

assumptions about:
- human learning;
- the user, such as:
 - (future) information needs;
 - foreknowledge and support needed;
 - decision making and rationality;
- natural and technical processes, opportunities and constraints;
- socio-economic processes, opportunities and constraints;
- advisory/educational processes;
- communication patterns.

In addition, there are methodological difficulties. It is difficult for anyone to analyze his or her own needs, and it is even more difficult to simultaneously evaluate the potential added value of an unknown technology in meeting such needs. Users are often not discursively aware of the needs that are already fulfilled, and have no need for information of which they are not even aware. In a way it can be argued that an information need only emerges when it is about to be fulfilled, i.e. when particular information is within reach. And only when one has access to particular information does it becomes possible to evaluate whether or not there was a real need for the information. Despite these inherent difficulties, many communication technologies incorporate rather specific assumptions about future information needs of users. In many cases, such assumptions are flawed, which severely limits the scope for using them.

Deduction, directiveness and normativity

Due to lack of insight in the information needs of potential users, designers and developers of communication technologies have often resorted to deducing such needs. Information needs have been derived from available knowledge, formal rational decision-making models and legal regulations. (Leeuwis, 1993:16). In other words, developers of communication technologies have built technologies on the basis of their views on what the information needs of users *should be*. Thereby, they have positioned themselves as *experts* and adopted a rather directive and normative approach towards users. From the point of view of users, however, such a 'teacher-pupil' role division may be unacceptable and cause them to reject the technology. Here we see, in fact, how certain assumptions about information needs, role division in educational processes, and the capacities and foreknowledge of users can be incorporated in communication technologies and lead to limited use.

Decision-making versus learning

Many communication technologies are geared towards supporting decision-making with regard to specific decisions. In many such systems users are required to follow

a linear decision-making process based on formal rational decision-making models. Deducing information needs in this manner is not without risk. Social-psychological studies (e.g. Janis & Mann, 1977) show that – when faced with problems – actors adhere to different patterns of decision-making, and that such patterns have a greater impact on actual information needs than formal decision-making models. Moreover, even if some patterns of problem-solving incorporate phases which are similar to those in formal decision-making models, these phases are run through in a non-sequential fashion (Engel, 1995:58), and can stretch over a longer time span. In everyday practice, it seems, decisions do not arise out of a discrete moment of decision-making, but rather from a long-lasting, often routine-like, and only partially conscious process of *learning*. Empirical research in agriculture has demonstrated that it is more effective, efficient and realistic to develop communication technologies which support learning than to develop communication technologies which support decision-making on specific issues (Leeuwis, 1993:413).

Facilitating learning, then, poses different demands on communication technologies than supporting decision-making. Transparency and flexibility are important conditions in this respect. Both these conditions can be violated easily by the complex models which tend to underlie Advisory Systems. When aiming at supporting processes of learning it becomes more sensible to direct user-oriented research towards identifying knowledge and information-related practices (or patterns of behaviour) and types of information needs, than it is to search for specific information needs. In all, it seems plausible that communication technologies can incorporate models of decision-making and rationality which conflict with the rationalities and decision-making processes which are found in actual practice.

Diversity and inadequate segmentation into target groups
It is generally agreed that one of the most important conditions for successful communicative intervention is 'client orientation'. In order to anticipate diversity among potential clients or users, it is important to adequately segment users into target groups. It is always possible to make a variety of different segmentation for one and the same population (e.g. along lines of sex, age, strategy, economic position). Hence, it is important to identify the most relevant segmentation providing the sharpest possible insight into differences which relate crucially to realization of intervention goals. Frequently, existing characterizations (originally developed for other purposes) are taken as a starting point for communication technology development. In these cases there is a real risk that relevant points of diversity remain unidentified and that provisions to deal with this diversity are not incorporated in the technology. As a result, users may find the technology too general and insufficiently tailored to their needs. Hence, in the process of technology development it is important to generate characterizations of diversity (i.e. 'models' of users)

specific to the communication technology. Empirical research suggests that such characterizations may be fruitfully based upon observed differences in knowledge and information-related practices within the potential target population (Leeuwis, 1993:335, 410).

The issue of diversity not only relates to assumptions about users, but may – indirectly – be connected with assumptions about natural, technical and socio-economic processes, opportunities and constraints. Different social groups may have rather different culturally and politically informed views, strategies and rationalities in relation to the natural, technical and socio-economic world. In any case, the assumptions regarding these matters incorporated into communication technologies, and most explicitly Advisory Systems, are usually far from neutral.[1] There may exist gaps or conflicts between the views, strategies and rationalities of developers as compared to end users of a communication technology.

Neglecting the external design

The design of adequate software and hardware often receives much attention in processes of communication technology development. Software and hardware components of communication technologies represent the technical dimension, or 'internal design' (Leeuwis, 1993:159). However, communication technologies have an social-organizational dimension as well: the contents of systems have to be updated regularly; technological infrastructures must be maintained; users require training and supervision; the parties involved must negotiate areas of responsibility, organize decision-making and solve conflicts. Communication technologies presume and induce organizational changes and develop within a social arena. This requires that various organizational arrangements are made; these arrangements can be labelled the 'external' design of the technology (Leeuwis, 1993:159). A communication technology can only function optimally when sufficient attention is paid to both its internal and external design.

Apart from initial supervision and guidance, the provision of a discussion partner can be an important aspect of the external design, which allows users to assess the relevance of the information provided for their own situation. In relation to this, a striking phenomenon is that the most tangible function of many communication technologies seems to be that they provide an agenda for discussion (Leeuwis, 1993). Frequently, the value attached to the opinions and views of the discussion partner tends to be higher than the value which is attached to the information and

1 Philosophers and sociologists of knowledge, technology and science have demonstrated convincingly that knowledge claims with regard to the natural and the social world are inherently connected with social interests of various kinds (Callon *et al.*, 1986; Latour, 1987; Knorr-Cetina, 1981). Hence, one cannot unproblematically label knowledge claims 'objective' or 'neutral', regardless of the origin of the claims.

advice generated by the communication technology. In this context, the efficiency of especially highly complex and costly Advisory Systems is at times debatable, since there are often alternative ways in which an adequate agenda for discussion can be generated.

Here we see that communication technologies incorporate inherently a number of assumptions which have social-organisational implications. This is most obvious in case of assumptions about the nature of advisory processes, and those about the user's foreknowledge and need for support.

Competition and lack of added value
Development of a communication technology is usually associated with the assumption that the particular technology will add something to an existing, or potential, communicative relationship. In must be recognized, however, that clients are usually part and parcel of highly sophisticated social networks in which information needs are created and solved. It happens regularly that communication technologies generate information which can already be accessed through other sources. The potential advantages of communication technologies[2] do not result in such technologies having automatically sufficient added value to compete with existing knowledge and information infrastructures (Van Dijk *et al.*, 1991).

In this regard, it is important to recognize that communication technologies have a number of disadvantages. Communication technologies, for example, do not socialize easily, and their 'brains' are far less context-sensitive, flexible, creative and associative as compared to human beings. Moreover, users must generally make considerable material and immaterial investments before they are able to reap the benefits of communication technologies. In all, given the complexities and intricacies of human communication, communication technologies can easily be developed on the basis of misguided assumptions about existing communication patterns. In such cases, users tend to be disappointed with the return on the investment made.

Conclusion
There are several ways in which the developers of communication technologies may fail to anticipate the context(s) in which the technologies are to be used. Moreover, this problem can be traced back to various inadequate assumptions underlying the technologies. Such anticipatory 'misfits' are not as much the result of a naive ignorance on the side of the developers, but must be seen in the context of selections

2 Some of the promises of communication technologies frequently mentioned include: breakdown of time and space barriers (through speed), message specificity as a result of interactivity, availability of large quantities of information, wide access to expert knowledge and efficient networking (Engel, 1989).

made in efforts to pursue specific interests and realize certain goals. The design of a particular communication technology, in other words, can often be best understood in the context of developers' strategic considerations; see Table 3.

Table 3: Strategic considerations of communication technology developers

- wish to tie customers;
- aspiration to create, maintain and reinforce an 'expert' versus 'layman' relationship;
- need to show the practical relevance of research models;
- ambition to alter organizational arrangements and missions;
- attempt to impose normative models of decision-making, rationality, reality and development;
- wish to demonstrate that one is not lagging behind in applying certain techniques and technologies;
- need to meet criteria for funding.

Source: Leeuwis (1993:416)

At the same time, it is not possible to predict straight forwardly that built-in anticipatory 'misfits' result necessarily in a limited adoption – at least not if we define adoption in terms of actual possession of the communication technology in question. A 'perfect' communication technology which totally suits the variety of users for which it was intended does not exist, and users are quite able to – at least temporarily – cope with, and correct for its particular shortcomings. Anticipatory 'misfits' (e.g. lack of flexibility) frequently come to the fore only when users gain experience with a communication technology. Interaction-centred studies highlight that not only the development, but also the adoption of communication technologies is linked to social interests.; see Table 4.

More than the simple possession of or access to communication technologies, anticipatory 'misfits' are likely to affect the duration, quality and nature of the technology's use. With respect to the latter, communication technologies may well generate forms of use which were not foreseen at the time of introduction and adoption. The question *to what extent* anticipatory 'misfits' will eventually prevent widespread adoption of a technology, however, can only be sensibly addressed in a contextual manner.

Table 4: Strategic considerations for communication technology adoption

- conviction that – in the long run – one will not be able to survive without using the communication technologies;
- ambition to be identified as 'progressive';
- effort to get access to special services or subsidies offered by suppliers of communication technology;
- free provision of communication technologies by suppliers in order to tie customers;
- attempt to maintain good relations with communicative interventionists;
- endeavour to secure access to particular actors or discourses;
- arrangements which effectively enforce use of the communication technology.

Source: Leeuwis (1993:405)

Enhancing communication technology development

As anticipatory misfits are incorporated into communication technologies during the developmental phase, it becomes important to reflect critically on the methods employed in present-day communication technology development. Many of these methods involve development of communication technologies with the aid of well-described procedures.[3] The procedures often begin with a feasibility study followed by a 'functional design' – a plan outlining which functions the technology should perform. Then, a 'technical design' is made, indicating how the required functions will be technically realized. Subsequently, technicians build the technology and test whether it works adequately. At this point the communication technology is considered ready for introduction.

Even when users have participated extensively in drawing up a functional design, such procedures pose problems. Due to the difficulties inherent in the identification of information needs, it is only *after* users are confronted with an operational version of the technology that they become aware of their true wishes and needs. An adaptation of a design on the basis of the users' learning experiences in this respect, however, is often prevented or delayed because of the considerable investments and decisions which have already been made at this stage in development.

Hence, mainstream methods for communication technology development tend to obstruct learning and fail to prevent and correct for anticipatory misfits. Moreover, such methods tend to represent technology development as a well-directed and rationally organized collective decision-making process resulting in predictable outcomes. Empirical studies, however, suggest that – in everyday practice – development processes constitute a continuous process of struggle and negotiation of which the outcomes are inherently unpredictable (Long & Van der Ploeg, 1989; Crehan & Von Oppen, 1988; Leeuwis, 1993). Clearly, such observations are consistent with an interaction-centred approach, which states that use of communication technologies involves a negotiation process which must be understood in the context of *earlier* interactions and negotiations.

The question remains as to how communication technology development processes can be improved and what role can be fulfilled by social scientists in such processes. Here I will merely touch upon some important criteria that a new approach will have to meet.[4] A key assumption here is that if processes of communication technology development indeed constitute simultaneously a process of learning and a process of negotiation, then it makes sense to *organize* them as such. This implies the following points.

3 Such procedures can be 'process-oriented', 'data-oriented', 'object-oriented', 'project-oriented' or 'socio-technical' in nature (see Bots et al., 1990).

4 The characteristics of a 'learning-oriented' method of communication technology development have been spelled out in detail elsewhere (Leeuwis, 1993:386-397).

First, in order to ensure adequate anticipation of users' needs and social context, the development process should be participatory in nature. That is, the various categories of prospective users should be involved in as many stages of the development process as possible.

Second, the development process should be iterative in nature in order that learning experiences of users can be rapidly integrated into both the internal (technical) and the external (social-organisational) design. For the internal design, this means that – on the basis of a rather rough analysis and specification of requirements – developers start to build almost immediately an equally rough working model of the communication technology. The prospective users, then, are asked to test and evaluate this working model. On the basis of comments and discussions, developers can create a new working model; this is a procedure which repeats itself until a 'final' and satisfactory version is obtained. Such a method is termed 'prototyping' (Vonk, 1990). For development of an adequate external design, such prototyping must be supplemented by field testing.

Third, the prototyping process should be preceded and accompanied by qualitative sociological/anthropological research. Research is needed to identify relevant diversity among (different types of) users (see previous comments). In order to do so, such studies must focus on diversity in (knowledge and information-related) practices, and explore the socially negotiated character of this diversity. In relation to this diversity, socio-anthropological research can help to identify initial criteria which the prospective communication technology might have to meet in order to have added value, and support adequately the practices in which various categories of users engage. Such criteria, in turn, can be used to give initial direction to the prototyping process.

Also, such qualitative studies can serve to determine for which cross-sections and coalitions of actors it may be realistic to develop an overarching communication technology. Different types or segments of actors may very well pose demands on the technology which are contradictory and mutually exclusive. Moreover, qualitative studies can be carried out to monitor the process of prototyping and field testing, and provide adequate feedback to the participants on the social nature of choices made, and possible consequences. Finally, socio-anthropological research may help to assess the overall feasibility and desirability of the would-be technology. In sum, social scientists, particularly communication scientists, can play a variety of roles in processes of communication technology development. They can act as researchers, facilitators, participants, intermediaries, negotiators and political activists.

Clearly, neither the type of method proposed nor the involvement of social scientists therein provides a guarantee for successful communication technology development. Due to the social nature of technology development processes, the outcomes will always be characterized by a considerable degree of unpredictability. In order

to maximize the chances for success, such a method can be applied most fruitfully in an organisational setting in which: communication lines are short; decisions can be taken rapidly; actors are prepared to work quickly and cheaply; access exists to sufficient software and hardware resources and experiences; the organizations involved are willing to delegate decision-making responsibilities, and the development process can be – at least temporarily – shielded from external conditions, intervention and formal planning.

References

Blokker, K.J. (1984) *Computergesteunde voorlichting: Een decisiegericht voorlichtingskundig onderzoek naar Epipre en andere geautomatiseerde informatiesystemen in de landbouwvoorlichting,* Wageningen: Extension Department, Wageningen Agricultural University.

Bosman, J., Hollander, E., Nelissen, P., Renckstorf, K., Wester, F. and Woerkum, C. van (1989) *Het omgaan met kennis – en de vraag naar voorlichting: Een multidisciplinair theoretisch referentiekader voor empirisch onderzoek naar de vraag naar voorlichting,* Nijmegen: Institute for Applied Social Science Research, University of Nijmegen.

Bots, J.M., Heck, E. van, Swede, V. van and Simons, J.L. (1990) *Bestuurlijke informatiekunde; Een praktisch studie- en handboek voor de mondige gebruiker van informatiesystemen,* Rijswijk: Cap Gemini Publishing.

Callon, M., Law, J. and Rip, A. (eds.) (1986) *Mapping the dynamic of science and technology: Sociology of science in the real world,* London: MacMillan.

Crehan, K. and Von Oppen, A. (1988) Understandings of 'development': An arena of struggle. The story of a development project in Zambia, in: *Sociologia Ruralis,* 28, 2–3: 113–145.

Dervin, B. (1983), Information as a user construct: The relevance of perceived information needs to synthesis and interpretation, in: S.A. Ward and L.J. Reed (eds.) *Knowledge, structure and use: Implications for synthesis and interpretation,* Philadelphia: University Press.

Dervin, B. (1991) Information as non-sense; information as sense: The communication technology connection, in: H. Bouwman, P. Nelissen and M. Vooijs (eds.) *Tussen vraag en aanbod: Optimalisering van de informatievoorziening,* Amsterdam: Otto Cramwinckel.

Dijk, T. van, Engel, P. and C. Leeuwis, C. (1991), Evaluatie AGROCOM proefproject, report, Tilburg: Noordbrabantse Christelijke Boerenbond.

Engel, P. (1989) Building upon diversity: A role for information technology in knowledge management for agricultural production, paper, European Seminar on Knowledge Management and Information Technology, November 23–24, Wageningen.

Engel, P. (1995), *Facilitating innovation: An action-oriented approach and participatory methodology to improve innovative social practice in agriculture,* Wageningen: Wageningen Agricultural University.

Fulk, J., Schmitz, J. and Steinfield, C.W. (1990) A social influence model of technology use, in: J. Fulk and C.W. Steinfield (eds.) *Organizations and communication technology,* Newbury Park: Sage.

Fulk, J. and Steinfield, C.W. (eds.) (1990) *Organizations and communication technology,* Newbury Park: Sage.

Giddens, A. (1984), *The constitution of society: Outline of the theory of structuration,* Cambridge: Polity Press.

Hawkins, R.P., Wiemann, J. and Pingree, S. (eds.) (1988) *Advancing communication science: Merging mass and interpersonal processes,* Newbury Park, CA: Sage.

Janis, I.L. and Mann, L. (1977), *Decision making: A psychological analysis of conflict, choice and commitment,* New York: Free Press.

Knorr-Cetina, K.D. (1981) *The manufacture of knowledge: An essay on the constructivist and contextual nature of science*, New York: Pergamon Press.

Latour, B. (1987) *Science in Action*, Milton Keynes: Open University Press.

Leeuwis, C. (1993) *Of computers, myths and modelling: The social construction of diversity, knowledge, information and communication technologies in Dutch horticulture and agricultural extension*, Wageningen: Wageningen Studies in Sociology, Wageningen Agricultural University.

Long, N. and Ploeg, J.D. van der (1989) Demythologizing planned intervention, in: *Sociologia Ruralis*, 29, 3/4: 226–249.

Markus, M.L. (1990) Toward a 'critical mass' theory of interactive media, in: J. Fulk and C.W. Steinfield (eds.) *Organizations and communication technology*, Newbury Park, CA: Sage.

Nelissen, P. and K. Renckstorf (1991) De vraag naar informatie: Een handelingtheoretisch perspectief voor onderzoek, in: H. Bouwman, P. Nelissen and M. Vooijs (eds.) *Tussen vraag en aanbod: Optimalisering van de informatievoorziening*, Amsterdam: Cramwinckel Uitgever.

Oonincx, J.A. (1982) *Waarom falen informatiesystemen nog steeds*, Alphen a/d Rijn: Samson.

Renckstorf, K. McQuail, D. and Jankowski, N. (eds.) (1996) *Media use as social action; A European approach to audience studies*. London: Libbey.

Rogers, E.M. (1986) *Communication technology: The new media in society*, New York: Free Press.

Röling, N.G. (1988) *Extension science: Information systems in agricultural development*, Cambridge: University Press.

Short, J., Williams, E. and Christie, B. (1976) *The social psychology of telecommunications*, London: J. Wiley and Sons.

Steinfield, C.W. (1991), Communicatie via computers binnen organisaties: Theoretische kaders en onderzoeksrichtingen, in: H. Bouwman, P. Nelissen and M. Vooijs (eds.) *Tussen vraag en aanbod: Optimalisering van de informatievoorziening*, Amsterdam: Otto Cramwinckel.

Trevino, L.K., Daft, L. and Lengel, R.H. (1990), Understanding managers' media choices: A symbolic interactionist perspective, in: J. Fulk and C.W. Steinfield (eds.) *Organizations and communication technology*, Newbury Park, CA: Sage.

Vonk, R. (1990) *Prototyping: The effective use of CASE technology*, London: Prentice-Hall.

Woerkum, C.M. van (1990) Een nieuwe benadering van ontvanger-onderzoek, in: K. Renckstorf and C.M. van Woerkum (eds.) *De vraag naar voorlichting*, Nijmegen: Institue of Applied Social Science Research.

8 Evaluation of CD-i Programme for Children with Learning Disabilities

Cor van der Klauw and Emely Spierenburg

In September 1992 CD-i was introduced in the Netherlands – nearly a year after its premier in the United States. At that time there were few Dutch titles available. Most titles available were – and still are – directed toward consumer interests. One of the first educational CD-i programmes in the Netherlands was entitled The Station. This title was developed to determine the possible value for CD-i in educational settings, and whether the technology could be valuable for instructing children with learning difficulties. Inasmuch as no title was available for this target group, the first task consisted of designing a suitable programme. Once developed, the titled was evaluated. This chapter reviews the educational model and development of The Station, the evaluation research project, and the findings resulting from that investigation.

The objective of this project was to investigate in what manner and degree multimedia technologies like CD-i can be used for teaching children with learning difficulties.[1] Due to the increasing complexity and volume of information available as well as changes in information access, it is often difficult for children with learning difficulties to adequately function in society generally and in the labour market specifically. Problems are particularly acute in that uncertain period between school and involvement in the labour market. One concern is whether it is possible to utilize information technology such as CD-i in order to bridge this ever-widening gap.

1 A series of interim reports were produced during the course of this project, two of which (Van der Klauw, 1992; Spierenburg, 1993) were particularly valuable in preparing this chapter.

103

The general objective of the CD-i title *The Station* is to improve the individual functioning of children with learning difficulties. Given this objective, it was decided to confront children with situations common to everyday life. By learning to apply knowledge which is useful for them and emerges from recognizable situations it was expected that this would contribute to an overall improvement in social functioning. The practical knowledge and experience under consideration included: learning to perform simple monetary transactions; planning a series of tasks; ability to complete a number of reasonably complicated actions; and searching for, interpreting and using information.

The choice was made for a programme designed to reflect an actual situation in which the programme simulates a real situation, both in terms of form and interaction with users. One of the situations important for children with learning difficulties is ability to travel to and from school, and making use of public transportation. This skill is also essential once the children are eligible for the labour market. For these reasons it was decided to simulate aspects of travelling by train in the CD-i title, including transactions and activities typically experienced at train stations.

The CD-i title *The Station* was developed primarily for children with learning difficulties engaged in special education programmes. The title several aspects which make it suitable for use by other groups: children with reading problems, non-native Dutch speakers, elderly persons, and children in primary education. The programme offers various levels of difficulty, depending on the capability of the users. Spoken text is used throughout the programme thereby reducing reliance on the reading skills of users. Texts are spoken slowly and clearly. The speed with which images change is in accordance with the information processing capabilities of the children. With these aspects, the programme provides an environment in which children can practice skills required in travelling by train.

Description of *The Station*

The CD-i title simulates a train station from which it is possible to travel to 33 different destinations. One of the most centrally located stations in the Netherlands – in the city of Utrecht – was chosen as point of departure. In the Utrecht station hall, the initial image on the screen, the user can purchase a ticket, either from a ticket dispensing machine or from an employee behind the ticket counter. There is also a flowershop in the station hall, a snack dispensing machine and a money dispenser.

At the moment when payment must be made for a ticket, flowers or a snack, a bag appears on the screen. In the bag is a purse which becomes visible by clicking on the bag with the mouse. After this the purse and the money available is shown. In the event there is insufficient money in the purse, the traveller may make use of a bank card in the purse for retrieving additional funds from a money dispenser.

Figure 1: Illustration of the ticket counter in *The Station*

With the aid of information boards noting departure times, the user can determine to which platform he must go to catch the correct train. At the platform itself are other information boards which indicate platform number and departure time of the next train. With this information, the user can verify whether the oncoming train is the one desired.

Once the user has chosen to step into a train, the ticket is controlled by a conductor and, if everything is in order, the train departs. Should the traveller have stepped into the wrong train or not have a ticket, he must immediately exit from the train. On arrival in another city, the user must decide to remain seated, transfer to another train or exit from the train. Once the final destination has been reached, information is provided about the city and slides shown of various attractions to be found there. The CD-i programme also includes a map of the Netherlands so that travellers may study the travel route, and at any moment it is possible to request further instruction and explanation.

At the beginning of the programme the user can choose to explore the station, ask for an assignment or request information about various symbols and signs employed in the programme. Once he has asked for an assignment, the user can select from four levels of difficulty.

A journey always begins with purchase of a train ticket for a particular destination. In addition, depending on the level of difficulty selected, other activities must be completed such as buying flowers or a snack. The trip can be made more difficult by not having sufficient money in the purse, having to search out the most suitable route for travelling, and having to complete the trip within a limited period of time.

During the task fulfillment, it is possible to request seeing the travel assignment again as well as which activities have already been completed and which remain. At the end of the journey, feedback is given on these tasks.

Theoretical considerations

The general objective of *The Station* is to assist children in remedial educational classes in learning how to travel independently by train. This objective can be achieved through development of skills which assist in processing relatively complex forms of information. Systematic and efficient information processing involves ability to select, order, interpret and generate information.

Another objective of *The Station* is to stimulate learning activities of children with learning disabilities, reduce fear of failure, and improve ability to structure infor-

Figure 2: Illustration of train conductor in *The Station*

mation cognitively. Moreover, the programme attempts to create an environment in which interaction is made possible between the user and simulation of real-life situations. By creating reactions which are replicas of what is experienced in real life, users are confronted with the consequences of their own actions and decisions. By designing the programme in such a manner that similar actions in different settings repeat themselves, it is possible for users to practice and recognize similarities and differences between old and new situations.

Interaction and feedback

The possibility for interaction is theoretically very large with CD-i programmes. This depends, of course, on the particular CD-i programme. CD-i programmes do not create all of the possibilities for development of all learning processes. For this reason it is necessary during development of CD-i applications for educational settings to pose the same questions as for other forms of education: what are the learning objectives, what kinds of knowledge are desired, which functions should interactions with students fulfil, which learning activities must students perform in order to learn what is intended, and in what matter should the programme be used. As noted above, interaction of the student with his environment (instructor, learning materials and other students) constitutes the core of the teaching and learning activities.

Characteristics of functional interaction in an educational setting, based on work by Borsook and Higginbotham-Wheat (1990), include the following points:

- The interaction must relate to the three aspects of an action to be mastered: preparation, performance and control of the performance.
- The interaction must be informative; the interaction must provide the student with information about future behaviour. He must be able to focus attention on possibilities for solving a problem, and it must accentuate the critical elements in a series of actions to be learned (feedback should consist of more than an elementary assessment of correct or incorrect answers).
- The interaction should take place relative quickly; the time period between the action of the student and reaction from the environment should be as short as possible.
- The access to interaction information should not be sequential; the student should have access to the necessary information, dependent on his need and independent on the manner in which the information is stored in the programme.
- The interaction should be tailored to the level and situation of the student.
- The interaction should be sufficiently interesting to hold the attention of the student.
- The interaction should be two-directional: both the student and environment should be able to take initiatives.

- The unit of interaction, especially with younger students and those with learning difficulties, should be limited in amount of information and time required for processing.

The objective was to implement the above characteristics of interaction into *The Station*. As already mentioned, the programme was designed to simulate a real-life situation, but this simulation had to be simplified while allowing possibility for interaction. The idea was that the programme would provide a responsive environment; whatever the student would do, the system would automatically provide feedback. There was, in other words, a form of implicit feedback which emerged from the programme structure. Explicit feedback was also provided through comparison between the actually performed actions and the desired end result. This comparison allowed assessment of student performance.

Achievement of interaction and feedback

In designing the programme much attention was paid to the possibilities for interaction between student and environment, i.e. with the simulation of situations encountered in taking a train ride. This environment not only *appears* like that in real life, but it also *responds* to actions by students much as would happen in real life – this is what is meant by implicit feedback. In this manner, interaction is prompted by and linked to the level of difficulty. The assumption here is that students will not hesitate to do something 'wrong' and be willing to try unknown alternatives.

Given that a student works at his own level successes are built into assignments. The programme offers students the possibility of working with the learning tasks in a safe, punishment-free environment. The student determines the tempo and may repeat an assignment as often as desired. The programme is, in other words, infinitely tolerant which increases the possibility that the skills required for train travel and other skills improve. It is further expected that self-discovery of solutions to assignments contributes to an increase in the self-confidence of students.

The learning material is presented in a non-linear manner and the student is free to follow his own strategy. If a student undertakes an incorrect action, the programme reacts through implicit feedback. For example, in the event a train ticket has not been purchased, it will not be possible to initiate the train journey; going to the wrong train platform results in arriving at the wrong train; and when flowers are purchased at a casual pace when the train is scheduled to depart within a few minutes, the student will miss the train. The student is confronted directly with the consequences of his own decisions and actions. The unpleasant and unintended consequences can be rectified through modification of actions. Explicit feedback is also given at the end of each assignment. The student sees the assignment once again, and every task satisfactorily accomplished is lighted up. In this manner the student can compare what he did with what was expected.

Evaluation research

During the development of *The Station* three research-based evaluations were performed. The first was conducted on the prototype of the programme, and the purpose was to provide feedback to programme designers at an early phase. The central question in this part of the evaluation was whether the programme was usable in the educational setting of the participating schools. During a week-long period interviews were conducted with both instructors and participants. Eight pairs of participants worked with the programme for two half-hour periods. The findings from this investigation provided input for completion of the programme.

Once the various components of the programme functioned satisfactorily, a beta version was developed. The objective of the evaluation research conducted on this version was to collect information on the educational effectiveness of the overall programme. Three schools and a day-care centre participated in this phase of the research project. The results of this phase contributed to recommendations for final changes in the programme, and 'version 1.0' of *The Station* was produced.

The third phase of the research project was then initiated on this programme version. Here, in contrast to previous phases, control groups were part of the design. The most important points of concern were: the learning effects of the programme, the usability within an educational setting, and the suitability of the didactical model on which the programme was based.

Two research populations worked with version 1.0 of *The Station*: participants classified as having moderate learning difficulties (MLD) in the age range of 14 to 16 years, and those with extreme learning difficulties (ELD). The first group (MLD) consisted of 32 and the second group (ELD) of 40 participants in the age range of 14 to 30 years. A quasi-experimental design was constructed; each of these groups was divided into experimental and control groups.

The experimental groups worked for a period of 12 weeks with *The Station*; the control groups did not use the programme and did not receive in any other manner instruction on train travel. Prior to working with the programme all participants were tested on a number of skills, answered questions regarding their knowledge of train travel and made an actual trip by train. After the 12-week period the same testing procedure was followed. During the final measurement interviews were also conducted with the participants, instructors and other personnel which worked with the participants.

Results from the three components of the research design are presented around three topics: the *learning and instructional setting* in which the programme was used (the didactic model), the *effectiveness* of the programme, and the *appreciation* of the programme by the participants, instructors and other personnel. Regarding results related to the learning and instructional setting, attention is paid to the value of the

didactic model employed in the programme. Attention is also paid to the representativeness of the programme, the degree of interactivity, the suitability of the programme within the curriculum and the user-friendliness of the programme. The achieved learning results are compared with those intended, and a distinction was made between learning results which emerged during working with the programme and those which appeared when both groups (MLD; ELD) were confronted with making an actual train trip.

Results: The didactic model

Various aspects of the didactic model were investigated on version 1.0 of *The Station*. Structured observations perfomed by trained personnel were conducted for this aspect of the research. Findings from a few of these aspects are briefly noted below.

Simulation produces confidence with reality. Recognition of specific aspects involved in making a train trip after completion of the programme was large by members of the experimental group. These participants, for example, went directly to the ticket sales counter on entering *The Station* and then, after purchasing a ticket, went directly to the departure and arrival displays in order to select the correct platform. In contrast, during the train trip taken before experience with the programme many children inspected the tickets, thinking the platform number would be printed there.

Successful experience reduces fear of failure. The Station was an attractive learning experience for most of the participants, judging by the enthusiasm with which they performed the required tasks. And when they reached the final station and experienced the series of slides about that destination they reacted with glee as if they had 'conquered' the task. And when something went wrong most did not hesitate to begin again; they were not, in other words, afraid to make mistakes.

Safe environment with possibility for repetition. As already mentioned, the participants were not afraid to do something wrong. This was probably a consequence of the fact that they felt at ease when working with the programme. They could determine their own rate of progress. In addition, they could repeat an exercise as often as they wished without anyone become irritated or angry at them. When particular aspects of one task did not succeed, they then tried out another task in which they tried once again.

Motivation through reward. The series of slides presented once the final destination had been reached was greatly appreciated by the participants. They were curious about the attractions awaiting them at locations like the capital city of Amsterdam. When someone completed a trip without any mistakes a special musical tune was played which was especially enjoyed by the participants.

Structure of tasks. The similarity in structure and approach of the assignments in the programme contributed to the participants clearly knowing which actions are required to travel by train. This became particularly apparent during the second actual train trip. While members of the control group hesitated to undertake actions, participants from the experimental group proceeded consciously and directly.

Experiencing consequences of own behaviour. A student is confronted by the consequences of his own decisions and actions in the programme. When someone, for example, ends up on the wrong landing they also end up in the wrong train. Insufficient money in the wallet leads to an undesired situation at the ticket window. Through experiences of these sorts the participants learned how to react to events which can also occur in real-life situations. Most of the participants made good use of these experiences. They checked at the beginning of a trip, for example, whether they had sufficient money in their programme wallet before purchasing a ticket. Such anticipatory behaviour was also observed during the train journeys.

Results: Effectiveness of *The Station*

The effectiveness of the programme is based on the degree to which learning objectives are achieved. Two forms of learning effects can be distinguished: learning effects related to working with the programme and those related to transfer information in the programme to real-life situations. In order to measure the first type of learning effect observations were conducted during the period in which participants experienced the programme. For example, the number of tasks performed and level of difficulty achieved were recorded. The amount of time required for performing tasks was also recorded, along with whether the tasks were understood and whether participants could perform the activities alone. As previously mentioned, actual train trips were taken before and after working with the programme. During these trips the participants were observed regarding ability to perform tasks and whether their self-confidence changed between the first and second train trip.

Learning effects: working with the programme

Participants with *moderate learning difficulties* (MLD) worked with the programme between 8 and 10 times during the 15-week evaluation period. Morning sessions were specially planned for this activity. Participants took turns working with the programme and performing tasks. Most completed two tasks per session with the programme, with an average of 20 minutes devoted to each task. All levels of tasks were performed with a clear progression from easy to difficult, as observed across time. A number of participants initially had difficulty with the tasks, but after a couple of exercises little support was required from instructors and personnel. Most assistance was required when participants had to 'change trains' during a task.

The participants seemed motivated and eager to learn; they wanted to use the programme repeatedly. All of the situations in the programme were tried and everyone tried a difficult task at least once. Those participants – mainly the boys – who were able to understand the programme early in the experimental period were also those who completed the most tasks per session. This group also completed the most difficult tasks measured across the entire 15-week period. Boys were from the very beginning more competent than girls in using the mouse.

Participants with *extreme learning difficulties* (ELD) experienced *The Station* as part of a course in travelling by train. Other learning materials such as a computer and workbooks were used to exercise skills like telling time, counting money and orienting oneself on a map. The course was given once per week during a 12-week period.

The participants can be divided into two groups: (1) a group which had much difficulty reading, calculating and telling time; and (2) a group which could perform these skills with a reasonable degree of competence. The participants from the first group were mainly active for the duration of the course with the easy tasks. Participants from the second group also began with the easy tasks, but near the end of the course many participants from this group were able to complete more difficult tasks. The better reading, calculating and speaking skills were already developed the more success these participants achieved with the programme tasks.

Transfer of programme information to reality
Earlier it was noted that children acquired particular learning experiences while working with the programme. A research interest was whether this knowledge was also transferred to real-life situations. Examples of knowledge transfer include improvement of basis skills such as counting money and telling time, and whether the participants could better prepare for a train trip and function once in a train.

Four sets of research instruments were developed for this evaluation:

1. Questionnaire and observation schedule regarding characteristics of the children – background information, degree of self-sufficiency, experience with travelling and public transportation, communicative skills, skill in reading and writing, and experience with computers.
2. Skills tests regarding awareness of and telling of time, body awareness, recognition and counting of money.
3. Questionnaire regarding knowledge of train travel.
4. Observation schedule regarding behaviour in the railway station and the train, completed during train trips taken before and after experience with the CD-i programme.

The control group of participants with moderate learning difficulties (MLD) scored

in the pre-test significantly better than the experimental group on the first and second of the above instruments. The experimental group of participants with extreme learning difficulties (ELD) scored significantly better than the control group on the first and third set of instruments in the pre-test.

On comparing the scores of the pre- and post-tests for Instruments 2, 3 and 4 of the control and experimental groups of particpants with moderate learning difficulties (MLD), it is evident that the experimental group improved significantly on all measures. The control group improved regarding knowledge of train travel (Instrument 3). See Table 1.

Table 1: Participants with Moderate Learning Difficulties
differences in absolute scores

	Instrument 2 Skills test (48)		Instrument 3 Knowledge trains (16)		Instrument 4 Train skills (70)	
	Experimental group	Control group	Experimental group	Control group	Experimental group	Control group
pre-test	39.80	42.22	9.53	11.87	25.27	30.13
post-test	41.47*	43.31	11.37*	13.44*	31.07*	32.19

Notes: Numbers in parentheses indicate maximum score possible for each test.
* indicates significance at $p < 0.05$ level; the score of the post-test is significantly better than the score of the pre-test (Wilcoxon test).

When the differences between the experimental and control groups are compared it is evident that the control group scored significantly higher than the experimental group during the pre-test, on instrument 2 (skills test). During the post-test, the control group scored significantly better than the experimental group on Instrument 4 (train skills). See Table 2.

Table 2: Participants with Moderate Learning Difficulties
differences in median scores

	Instrument 2 Skills test (48)		Instrument 3 Knowledge of trains (16)		Instrument 4 Train skills (70)	
	Experimental group	Control group	Experimental group	Control group	Experimental group	Control group
pre-test	41.00	43.00*	11.00	11.50	44.00	51.00
post-test	43.00	44.00	14.00	14.00	50.00	55.00*

Notes: Numbers in parentheses indicate maximum possible score for each test.
* indicates significance at $p < 0.05$ level; the average median score between experimental and control group for pre-test and post-test (Mann-Whitney test).

The experimental group failed to score higher than the control group on any of the measures. As mentioned earlier, there are difficulties in comparing the differences found between control and experimental groups involving such small numbers taken from such diverse populations. For this reason, more value is placed on the differ-

ences found between the pre- and post-tests rather than between the control and experimental groups.

Regarding participants with extreme learning difficulties (ELD), both members of the control and experimental groups showed substantial improvement in the skills test and knowledge of train travel (Instruments 2 and 3). In addition, the experimental group achieved significant improvement regarding skills in train travel (Instrument 4); see Table 3.

Table 3: Participants with Extreme Learning Difficulties
 differences in absolute scores

	Instrument 2 Skills test (48)		Instrument 3 Knowledge of trains (16)		Instrument 4 Train skills (70)	
	Experimental group	Control group	Experimental group	Control group	Experimental group	Control group
pre-test	34.20	28.70	7.45	4.90	41.15	40.05
post-test	38.50*	31.70*	11.50*	7.45*	49.55*	45.85

Notes: Numbers in parentheses indicate maximum score possible for each test.
 * indicates significance at $p < 0.05$ level; the score of the post-test is significantly better than the score of the pre-test (Wilcoxon test).

The differences between the control and experimental groups of participants with extreme learning difficulties are noted in Table 4. During the pre-test the experimental group scored significantly better than the control group in the area of train knowledge (Instrument 3). The experimental group maintained its advantage on this instrument during the post-test, even though the control group itself demonstrated significant improvement in this area. The experimental group also scored significantly better on the skills test (Instrument 2). No significant differences were found on the train skills test (Instrument 4). The relatively high scores of the control group can be explained by the fact that this group scored significantly higher on Instrument 1, a measure among other things of independent travel experience.

Table 4: Participants with Extreme Learning Difficulties
 differences in median scores

	Instrument 2 Skills test (48)		Instrument 3 Knowledge of trains (16)		Instrument 4 Train skills (70)	
	Experimental group	Control group	Experimental group	Control group	Experimental group	Control group
pre-test	37.50	29.00	7.00*	3.00	38.50	43.00
post-test	42.00*	33.50	12.00*	8.00	47.50	47.50

Notes: Numbers in parentheses indicate maximum possible score for each test.
 * indicates significance at $p < 0.05$ level; the average median score between experimental and control group for pre and post-test (Mann-Whitney test).

From these data it appears that no clear picture emerges regarding the learning effects of *The Station*. It appears that the experimental groups achieved significant improvement between the pre and post-tests. When these scores are compared with the control groups, however, then the improvement appears smaller. When consideration is given to the fact that the control groups already were better on the tests than the experimental groups, then it is fair to conclude that experience with *The Station* resulted in substantial learning improvement.

Several observations made during the first and second train trips are valuable to mention at this point. During the first train trip many children from both the experimental and control groups wandered around not knowing what was expected of them or what to do. During the course of the second train trip, however, a distinct difference between the two groups was evident in ability to act independently. Members of the experimental group went directly to the ticket window on arrival at *The Station* and made a purchase. Afterwards they walked with assurance to the departure and arrival boards, and knew which information they needed to search for. For members of the control group it remained uncertain what they were to do once they had purchased tickets.

Results: appreciation of *The Station*

The degree of pleasure with which participants with moderate learning difficulties (MLD) worked with the programme correlated strongly with the amount of concentration they were able to maintain during sessions. When the tasks were performed with much pleasure they also were able to concentrate well on the tasks. Their opinions about the programme varied and seemed influenced by particular conditions of the moment and other activities which they were required to perform.

A number of participants initially had difficulty with the programme, but this generally improved after a number of trials. Some participants continued to find certain tasks in the programme such as retrieving money from the wall dispenser and transferring trains. Although most participants could work independently with the programme, they appreciated the presence of an instructor or other personnel. The overall form of *The Station* was highly appreciated by the participants.

Participants with extreme learning difficulties (ELD) also generally appreciated *The Station*, and the level of concentration these participants were able to attain increased while working with the programme. Opinions regarding the difficulty of tasks varied from easy to quite difficult. Performing tasks without error, paying for a train ticket and flowers, and searching for the intended station on the lists of arriving and departing trains were mentioned as difficult exercises.

Instructors of the participants from both groups (MLD and ELD) felt that the CD-i title increased interest in and continued to motivate participants with aspects of train

travel. The programme approached the experiential world of these participants reasonably well, but the programme is better suited for participants who can already read reasonably well and count units of money. The programme stimulated both social contact and independent working habits. Finally, the programme seemed to increase self-esteem of participants.

Follow-up study

In 1996, three years after the above evaluation study had been completed, 6 of the 20 original participants with extreme learning difficulties were retested on retention of learning effects based on working with the CD-i programme. In this follow-up study participants worked with *The Station* for one hour. During this period they completed 3 assignments on average (mean time of 13 minutes per assignment).

Recognition of the programme was very high. Participants still knew the meaning of the icons used in the programme, and they experienced no difficulty in moving through the programme sequences. Further, they still knew how to use the bag, purse, and bank card. Buying a train ticket, flowers or a snack was relatively easy. They recognized the characters in the programme and reacted very positively towards them. This follow-up study suggests that the learning effects of the programme are quite stable and degree of retention of the programme is very high.

Conclusions

Development of an educational multimedia programme is not a simple undertaking. Findings from evaluations of the preliminary and beta versions of the programme suggested many aspects for improvement. Similarly, evaluation of version 1.0 also resulted in a list of points for improvement, and version 2.0 of *The Station* reflects these points.

Investigation of the effectiveness of the programme was also difficult. Learning is dependent on many factors, and it is difficult to isolate the influence of each factor in a research design. Moreover, it is important that the experimental and control groups can adequately be compared and that no contamination takes place between the two groups. Also, the manner in which a training period is completed – for example, the intensity with which the programme is used – determines to a degree the amount of learning effect which results.

In spite of these general research design difficulties, it is possible to conclude that the participants with learning disabilities experienced *The Station* with much pleasure and enthusiasm. By working with the programme improvement was observed regarding basic skills and those related directly to train travel. Furthermore, the participants expressed improved insight in aspects related to travelling, and performed

actions with more self assurance. The participants indicated in interviews that they felt more confident in travelling alone by train. And, as demonstrated in the follow-up study conducted three years after the experiment, learning effects appear stable and programme retention high. During this subsequent study, participants showed recognition of the programme, worked with concentration and motivation, and expressed joy and pleasure during the test.

This having been said, it is important to note that *The Station* is not meant to be a substitute for existing instructional materials and techniques, but is designed to complement them. Further practice in train travel is recommended for participants with learning difficulties, in addition to that provided by this programme. *The Station*, however, provides a simulated environment in which much of this practice can take place.

References

Borsook, T.K. and Higgingbotham-Wheat, N. (1991) Interactivity: what is it and what can it do for computer based instruction? *Educational technology*, 31,10: 11–17.

Klauw, C.F. van der (1992). *Het Station: Een interactieve microwereld*, research report, Rotterdam: Erasmus University, Department of Educational Technology.

Spierenburg, E.J. (1993). *Evaluatieonderzoek van het CD-i-programma 'Het Station' bij (zeer) moeilijk lerenden*, master's thesis, Rotterdam: Erasmus University, Department of Educational Technology.

9 Using CD-ROM Courseware in Distant Education

Rob Nadolski and Fred de Vries

Until recently, digital image processing could only be taught through interactive use of powerful and expensive image-processing computers. This centralized approach, along with the limited distribution of these computers, meant that only a small number of students could familiarize themselves with such systems and techniques. Recent advances in computers, disc storage and software have made training in image-processing possible for smaller institutions at greatly reduced cost. An important objective in the university course 'Remote Sensing; Basics and Environmental Applications' is that students should understand and acquire the necessary skills for manipulating and interpreting remotely sensed images. In order to achieve this objective the CD-ROM programme RESEAT was designed. This chapter describes the procedures for developing interactive media applications at the Open University (OU) of the Netherlands, and development of the application RESEAT in particular. Special attention is paid to the educational functions of these procedures. The results of a field test with the programme are also described, and the suitability of these design procedures for further interactive media development is considered.

The Open University (OU) of the Netherlands has an open admissions policy which means that no formal qualifications are required of applicants. Consequently, the student population of the OU is very heterogeneous regarding prior knowledge, study habits, motivation and situational circumstances. Students are also able to complete courses at their own pace.

The OU has been involved in developing course materials suitable for distance education for many years. These materials, mostly prepared in written form, are designed especially for guided self-tuition. When functionally required, (interactive)

media applications such as audio, video, computer, interactive videodisc, and CD-ROM have been included as part of the course materials. CD-i is not a technology which the OU supports as a matter of policy. CD-i was, however, employed on an experimental basis in the course General Toxicology (De Vries, 1991). Media applications of this and other courses are available in study centers around the country. Students can also use these applications at home in the event they have the required equipment.

Individual guidance in completing a course is given either by telephone or in person. In the near future computer networks are expected to play an important role in such counselling (see description of a similar development in chapter 10). From a very early stage in the design and organization of the OU, then, it was decided that electronic media and personal tutoring, in comparison with the primary role of printed material, should have a limited but vital place in teacher-student contacts (Gastkemper & Van Enckevort, 1985). Given this, integrated multimedia learning environments are anticipated at the OU in the near future. Currently, the OU is developing several courses in which extensive use of telematics takes place: electronic mail for tutor-student contacts, cooperation between students in groups via conferencing systems, and access to resources on the Internet.

PROFIL: Tool for developing interactive media applications

Computer Based Learning (CBL), as the term is employed here, refers to all computer programmes used by students in the context of the teaching and learning process. Interactive media applications are also included in this definition and are characterized by use of audio and video in an interactive mode. *Media application* refers to an instructional design programme with specific objectives for a specified target group in which one medium is the central and the most important carrier.[1]

Courses developed at the OU often consist of various media applications; the media in these applications are called the *media mix*. Clark (1983) correctly observes that people do not learn from media, but from the way media are used in an instructional design. In contrast to Clark, however, we believe some media are better suited than others when a specific educational design is implemented (see Kozma, 1991).

In this regard, staff at the OU have developed a procedure for such an educational design: PROFIL (PROduction method For Interactive Learning systems); see Koper (1990; 1995). The PROFIL approach to educational design stresses the following conditions:

1 For example, when we speak about an interactive video application, the medium interactive video plays a central role but there could also be some printed material and/or co-counsellorship that is part of the instructional design program.

- systematic developmental procedure should be employed;
- media should also be selected systematically;
- the elements of a multimedia course should be integrated;
- the methodology should be compatible with different didactic models and programming techniques;
- projects should be a result of multidisciplinary development teams, with the educational technologist playing a central role;
- the technical structure and user interface should result from the didactic design;
- script production should proceed actual course programming;
- the methodology should not restrict the programming approach.

The PROFIL design procedures are enacted in a series of six phases, each with its own products; see Table 1. In the first phase, the *preliminary investigation*, the course is designed and media applications are selected. A selection is made from various media application alternatives. For each alternative the objectives, target group, didactic scenario and media are described. The selection is based on functional, economic, theoretical and policy factors. This results in the media mix for the complete course. The following phases are completed for each media application in the media mix. In this chapter, however, discussion is limited to development of CBL.

In the *definition* phase, didactical analyses of the media application and the technical structure are carried out, and the user interface of an application is inferred from the didactic design. This more detailed analysis of the didactic scenario results in a description of the functional objects, the relations, the communication channels and processes. For every functional object an implementation is specified. The communication channels between objects are also specified (e.g. from speech to text).

In the *script* phase, the behavior of the various objects is described in detail in a script language (e.g. Inscript; see Koper, 1989), and various design aspects (e.g. databases, screen design) are worked out in detail. Discardable prototypes can also be used to facilitate communication among members of the course team. The outcome of this phase is a full functional description of the programme, and the programme is adjusted to the other media applications.

The *technical realization* phase includes technical and formative testing. The script forms an input for the technical design of the programme. The programme is implemented and testing continues until a sufficiently bug-free version has been attained. Some of the software used in this phase includes Windows (3.1), Toolbook and Turbo Pascal for Windows. The technical realization and the functional design of the user interface should adhere to the CBL house style in which general guidelines are described with respect to user interface, graphic design and Standard Objects CBL (SOC's). At the end of this phase, a formative evaluation (field test) is carried out and the results are implemented in a 1.0. version of the programme.

In the *implementation* phase, the 1.0 version of the programme is distributed among OU study centers. If usage at home is possible and permitted, the programme is also copied for students. In this phase, counsellors and staff of the study centre are informed of the programme availability and trained in its use.

Finally, in the *exploitation* phase, support, evaluation and maintenance play an important role. Log files and electronic questionnaires are used to gain information about usage and appreciation of the programme. Usually, this data serves as input for future revision. Normally, such revision takes place after five years of operation.

Table 1: Phases of PROFIL

PROFIL phases	Products
1. Preliminary investigation a. analysis of intitial situation b. generating alternative media applications, considering objectives, audience, didactical scenaria and media mix c. chosing media application	Synoposis (course description)
2. Definition (1st design phase) a. further didactical analysis and specification of design for media to be used b. specifications for media application	Definitions
3. Script phase (2nd design phase) a. 1st concept of script b. final script version	Script
4. Technical realization a. realization of version 0.9 b. testing & implementing version 1.0	Working prototype
5. Implementation a. documentation b. distribution c. training	Documentation Training programme Implemented version
6. Exploitation a. support b. evaluation & maintenance	Evaluation report

Application of PROFIL to CD-ROM RESEAT

The course 'Remote Sensing, Basics and Environmental Applications' (RESEAT) is intended to familiarize users with the potential of remotely sensed information in the context of the natural sciences and current socio-economic and environmental problems. It also serves as the foundation on which other more specialized courses in the environmental sciences can be set up when there is need to use remotely sensed data in illustrations and exercises (Leinders, 1992). The OU does not offer a complete training programme for remote sensing, but regards this skill as an important secondary subject in the environmental sciences.

An important objective of the course is that students should understand and acquire skill in manipulating and interpreting remotely sensed images. This objective can be divided into two components: manipulation and interpretation. In order to be able to adequately interpret images there should be a wide range of images available from various parts of the electromagnetic spectrum. Before interpretation of images is possible one or more operations (manipulations) must be performed with the aid of a computer. To gain insight into the manipulations and corresponding effects, students should be able to perform these operations by themselves. This is a prerequisite to interpreting the images properly.

Given the above conditions, the objective can only be fully achieved with the aid of an interactive media application. Therefore, it is necessary to integrate the concepts of remote sensing in the various written materials. Before students can master the required skills they must first have awareness of prerequisite knowledge. In other words, integration precedes application. In the course lessons this type of integration is strived for in accordance with the mastery learning theory developed by Bloom (1968). This theory makes use of case studies. Because of the required

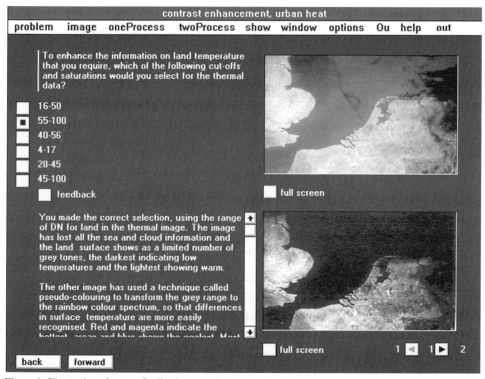

Figure 1: Illustration of course feedback

Note: This illustration of a computer screen shows the feedback provided to a student who answered a particular question in one of the lessons. The image in the lower right corner is part of the feedback; the image in the upper right corner refers to the posed question.

presentation facilities (database with remotely sensed images) and the simulation facilities, a computer is necessary for presenting these cases. The cases are designed to evoke activities from students experienced as useful and realistic. In the practical exercises in the course case studies are used in which learning theory from Galperin (1972) serves as a guideline.

Apart from the functional factors mentioned above, economic and policy factors can also be identified. The range of required color images for all of these factors, however, is so large that no book or printed course is able to adequately do the job. Because the computer disk which contains the library of images is only accessible for a relatively small number of hours per user (12 hours), it is important that a minimum number of images be included in the written material. As the course is designed for an international market, help functions are provided in a separate booklet available in both Dutch and English. This publication also contains background information on each of the case studies found in the practical section of the course as well as a global description on how the programme is organized.

Theoretically, there were two alternatives for the interactive application meant to accompany this course. Inasmuch as it was only necessary to have a disc on which to store images and audio, the disc to be chosen could be an interactive videodisc (IV) application or a CD-ROM. An advantage for chosing an IV application was that expertise in development and production was already available at the OU. Moreover, OU study centers are equipped to use this medium. The main main disadvantage, however, was that the medium is mainly reserved for institutional use and is not anticipated to penetrate the home market.

A CD-ROM application has several advantages: use of digital data, relatively cheap to update versions, and the data are easily transferable to another platform. Disadvantages included lack of expertise at the OU in development and production of CD-ROM, and the study centers were not equipped with the required hardware. Given these considerations, a final decision was postponed regarding multimedia platform. At the same time, though, design specifications were refined which would allow the title to be produced on various platforms.

This preliminary investigation resulted in the following course materials: two course books, two color books and a student aid (printed material), and a planned CD-ROM or an interactive videodisc (electronic material). Two separate course books and color books were needed because the course was intended as a revision and extension of the already existing course 'Remote Sensing' which consisted of one course book, one color book and an interactive videodisc application. This interactive videodisc contained the image atlas and a differently designed section with lessons. It was decided to adopt and modify the already existing material from this videodisc for the new, to-be-produced electronic material.

As already mentioned the PROFIL procedures and phases are applied to the design and development of all course materials. In the next section, details are only given regarding application of PROFIL to RESEAT.

RESEAT's didactic scenario

The RESEAT programme is designed in such a way that it can be seen as a replacement of a practical course and is further suitable for self-tuition. Most of the educational functions proposed by Van den Boom and Schlusmans (1989) are fulfilled by the computer programme with respect to the objective 'students understand and have the necessary skill in manipulating and interpreting remotely sensed images.' However, the educational function 'guiding the study' is fulfilled partly by a student aid in which the objectives are stated and in which a recommended way for working with the programme is sketched. In addition, background information for each exercise is included to introduce the content. The educational functions 'activation and practicing', 'motivating' and 'evaluation and feedback' are fulfilled by the computer programme.

In the *lesson* part of the course the various concepts in the field of remote sensing are treated. As a result, students learn how to interpret remotely sensed images. In this programme the student can follow individual lessons from an electronic teacher. The teacher presents information by means of text/images, asks questions, gives feedback and gives some additional information about an image or about a technical term on request of the student. This additional information can be textual or sound. Questions may consist of textual information and/or images. Multiple-choice questions as well as open questions may be employed. Teacher feedback on these questions can consist of a textual response with or without images.

In the *exercise part* of the course students learn how and when to apply the various image-processing techniques in order to detect some specific phenomena on remotely sensed images. They are able to work on 'real world' problems such as coastal management, phytoplankton control and pollution.

In this section of the programme the student acts as a trainee in a remote sensing consultancy. In each exercise the student gets a so-called Global Task from an (electronic) teacher. While working this out the student can use the various image-processing techniques in the electronic laboratory, and there also is an (electronic) colleague available. This colleague can assist the student in solving the Global Task through the use of questions and feedback.

While working out the Global Task the student may complete an electronic report. When the student has carried out the Global Task he receives feedback from his teacher in the form of an idealized solution. The teacher formulates the Global Task

in text and places some source material – such as text, locality maps, graphs and tables – at the student's disposal. The conversation between student and colleague is included in the text. The type of questions, multiple choice or open, are the same as in the lesson part of the exercise, and only contain textual material; this is also the case for the feedback material provided.

In the exercise 'using the laboratory' a fictive electronic colleague assists the student in working with laboratory equipment. In the other exercises the student has to concentrate on the content of the case. In solving the Global Task the student should make notes on how to consider a remotely sensed problem in order to be able to extract a more general strategy for solving it. For this purpose, the conversation between student and colleague is part of these notes. The electronic report consists of two chapters; the chapter 'notes' and the chapter 'task'. In the chapter notes the student can edit his notes when solving the Global Task. When solving a problem the student has to use various functions for interpreting images in the laboratory. If he thinks an image result is suitable then he can also add it to his notes in the report. In the chapter 'task' the student can formulate answers to the questions posed in the Global Task.

It is possible for a student to look at his notes and at the same time at his/her answers to the various questions of the Global Task. The student can also receive feedback on one of the questions in the Global Task. In this case, the feedback consists of textual material. The student can also request feedback on the performance of the Global Task as a whole, but then the feedback consists of an audio summary in which various images are used to show the intermediate or end results when working out the Global Task. The student can compare these with the images in his own report.

This definition process results in creation of three sections for materials in RESEAT: lessons, exercises and an image atlas. The lesson section deals with the main techniques of image processing. In the exercise section the student is asked to apply the various techniques in a number of case studies and to interpret the results. In the image atlas the student may view a variety of phenomena detected by remote sensors.

Characteristics of RESEAT

The programme RESEAT contains context help, 'hot words' (hypertext), and audio material. As in all OU interactive programmes, special attention is paid to the development of a clear and easily understandable user interface, reflected in the design of the didactic scenario. So-called 'hot words' are used inasmuch as students often differ with respect to their prior knowledge of the subject matter. Because the programme is designed for self study a context help is included which makes it possible to anticipate students who differ in prior knowledge with respect to computer usage.

Apart from this aspect, the context help can also assist students by making them familiar with the programme. However, students are expected to have some basic understanding of the Windows interface. Other elements in the programme which make it possible to serve students with a different prior knowledge are terminology and task lists. In the terminology list students can look up unfamiliar words. In the task list students can look up explanations on how to carry out specific tasks by making use of the programme.

We have tried to indicate that the functionality of the programme is derived from the specific educational situation for which it was designed: distance education, self-study, functions derived from both the content and educational approach. For example, the programme consists of only those image-processing functions that are necessary for solving the cases in the various exercises. This is the primary reason why RESEAT is unable to compete with a real image-processing package.

Field test of RESEAT

A field test was conducted of the exercise part of the programme. The lesson part and image atlas were improved using the results of the field test conducted with the interactive videodisc in 1990. This version of the field test did not contain 'context help' and some other aspects of the help functionality.[2]

Four general concerns guided the design of the field test. First of all, it was important to determine the suitability of RESEAT for self-study. Second, information was desired on the planned help functions (context help, task list); to what extent were they necessary and what should they contain? In this regard, the field test was meant to determine the user friendliness of the programme. Other points of concern included the degree of use students made of particular aspects of the programme, the amount of study time required by the programme and whether the programme was free of technical bugs.

The field test was conducted under 11 students (9 male, 2 female) selected from a group which had completed the final examination for the course in February 1993. They had, at that point in time, recently completed the earlier version of the course 'Remote Sensing'. In addition, students were selected who had already studied new course material and planned to take the examination later in the same academic year (May 1993). All 8 students from the first group were asked to take part in the field test; 5 consented. A letter was sent to the second group of students (57), of which 6 were selected. Five students had no experience with graphic user interfaces (GUI) and mouse control. The 6 other students did have experience with GUI and Windows.

2 The field test was performed with 386-processor (20 Mhz) computers. Students were advised, however, to acquire computers with 486 processors if they plan to use this courseware.

The material for the field test consisted of the written material for chapters 9–11 (coursebook 2 and color booklet 2); the student aid; and the electronic material, the exercise part of RESEAT. Students completed questionnaires regarding the learnability of the study material. In order to study RESEAT the students had to visit the Centre for Educational Technology of the Open University. User observations were conducted for 7 of these students. Each student was instructed at the beginning of the computer session and asked to complete a questionnaire at home after having worked for a 4-hour period with the computer programme. All of these questionnaires were returned.

Results

Students used more or less all parts of the programme, depending on which exercise was being completed; see Table 2. All students made use of the colleague and report options. Observations of students' behavior suggest they only made use of the colleague option when unable to find a solution on their own. In the report option the chapter 'task' was more often used than the chapter 'notes'. Because the solution to the problems in each exercise requires use of the look-up table (LUT) and palette options, these were used frequently. Not every student used the feedback option in the audio resumé. However, when used, the solution to the problem became much clearer to those students. Some persons indicated they had to use the student aid when learning to work with the programme, which was confirmed by researcher observations. Students also said the programme offered enough guidance to solve the central problem in an exercise.

Table 2: Example of Student reponses

Question 6: Can you indicate the extent to which you used parts of the programme?					
never				very often	
1	2	3	4	5	
One process techniques	3	3	3	2	0
Two process techniques	3	3	3	2	0
report option	0	0	9	1	1
colleague option	0	2	2	5	2
LUT option	0	0	3	5	3
palette option	0	1	5	2	3
context help*	–	–	–	–	–
task list*	–	–	–	–	–
terminology*	–	–	–	–	–
audio resumé option	1	5	4	1	0

Note: The frequency of each answer is scored in the table for the total number of respondents (N= 11).

*The field test did not contain items content help, task list and terminology

Most students had no need for personal support. They also indicated they had no problems answering questions in the Global Task or from the (electronic) colleague.

The feedback to questions was clear and adequate. All students stated that the student aid offered enough information to work with the programme, but two persons mentioned they lacked adequate geographic knowledge (i.e. some locations were not known). Almost all students indicated ability to control the programme well, although a few had some initial problems. The reason for this could be that they did not study the 'introduction to the exercises'.[3] A few students encountered technical problems while working with the programme. It is expected that once the help function is fully implemented such problems as these will be reduced.

Almost all students were satisfied with the quality of the images, readability of the texts, use of colors and sound. Any complaints about the quality of a picture were, in fact, already known prior to the field test. Several students complained about the slow speed of the computer programme (N=5), even though they knew the field test had to be conducted on such slower machines.

Some students indicated they did not study all of the exercises. The average study time for each exercise was less than one and a half hours. The study time for the first exercise was always considerably longer (average of 2 hours). When writing out the first exercise the student has to learn to work with the various possibilities of the programme. It is estimated, based on these results, that the total study time for the exercise part would be about 7 hours. Use of faster computers may decrease this amount of time somewhat.

Observations of students made clear that their study habits differed considerably. Most tried to experiment with the programme, especially with the functionality of the laboratory. Some tried to solve problems without assistance from the electronic colleague, others made use such colleagues quite often. It seems that experimenting was encouraged by students with familiarity with graphic user interfaces. Students who already had experience in using Windows experimented more than those lacking such background.

Using the programme was not a problem for students familiar with Windows. There were, however, some starting problems for students not familiar with a Windows environment and mouse control. Generally, these students did not follow the advice given in the student aid to examaine the programme 'Intro Windows' first before studying 'RESEAT'. All students were pleasantly surprised by the fact that they had to do so much on their own (active participation) when working with the programme. When students encountered problems concerning the control of the programme they were generally solved through use of the help function.

3 One student did indicate this as the reason for his initial problems and another student indicated he
 did not know how to work with Windows.

Conclusions

Students enjoyed working with the exercise part of RESEAT probably because an active attitude was expected from them. However, experience with Windows turned out to be valuable in order to to benefit most from the programme's functionality. Problems concerning the user interface were adequately explained with the context help function. Students seem to have different study habits, but such differences did not lead to different solution of the problems in the exercises. The degree of difficulty of the problems treated in the exercises seems adequate for students having completed the chapters of the written material of the course. The study time that was measured slightly exceeded the expected study time. Overall, however, the study time remained within the regular 100 hours planned for the course.

References

Alessi, S.M. and Trollip, S.R. (1986) *Computer-based instruction: methods and development*, Engelwood Cliffs, NJ: Prentice Hall.

Bloom, B.S. (1968) Learning from mastery, *Evaluation comment*, 1, 2, University of California, Los Angeles.

Boom, W.J. van den and Schlusmans, K.H. (1988) Een cursus ontwikkelen volgens het leereenheden cursusmodel van de Open universiteit, report, Heerlen: Open universiteit, Centrum voor onderwijskundige produktie.

Boom, W.J. van den and Schlusmans, K.H. (1989) The Didactics of Open Education-background, analysis and approaches, research report, Heerlen, Open University, Educational Technology Innovation Centre.

Bork, A. (1986) Pedagogical development of computer-based learning material, in: A. Bork and H. Weinstock (eds.) *Designing computer-based learning materials*, Berlin: Springer.

Clark, R.E. (1983) Reconsidering research on learning from media, *Review of educational research*, 53, 445–459.

Galperin, P.J. (1972) 'Sovjetpsychologen aan het woord,' in: C.F. van Parreren and J.A. Carpay (eds.) *Sovjetpsychologen aan het woord*, Groningen: Wolters-Noordhof.

Gastkemper, F. and Enckevort, G. van (1985) *The use of media in education at the Dutch Open University*, Heerlen: Open University.

Hartemink, F.J. (1987) Handleiding voor de ontwikkeling van educatieve programmatuur, report, Enschede: COI.

Koper, E.J. (1989) Inscript: een scripttaal voor het systematisch ontwerp van interactieve leersystemen, research report, Heerlen: Open University, Educational Technology Innovation Centre.

Koper, E.J. (1990) De ontwikkeling van computerondersteund onderwijs aan de Open universiteit, COP document, Heerlen: Open University.

Koper, R. (1995) The PROFIL, a method for the development of multimedia courseware, *British journal of educational technology*, 26,2: 94–108.

Kozma, R.B. (1991) Learning with media, *Review of educational research*, 61: 179–211.

Leinders, J.J., et al. (1992) Course description 'Remote Sensing Basics and Environmental Applications', Heerlen: Open University.

Merrill, M.D. (1983) Component display theory,' in: C.M. Reigeluth (ed.) *Instructional design theories in action*, Hillsdale, NJ: Lawrence Erlbaum.

Vries, F. de and Niesink, R. (1991) CD Interactive as a self-study alternative to a science practical at the Open University of the Netherlands, in: F. Le Fevre, C. Nagtegaal, and G. Peper (eds.) *Proceedings ETTE '91*, Amsterdam: Vienna Novep.

10 Hortonomy: On-line Programme for University-level Education

Peter Linde

Increasingly higher demands are being made of employees, requiring them to contend with problems. This trend means students need to learn other skills in order to adequately cope with these expectations. And that means methods of learning – and education generally – deserve reexamination. The objective of this chapter[1] is to contribute to this search for new approaches to university-level education with the aid of multimedia and other new communication technologies. Questions raised here are: what are the characteristics of the ideal learning environment, and what consequences does introduction of new communication technologies have for both instructors and students? These and similar questions are considered in this chapter through examination of a single case of educational innovation developed at the University of Wageningen in the Netherlands. Called Hortonomy – a term referring to integration of horticultural, economics and education – the pilot project involves utilization of multimedia and network technology as supportive and complementary educational tools.

The Department of Horticulture at the University of Wageningen is responsible for courses providing students with knowledge of and awareness in various sectors of the study, such as glasshouse and open-field cultivation. In 1993 the department initiated a project called Hortonomy as a method to integrate eight of these courses into a single new course of study designed for second and third-year students (Berghoef, 1993). The general objective of this new course was that students were to learn how to cope with overall issues and problems encountered in the horticultural production chain.

This intention[1] required a change in the basic educational model then operational: from *subject-based to problem-based learning*. In the situation in which eight separate courses were taught, expertise was generally conceived in terms of content, based on the idea that to be an expert is to have command of factual content. In the new course attention is placed on acquiring cognitive skills. Problem-based learning emphasizes the ability to gain propositional knowledge as required and then apply it to specific situations. Expertise here is seen as the ability to make sound judgements as to what is problematic to a situation, to identify the most important problems, and to know how to go about solving or at least reducing these problems (Margetson, 1991).

Wilkerson and Hundert (1992) suggest that problem-based education involves, in addition to learning problem-solving skills, the following:

- awareness of the complexity of real-world issues;
- acquisition of or exposure to a body of knowledge;
- motivation for learning through use of profesionally-relevant materials;
- capacity for self-directed learning.

The initial plan for developing the general studies course noted above was to develop a self-instruction computer-assisted educational programme on CD-ROM (Joziasse *et al.*, 1994). This programme was envisioned to contain a database with basic information on horticultural cultivation and an educational module in which students could learn through exercises and assignments how to make effective use of the database information.

During development of the project, however, the possibilities of Internet for acquisition of information became apparent, and it was decided to utilize this on-line facility. One of the considerations in this transformation was realization that there was little reason to 'conserve' the knowledge on agricultural cultivation within the university department onto a CD-ROM given the possibilities for rapid on-line data exchange with similar horticultural centres elsewhere. Moreover, access to these databases is relatively easy for students, independent of the place or time at which they are studying.

On-line learning via the Internet

The Internet is a very complex, dynamic, distributed aggregation of more than 45,000 autonomous networks. In order to measure the growth of the Internet, regular surveys are being made to discover active Internet hosts. The third quarter of

1 The author is indebted to all members of the team which developed Hortonomy: H. Smolenaars, M. Jaspers, R. Verbeek and the staff of the Department of Horticulture, in particular J. Berghoef and M. Joziasse. The author also wants to express his thanks to C. Blom from the Department of Agricultural Education of the University of Wageningen, and Inge Riemersma for their critical comments on an earlier version of this text.

1994 showed an overall growth of 21%, the highest rate of growth recorded to date. On the basis of these figures the projected point at which the number of Internet hosts will reach 100 million is estimated to be in early 1999.[2] These numbers do not discriminate towards type of use, nor do they give a good impression of the volume of the 'traffic' involved. However, the rapid growth of the number of Internet hosts provides a fair impression of the potential reach of the network.

According to Rutkowski, Internet offers ready access to significant knowledge-building tools and capabilities. She considers the Internet as a teaching space rather than a teaching tool. Internet is a global intelligence community and, as such, offers all learners, independent of age, access to information from around the world, both in a raw and unprocessed form as well as in enhanced forms, like that provided by World Wide Web (WWW) (Rutkowski, 1994).[3]

Internet further provides the possibility of eliminating time and place limitations with 'tools' for simultaneous and delayed communication by both groups and individuals. The primary tool for delayed or asynchronous communication is electronic mail (e-mail). With the aid of e-mail students are able to participate, for example, in discussions or conferences. A discussion list is, in fact, an electronic address with a distribution function plus an archive of previous contributions to the discussion. E-mail is text-based, low-tech and hence widely used for distance education.[4]

Video conferencing is an example of a tool for simultaneous or synchronous communication that uses both audio and video. The potential for educational use of the Internet, applying this kind of functionality is enormous. A pilot for conducting remote seminars using video conferencing techniques via the Internet has been implemented, using the so-called multicast backbone (Sasse, *et al.*, 1994). The pilot however, clearly showed that there are still many (technical) limitations to overcome. These limitations refer to the fact that the bandwidth available to an endpoint over the Internet is a dynamically varying quantity. This means that a dramatic degradation in performance will occur as the total network load increases. The pilot proved that low quality video is considerably less disturbing to an audience than bad audio; the audio thus being the most critical medium in a conference. Yet the audio is most likely to suffer from congestion on the Internet. The current network infrastructure does not allow for large scale implementation of desktop video conferencing due to technical limitations and the limited bandwith available.

2 Information regarding the growth of Internet is maintained by the Internet Society; see http://www.isoc.org.

3 WWW has rapidly become the de facto standard for the on-line distribution of multimedia course content by numerous educational institutions all over the world. For an overview see a compilation made by Steve Eggleston; http://www .access.digex.net/~nuance/index. html.

4 DEOS-L (Distance Education On-line Symposium) is a discussion list about topics related to distance education; In addition to discussion on all kinds of actual themes, the user can use the list to gather or give information about electronic classes.

However, as of early 1996 Wageningen Agricultural University is participating in a two-year project within the EU Telematics Applications Programme. This project, called Aquarius, involves universities in Wageningen, Gent and Trondheim which plan to develop a pilot of a European Education/Training and Information Service. In order to overcome current limitations, this service will be based on the integration of new broadband communication protocols (e.g. ATM) and the related tools in the academic infrastructure, thus enabling students and lecturers to ingage in synchronous communication (e.g. desktop video conferencing) as well as asynchronous communication (e.g. video-on-demand).

A new development with many educational possibilities both for synchronous and asynchronous learning are the so-called MOOs (Multi-user dimension or domain, Object Oriented).[5] The term refers to the fact that many people can simultaneously connect to an Internet address and find themselves in a space described through the objects within it. For instance, a collection of rooms where people or things can interact with objects; objects being a text-based description of events that may occur, like going from the one room to another, or feedback from a 'virtual' teacher. A MOO, in addition to being a conferencing environment, is also an environment where users can create and build interactive objects themselves.

It is possible, for instance, to conduct collaborative on-line information searches from a MOO. Another option is to use a MOO in game-like settings (MOOs are an out-growth of the game 'Dungeons and Dragons'), by having one group of students play one side, defending their positions and practices, and other groups playing opposing parties. In this manner, it is possible to simulate a public policy and private practice debate, for instance, related to environmental problems. The debate is conducted in an open forum but structured as a MOO and not simply as a free-flow conference. Distance educators consider MOOs a valuable means for enhancing existing distance education delivery systems.

The 'ideal' learning environment

Much current educational research is concerned with how learning takes place and which factors can enhance cognition, in order to understand how this process can be facilitated. The socio-historical school, an approach which influences much of the work in this area, postulates that learning is both an individual, self-directed activity as well as a social endeavour (Teles, 1994). The implication for educational practice is that collaboration and group interaction should be actively supported to promote learning. Individual learning can be combined with coaching, peer interaction, and collaborative work to encourage social learning interactions with instructors, peers, mentors and experts.

5 This text on MOOs is a compilation of the contributions of Thomas Danford, Paul Bowers and Sam Lanfranco to DEOS-L between 10 and 13 December 1994 in reply to a posting <what is a MOO?>. An example of an educational MOO is Collegetown located at next.cs.bvc.edu 7777.

The 'places' where learners and their instructors, mentors, or peers interact are called learning environments. These environments are shaped by participants according to various approaches to instructional design, moderating and self-paced learning. When designing or evaluating learning environments, four dimensions and their respective characteristics should be considered: content, methods, sequence and sociology; see Table 1.

According to Teles (1994) these dimensions and characteristics are important design factors supporting knowledge-building in on-line learning environments. Although learning is mediated by the computer, the process itself is composed of human interactions that must be detailed and provide collaborative instances. A carefully designed environment that provides instances of collaborations, coaching, feedback, reflection and exploration is essential to support on-line learning.

Table 1: Characteristics of an ideal learning environment

Content	Methods	Sequence	Sociology
Domain knowledge	Modelling	Increasing complexity	Situated learning
Heuristic strategies	Coaching	Increasing diversity	Culture of expert practice
Control strategies	Scaffolding	Global or local skills	Intrinsic motivation
Learning strategies	Fading		Exploiting cooperation
	Articulation		Exploiting competition
	Reflection		
	Exploration		

Source: Teles, 1994

Kraut *et al.* (1988) assert that the main technologies which have been developed so far to support group work have been largely unsuccessful because they do not adequately support productive personal relationships, and focus primarily on task completion. According to these authors, cooperative projects consist of diverse phases in which activities related to tasks as well as activities regarding relationships exist. The diversity of goals and tasks that characterize each phase of the process calls for a rich palette of collaborative tools from which to chose. What is needed are tools and methods which also support personal contact, since this is the 'glue' binding the collaborative process.

Hortonomy as an integrated learning environment

The pilot version of Hortonomy is an integrated learning environment (Joziasse *et al.*, 1994) that consists of two components: a computer-based information search and retrieval shell in which multimedia and network technology support and complement educational objectives, and a number of scheduled and voluntary 'live' meetings where students and instructors meet. In the Hortonomy environment, students work individually as well as in teams in learning to analyze and solve horticultural problems.

The course is structured by a number of scheduled, plenary meetings in which the teaching staff introduces new topics and initiates the knowledge acquisition process of the students by giving them assignments to solve particular problems. Each assignment builds on previously encountered assignments, thus structuring and steering the knowledge building of the students. The students collaborate on the assignments in (sub)groups of four. One of the tasks of these teams, is to analyze the problems within the assignment and formulate tasks which can be completed individually. Subsequently, the individual work consists of searching and processing information that is relevant to the assignment, and can be done independent of time and place. The student collects information via a specially developed computerized information search and retrieval shell giving access to all kinds of databases, both local and on-line. To be useful the information must be processed, gathered, indexed, sorted, stored and retrieved. This process involves developing criteria for selection, cultivating sources, and determining the reliability of these sources.

After the students have completed their individual tasks, they will plan a group meeting in order to make a synthesis of the individual work. This allows members of the subgroup to analyze and evaluate the information gathered individually, to evaluate the collective set of material and thus create a new original body of knowledge related to solving the problem posed in the assignment. Once finished, the team prepares a collective presentation to the next plenary session where the quality of their work is judged by their peers and the lecturer.

To support the educational methodology described above, students use the specially-designed Hortonomy shell. The shell gives access to several documents and functionalities. First, there is an individual work or information processing document to store the results of the individual work. Second, there is a document that gives an overview of the assignments that form the structure and 'engine' of the course element; see Figure 1. Furthermore students can access the group or multimedia document. Towards the end of the course, this multimedia document represents the knowledge domain students have mastered; during the course students can refresh prior knowledge needed to fulfil a new assignment from it.

Next, the shell also offers access to locally and globally available information databases. These databases vary from a horticultural database developed especially for the project containing prerequisite knowledge such as basic physiolotgical processes, to information databases available through Internet. The information available in the databases can be text-based, but it can also be an audio track, a digitalized film or still image. This so-called multimedia environment constitutes a plus value compared with text-based systems, since images can contribute to the effectiveness in the search for creative solutions to problems. Working with images is especially valuable in learning processes in which becoming aware of all the facets of a particular problem is important and when all kinds of loose pieces of information need to be brought together. In a visual presentation it is possible to simultaneously imag-

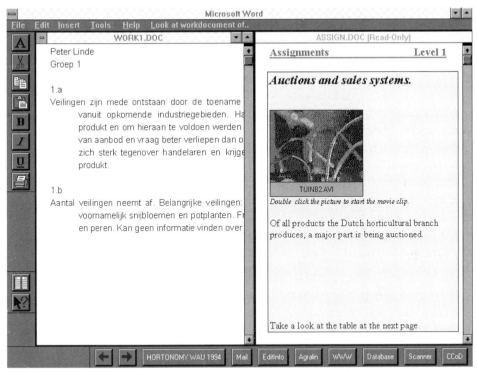

Figure 1: Illustration of screen in Hortonomy course

ine various characteristics of a problem situation. In this manner it is possible to connect aspects which would be difficult or impossible to relate through language alone (Linde, 1994). The shell supports transfer of information between the databases and the individual working document by means of a copy and paste command. Finally, students can gain on-line access to library catalogs and *Current Contents* on disc.

In order to support the collaborative work the shell facilitates asynchronous group communication by giving students the possibility to access the individual working documents of their team members. Thus, they can check on the findings of their peers and make annotations if needed. There is also an e-mail facility, for instance, to plan a meeting of a sub-group, and to communicate with the 'outside world'. The lecturers, in turn, can use the e-mail facility to answer student questions and monitor progress. They can use the shell to search and retrieve recent information when preparing a new assignment.

Role of the instructor

Problem-based learning encourages open-minded, reflective, critical, active and competetive learning. This can be a threat to those who prefer passive students in circumstances where the teacher has maximum control over what is to be learned

and sees loss of this control as loss of power. According to Margetson (1991), problem-based learning requires a change of attitude on the part of teaching staff, because with problem-based learning both student and teacher are seen as persons with knowledge, understanding, feelings and interests who come together in a shared educational process. Teachers who undergo a shift to a problem-based mode of teaching are also faced with the need to reexamine the several roles they fulfil in the teaching process. Wilkerson and Hundert (1991) suggest there is a shift in accent from a teaching role as knowledge disseminator and evaluator as practised in subject-based learning, to one of mediator in a problem-based learning approach. That is to say, the instructor must take on the role of intermediary in conflicts between students in order to support productive personal relationships. These conflicts may relate to simple differences of opinion regarding content, differences in values, feelings of competition. Thus, at the relationship level, the role of mediator is essential for the maintenance of a safe learning environment, a prerequisite to the accomplishment of any other learning objective.

At the task level instructors should support students as apprentice knowledge builders in acquiring critical research skills and attitudes (Farber 1994). This is especially true when students use information that originate from Internet.

> Navigating on Internet with software like Mosaic or Netscape, one may feel like touring in Wonderland. However, one should not confuse the 'roads' with the 'goods' being transported. These Internet facilities are, indeed, good roads – the best 'highways' seen up to now – but there is no quality control on the goods; nor are their intelligent road signs. Thus, students need guidance in finding and selecting information, particularly since the information comes in overwhelming quantities. (Farber, 1994:76)

Lecturers need to support the students to become information literates. This aspect is cogently formulated by the Presidential Committee on Information Literacy of the American Library Association:

> To be an information literate, a person must be able to recognize when information is needed and have the ability to locate, evaluate and use effectively the information needed. Ultimately information literate people are those who have learned how to learn. They know how to learn because they know how knowledge is organized, how to find information, and how to use the information in such a way that others can learn from them. They are people prepared for the lifelong learning because they can always find the information needed for any task or decision at hand. (cited in Fjällbrant, 1994)

Theory in practice

Since development of the project, 10 foreign masters-level students have been exposed to the Hortonomy integrated learning environment. All of these students

have had work experience prior to enrolment at the University of Wageningen. This group was generally positive regarding use of the computer as an on-line information search and retrieval device, as compared to the problem-based approach. The group, however, cannot be considered representative of most students in the Department of Horticulture inasmuch as they are older and generally more motivated than other students. A research project is currently being designed to test the information system among a sample of a larger, more representative group of students.

The staff of the department and the development team are both convinced that instruction can take place more efficiently with more flexibility thanks to the approach. Rather than the present six instructors, in the future the course can be taught with two instructors. Moreover, students will be to a large degree able to complete the coursework at times and places convenient to them.

There remain, however, many uncertainties, and the two most important are:

- To what degree are students able to work according the developed concept of the integrated learning environment? There is uncertainty, in particular, whether students will be able to provide sufficient self-discipline to complete exercises within the prescribed time. And, at least one instructor has strong doubts on the ability of students to work constructively in a group.

- To what degree is adequate information offered via the hortonomy database, or to what degree are students themselves able to search for the information elsewhere, e.g. via Internet? The instructors prefer to the extent possible, that information be contained in the Hortonomy database. In addition to substantive considerations (e.g. required prior knowledge), another aspect which plays a role here is that instructors are themselves insufficiently informed or have little experience in searching for information via Internet. They are, moreover, concerned that students may be overwhelmed by the large amount of information, often irrelevant to the task at hand, available on Internet.

Instructors have generally accepted the situation that they will be fulfilling another role in the education process. Plans have been made for providing instructors with consultation and training in this new role as mediator in supporting productive personal relationships) and the role as guide (in making students information literate).

Finally, the instructors will be assisted in preparing assignments by an educational technologist. The quality of the assignments does, in fact, to a large degree determine whether the learning objectives are achieved and whether the implemented tools and educational methodologies are successful (see Teles, 1994).

The project is good example of the way multimedia and network technology can be used in an academic educational setting.[6] The project demonstrates that a tool like the learning environment described in this chapter can be adapted to other disciplines besides horticulture and may, in fact, be generic in character. With the future option of students joining in from abroad – through, for example, video conferences – the concept of a full on-line learning environment can be realised. The basic question here is whether video conferences can adequately support personal contact in 'virtual' group meetings and 'virtual' plenary sessions. The future student may, indeed, be spending most of his/her time during a course in a multimedia environment like a 'HortonoMOO'.

References

Berghoef, J. (1993) Hortonomie, internal document, Department of Horticulture, Wageningen Agricultural University.

Farber, M. (1994) The quality of information on Internet, *Computer networks and ISDN systems*, 26,2–3: 75–78.

Fjällbrant, N. (1994) EDUCATE- end-user courses in information access through communication technology, in: B.R. Plattner and J.P Kiers (eds.) *Proceedings of INET'94/JENC5*, book 1, Prague.

Joziasse, M., Linde, P.J., Smolenaars, H.J. (1994) Definitie studie, internal document, Department of Horticulture, University of Wageningen.

Kraut, R., Galagher, J., Egido, C. (1988) Relationships and tasks in scientific research collaborations, *Human computer interaction*, 3,1: 31–58.

Linde, P.J. (1994) *Video in de voorlichting; Handleiding voor de produktie van voorlichtingsprogramma's*, Coutinho, Bussum.

Margetson, D. (1991) Why is problem based learning a challenge? in: D. Boud and G. Feleti, (eds.) *The challenge of problem based learning*, London: Kogan Page.

Rutkowski,R. (1994) Knowledge building map of the Internet, *Internet Society NEWS*, 3,2: 20–23.

Sasse. M.A. et al. (1994) Remote seminars through multimedia conferencing: experiences from the MICE project, in: B.R. Plattner and J.P Kiers (eds.) *Proceedings of INET'94/JENC5*, book 1, Prague.

Teles, L. (1994) Cognitive apprenticeship on global networks, in: L.M. Harasim (ed.) *Global networks, computers and international communication*, Cambridge: MIT Press.

Wilkerson, L. and Hundert, E.M. (1991) Becoming a problem-based tutor: Increasing self-awareness through faculty development, in: D. Boud and G. Feleti (eds.) *The challenge of problem based learning*, London: Kogan Page.

6 In December 1995 four vocational schools in the Netherlands initiated a pilot project in the framework of a programme sponsored by the Dutch Ministry for Education, Arts and Sciences, the aim of which is to translate the Hortonomy concept to relevant knowledge domains at the vocational level.

11 Pointing in Entertainment-oriented Environments: Appreciation versus Performance

Joyce Westerink and Karoline van den Reek

Multimedia applications for consumer entertainment often employ a point-and-select interaction style, borrowed from more task-oriented computer applications. The environment of use and the pointing devices involved are so different, however, that a higher importance should be attributed to the users' appreciation of the pointing device than to its efficiency or any other objective performance measure. We set up an experiment to investigate how appreciation and performance measures relate. The experiment involved six different input devices, two CD-i titles and 16 subjects making both voluntary and prescribed cursor control movements. For the mouse-like pointing devices we obtained a Fitts' Law-like dependence on target width and target distance. Concerning the performance measures we found that neither time-to-target nor relative-path-length on its own is a reliable indicator of users' appreciation. Together, however, they might explain appreciation scores to a considerable extent.

Multimedia applications are gradually entering the consumer market, often meant for entertainment, such as Philips' system for multimedia applications, CD-interactive (CD-i). In many of those applications, a point-and-select paradigm (Whitefield, 1986) is used as the basic interaction style, adopted from more computer and task-oriented environments.

For these latter environments, research on pointing devices is quite extensive: it includes the physical characterization of the pointing devices (Whitfield et al., 1983;

Mackinlay et al., 1990), although most attention has been given to what is generally known as Fitts' Law (see Fitts & Peterson, 1964). Later refined by MacKenzie (1992) and others, Fitts' Law describes the relation between the time needed to point to a certain target and the size of and initial distance to this target. For some input device types – though not for all (see Card et al., 1978) – it is found that primarily the ratio of target distance to target width determines the time-to-target, and the latter is in fact linearly related to the logarithm of that ratio. The slope of this linear line is often considered to be an indication of the 'information capacity of the human motor system', in analogy to the concept of channel capacity in Shannon's (1948) information theory. Various input devices can differ in the information capacity they support, although the values found for a specific type of input device, e.g. a mouse, can vary enormously across investigations (MacKenzie, 1992). Thus, most studies focus on an objective characterization of the efficiency of the pointing device.

Pointing in entertainment-oriented environments is different from pointing in task-oriented environments in two respects. First, the pointing devices are designed to allow a relaxed sitting position at a substantial distance from the screen. Second, the efficiency of the pointing device is much less important than its appreciation by the user although, of course, efficiency can be one of the factors contributing to appreciation. This can be generalized to other performance measures besides efficiency: also their use in evaluating a pointing device is dependent on the extent to which they reflect the users' appreciation. In this article we will therefore investigate both (subjective) user appreciation and (objective) performance measures, and more specifically how the two relate.

Design of experiment

An experiment was set up to investigate the 'subjective-objective' relation for a set of six different pointing devices, using two existing CD-i titles as multimedia applications[1]. The experimental design was a within-subjects design with CD-i titles as a between-subjects condition: each subject worked with all six pointing devices, but with only one of the two CD-i titles.

Sixteen subjects, between 20 and 40 years of age, participated in the experiment. Half of the subjects were female and eight subjects were assigned to each title. Some were colleagues at the Institute for Perception Research and some drawn from the Institute's pool of subjects for experiments. They were specifically selected for their

1 This is a slightly adapted version of a publication in the January 1995 issue of the SIGCHI bulletin. The authors would like to thank Cor Luijks and Frank Stevers of Philips CE - Interactive Media Systems for their contribution in writing and implementing the event-logging module for this experiment.

interest in the content of the title with which they would work, as pilot experiments had shown that without such interest no serious results could be expected.

The core of our experimental set-up consisted of a professional CD-i player with additional software that allowed us to event-log all cursor positions on the screen and all button presses on the pointing device. The player's output was to a normal television set for presentation of both the visual and auditory content of the CD-i titles.

The six pointing devices are described in Table 1. The two mouse devices were identical as far as their physical characteristics were concerned, and the same holds for the two joysticks. The 'Airmouse'[2] is an absolute device sensing its position and orientation in space. As required for CD-i, all these pointing devices had two different selection buttons.

For entertainment software, we used two CD-i titles: Time/Life Photography Course and Jigsaw, an electronic puzzle game. Both employ a 'point-and-click' interaction style. In order to simulate a typical livingroom and leisure-like situation, the television set was placed on a low table. The subject was seated in a comfortable armchair at a distance of some two meters from the television screen. Most of the pointing devices could be held in the hand or on the lap. A small horizontal plate was attached on the armrest of the chair to serve as a base for the mouse devices, so that they, too, could be used in a relaxed way.

Table 1: Overview of pointing devices

Pointing device	abbreviation	characterization
Airmouse	am	absolute pointing device, sensing its position and orientation in space
joystick	j+	relatively high speed/control ratio
joystick	j−	relatively low speed/control ratio
mouse	ms	high resolution of 350 dots per inch
mouse	ml	low resolution of 250 dots per inch
trackerball	tr	standard CD-i remote control

The following procedure was followed. First, the subject was made comfortable, and the experiment leader explained the way CD-i works (basically the point-and-select paradigm) using the trackerball. Then the subject was invited to explore the title and pointing device. The experiment leader stayed in the room and, in order to create a relaxed atmosphere, adopted the role of a friend to talk to and enjoy the CD-i title with. After five minutes, the experiment leader asked the subject about his opinion on the pointing device and to express his overall appreciation in the form of a score on a scale[3] from 1 to 10. After that, the subject was requested to perform a

2 Airmouse is a trademark of Selectech, VT, USA.

3 This scale is familiar to Dutch subjects as it is used in all primary and secondary schools.

series of prescribed movements. They involved four repetitions of a pattern that consisted of ten consecutive movements. Each movement was based on screens available in the particular CD-i title, and was indicated in terms of a target area to go to, while a button was to be pressed once the target was arrived at and this last position then functioned as the starting position of the next movement. The movements varied in target distance, target size and target direction. If needed, the subjects could look up the intended movements on a reminder posted next to the TV screen. During these prescribed movements the experiment leader took care not to interfere with the subject's tasks unless correction of a mistake needed to be pointed out.

This same procedure was then repeated for the other five pointing devices. The order of their presentation was trackerball, mouse devices (pseudo-random), joysticks (pseudo-random) and Airmouse. Though this order is not neatly counterbalanced, it was deliberately chosen to allow the subjects to compare impressions on similar pointing devices.

The objective data were derived from our event-logging recordings. We selected two performance measures. The first is time-to-target, well known from Fitts' Law, which we defined as the time needed for a specific movement, starting with the button press at the end of the previous movement, and ending with the button press on the intended target position. The other performance measure we call relative-path-length, and we defined it as the length of the path between the beginning and end point of a certain movement, divided by the (minimum) distance between these two points. Thus, both performance measures are calculated for each repetition of each (prescribed) movement for each pointing device and for each subject. As described above, the experiment also yielded subjective data on the appreciation of the pointing devices in the form of a score on a 10-point scale. These judgements were obtained from each subject for each pointing device.

Results and discussion

Judgements
The appreciation scores for the pointing devices were averaged over all subjects (and thus over the two titles) and are shown in Table 2. Although subjects differed in their appreciation of the various pointing devices, the difference between titles was minimal, and the average scores for the pointing devices describe most of the variance. They show that the high-resolution mouse, the low-resolution mouse and the trackerball are appreciated equally and best, followed at quite some distance by the Airmouse and the low-speed joystick. The high-speed joystick was considered worst of all.

Table 2: Average appreciation judgements

Pointing device	average score	standard error-in-the-mean
mouse ms	8.0	0.2
mouse ml	7.9	0.2
trackerball tr	7.8	0.1
Airmouse am	5.4	0.5
joystick j–	4.8	0.3
joystick j+	3.4	0.4

Note: Scores are averaged over subjects and titles.

Event-logging data

The time-to-target values were averaged over subjects and repetitions in order to yield one value for each prescribed movement with each pointing device in each title. For half (5) of the movements in each title, these averages turned out to be considerably higher (1 to 2 seconds) than for the other half, as a result of small delays due to system processing. Although these delays increased time-to-target values, subjects hardly complained about this, mainly because the application feedback was adequate in signalling the disabled interaction.

Because we want to describe the pointing devices and not the CD-i system's processing, we limited our analyses to those movements unaffected by the waiting times. Figure 1 shows the average time-to-target values for the title *Jigsaw* as a function of the ratio of target distance and target width (in the direction of movement). The graph shows that for both mouse devices (the results of which were not signif-

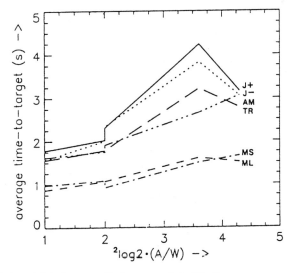

Figure 1: Time-to-target data for prescribed movements in title Jigsaw

The values in the figure are plotted in Fitt's Law format, that is according to the logarithm of the ratio of twice the target distance A and the target width W. Thus, various combinations of distance and width can result in the same ratio.

icantly different) Fitts' Law applies as expected, with a slope of about 130 ms/bit, which is well within the range from 96 to 392 ms/bit, as specified by MacKenzie (1992). Also Fitts' Law applies to the Airmouse with a slope of approximately 200 ms/bit. For the other three pointing devices we do not find Fitts' Law, a fact mainly due to the low values found for a long movement to a small target near the edge of the screen (points on the extreme right in Figure 1). This low time-to-target value reflects the beneficial influence of the cursor constraint which prevents the cursor from moving off the screen, and we observed that the subjects made active use of that feature. For the Airmouse the constraints do not help since a movement off screen has to be fully recovered by an absolute pointing device, and for the mouse devices the constraints are apparently not needed.

Although results for the title *Time/Life Photography Course* turn out to be slightly more noisy, they are similar to the results for the title *Jigsaw*: Fitts' Law applies for the mouse devices and the Airmouse, but not for the joysticks, and a beneficial effect of cursor constraints is found for all relative pointing devices.

In a similar way we calculated the relative-path-lengths for those movements that were unaffected by extra waiting times. For most movements, the average actual path length appeared to be between 1 and 3 times the minimum required distance, and showed little relation to the time-to-target values for the same movements.

Comparison of appreciation and performance
Figure 2 shows the scatter diagrams of both performance measures versus the appreciation scores, and indicates that there is certainly some relation between the two. In a way, this is surprising because aspects of grip and handling (e.g., Neervoort &

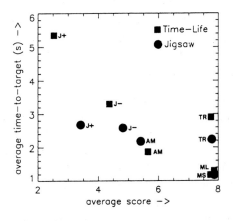 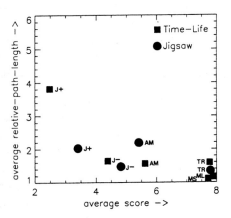

Plot A: time-to-target data Plot B: relative-path-length data

Figure 2: Appreciation and performance measures for both titles

Data in both graphs are plotted against average judgement scores.

McClelland, 1993) must also have had their part in the overall pointing device judgments, but can only be indirectly reflected in the cursor control patterns and the values derived from them. On the other hand, the difference between the two joysticks – which are identical as far as grip and handling are concerned – confirms that gain characteristics can also influence the user's appreciation and performance.

Neither the time-to-target measure, nor the relative-path-length measure, however, fully reflects users' appreciation judgements. The time-to-target measure reproduces the relation between the appreciation scores of joysticks and Airmouse, but fails to provide a reason why the trackerball is considered to be so much better than the Airmouse and about just as good as the mouse devices. The relative-path-length measure, on the other hand, is better at reflecting the clustering of appreciation scores for the three best pointing devices (ms, ml and tr) and relating them to the Airmouse but fails, at least for the title *Jigsaw*, to explain why the slower joystick (j–) is generally found to be worse than the Airmouse. Thus, the data suggest that the two performance measures complement each other in reflecting the appreciation scores.

Conclusions

Two areas of concern lend themselves to summary conclusions. First, for our time-to-target measure we indeed find Fitts' Law for a number of pointing devices. This shows that our results are in line with pointing device literature. Where our results do not follow Fitts' Law, we could attribute the deviations to the beneficial influence of cursor constraints. However, we also have reason to believe that the time-to-target measure present in much of the research involving Fitts' law overemphasizes the importance of efficiency, especially in leisure-oriented environments. Indications of this overemphasis are the lack of complaints in waiting-time situations and the contribution that the relative-path-length measure can make to explaining users' appreciation judgements. It can be expected that other performance measures will also succeed in describing the appreciation data to some extent.

A second area of concern is the differences we found between the titles. They indicate that although we restricted ourselves to titles with a point-and-click interaction style, various cursor control strategies have occurred, possibly as a result of other differences between the titles, for instance, the size and distance of the hot spots, the influence of cursor constraints or the different higher-level intentions and interests a title invokes in users. As far as the subjective appreciations are concerned, the differences between the titles are hardly important. Thus, the conclusion is warranted that especially for point-device evaluation experiments which involve derivation of objective performance measures from event-logging data, a careful and well-argumented selection of title material is essential.

References

Card, S.K., English, W.K. and Burr, B.J. (1978) Valuation of mouse, rate-controlled isometric joystick. Step keys and text keys for test selection on a CRT, *Ergonomics*, 21: 601–613.

Fitts, P.M. and Peterson, J.R. (1964) Information capacity of discrete motor responses, *Journal of experimental psychology*, 6: 103–111.

Mackinlay, J., Card, S.K. and Robertson, G.G. (1990) A semantic analysis of the design space of input devices, *Human-computer interaction*, 5: 145–190.

MacKenzie, I.S. (1992) Fitts' Law as a research and design tool in human-computer interaction, *Human-computer interaction*, 7: 91–139.

Neervoort, P. and McClelland, I.L. (1993) CD-I remote control handling behaviour, Philips Corporate Design Internal Report No. AE 93–07.

Shannon, C.E. (1948) A mathematical theory of communication, *Bell systems technical journal*, 27: 379–423.

Whitefield, A. (1986) Human factors aspects of pointing as an input technique in interactive computer systems, *Applied ergonomics*, 17: 97–104.

Whitfield, D., Ball, R.G. and Bird, J.M. (1983) Some comparisons of on-display and off-display touch input devices for interaction with computer generated displays, *Ergonomics*, 26: 1033–1053.

12 User-centred Design: Interaction Between People and Applications

Maddy D. Brouwer-Janse

Long term success factors for multimedia systems lie with the design of usable, flexible user interfaces which match the needs and capabilities of users with the capabilities of the technology. User-centred design methods focus on the user needs and requirements in the early stages of the design and development cycle. In this chapter an overview is given of the development of user-centred design methods and their particular relevance for development of multimedia applications.

User-centred design methods focus on the user needs and requirements in the early stages of the design and development cycle. With user-centred design the focus is on user task models and not on engineering models of the system. In other words, it is fully recognized that users have goals and that designers want to present the underlying system and points of access to it. The users' and the engineers' ways of looking at systems and applications are considerably different. They are at the heart of the human-system interaction problem. This human-system interaction problem is exploding into even more complexity with the onset of multimedia technologies and systems that are to be used by the public at large instead of by trained professionals. The user interfaces of these systems have to address individual differences and human attributes such as, literacy, bilingualism, visual acuity, aging, special needs, multi-culturalism, and technophobia. Furthermore, the media through which users can interact with these systems are expanding into a jungle of input and output devices. For example, hundred-button remote controls, WIMPS (Windows, Icons, Menu's, and Pointers), three-dimensional mice, pens, touch screens, video, speech, helmet-mounted displays, and virtual environments. The demands on the requirements and management of these input and output devices and the dialogue types that are most useful for different applications are

149

growing rapidly. To make matters worse, usability to users is not the same as usability to designers.

Multimedia systems are at the crossroads of several technologies, each with its own history in the way they are used to interact with end users. For example, menu and window systems are finding their way from the computer world into the products of consumer electronics. Instead of knobs and dials for direct access, users have to programme their audio and video equipment by means of menu's and pointers. Furthermore, the functionality of products in the telecommunication world has exploded. The user interface of the phone terminal, however, has hardly changed since its introduction, depriving the users from access to extra functionality. Meanwhile, in computer technology the command language interfaces for professionals and technicians have evolved to dedicated applications and user interfaces that are tailored to the tasks of the end user. User interface practitioners from these different domains – consumer electronics, telecommunications, and computing – have a very different expertise with regard to the design of user interfaces and very different expectations with regard to the needs and requirements of users of multimedia systems. In other words, there is not yet a common and well-established language of communication between practitioners from different disciplines to transform user needs to formal system and user interface requirements. No wonder, then, that the current situation with respect to multimedia systems is bewildering for practitioners.

In this chapter an overview is given of how user interface design has evolved over time with the development of technology and with the changing demands of end-user populations. This implies disentangling the concepts that distinguish multimedia applications from 'traditional' applications and clarifying the terminology that has been borrowed from different domains and whose meaning depends on the context of use. First, the notion of 'interaction in the user interface' is discussed in the context of evolving system design and system usage. Second, I consider the rational and the major characteristics of user-centred design as a way to accomplish interactivity in user interfaces.

Interaction

People interact with systems via user interfaces. The term user interface, however, is a technology-centred term that assumes specification of the user (Grudin, 1990). Actually, this term was not needed at all for computer systems that were developed in the 1960s and 1970s. Most users at that time were engineers and programmers, and the interaction between user and system was defined as all inputs from the user to the system and all outputs from the system to the user. This definition is at the level of one dedicated user who knows the machine and its behaviour inside out. It

is, however, not sufficient to encompass the complexities of the interactions between today's users and systems that integrate advanced multimedia technologies. The term human-machine interaction, HMI, (or the terms human-computer interaction, man-machine communication, human-computer communication) defines all interactions between user communities in the context and environment of use with all aspects of the systems and their infrastructure. This definition implies that compatibility between different applications, for example between word processing and spreadsheets, are determinant factors for the quality of the user interface of office applications. Or, if a system is intended to service the public at large, the accessibility and usability for people of very different capabilities, are determinant factors for the quality of the user interface. In sum, the user interface comprises more than keystrokes and mouse clicks from the user and responses from the system; it is the experience in which people are engaged.

Five levels of development of user interfaces can be distinguished from a historical perspective (Grudin, 1990). For each level, the approaches to design and the skills required of practitioners are different. The five levels, chronologically ordered, are:

- *Interface as hardware* (1950s). The users are engineers and they work out of necessity with intimate knowledge of the system.
- *Interface as software* (1960s–1970s). Users are programmers. They are removed from the hardware by layers of software, virtual memory and other software constructs.
- *Interface as terminal* (1970s–1990s). Users are non-programmers. They are so-called 'end users' and the systems are interactive. They have direct-manipulation graphics in the user interfaces. Perceptual, motor, and low level cognitive issues that pertain to the use and layout of cursor keys, function keys, mice and buttons, command names, menu navigation and organization, design of icons, graphical layout, use of colour and sound are taken into account.
- *Interface as dialogue* (1980s–). Users are 'end users'. The focus is on the higher level cognitive processes that are represented in human planning and decision-making, human problem solving, discourse over time, and individual differences.
- *Interface as work setting* (1990s–). Users are considered as participants of social groups. In other words, the scope of the computer interface goes beyond the individual and out into the personal and work environments. This is the advent of 'groupware' and the development of systems that support professional organizations and community services.

This historical trend of the computer user interface demonstrates the continuity that extends through two shifts in the user population: the shift from engineers and programmers to end users as primary users, and the shift from supporting individuals to supporting groups.

From an engineering perspective, the ideal interface mirrors the underlying mechanism and affords direct access to control points in the system. For the user, however, the interface should be task oriented. The first interfaces for radically new technologies tend to be closely matched to the engineering model because this is the simplest interface to implement and the early users are usually technically oriented anyway. For example, the first computers were programmed by plugging wires into large patch panels to directly alter the electrical circuits. And, the Phelps tractor in 1901 was controlled largely by reins and introduced as a direct replacement for the horse in farm work (Gentner, 1990). These examples also show that in addition to presenting the underlying mechanism, the user interface also simulates an existing technology. A contemporary example of this simulation is use of the phone interface for interactive television and/or teleshopping. That is, user interfaces that simulate the previous technology reduce or eliminate the required learning, and users can transfer their knowledge of existing systems to the new system. Another example is the use of WIMP user interfaces for multimedia systems. Designers are familiar with these interfaces through their development tools and they allow them to tune and twiddle the system. Depending on which users need to be targeted and under which conditions, this might be either a good strategy or a total failure for multimedia applications. User-centred, task-oriented design methods help to bridge the gap between the engineering models of systems and the goals, expectations, and behaviours of users.

Multimedia applications provide an additional challenge to user-interface design. That is, how can the user interface contribute to entice the targeted user into receiving the message from agents that are using multimedia systems for delivery, or how can the user interface contribute to engage the user into active participation? Multimedia applications have to mediate the interactions between content attributes, technical system attributes, human attributes, and stake-holder attributes. User interface development is gradually adapting to these challenging demands. The focus is shifting from attainment of technical perfection to concentration on human emotional attributes. This trend can be represented in five stages:

- *Technical perfection.* At this stage, only technical attributes count. The users of the system are not in the picture. This stage only concerns the engineering model of a system. Systems are evaluated with regards to reliability, robustness, functionality, and performance.

- *Multiplication of functionality.* At this stage, technology permits the development of more functionality and addition of more features and functions. This stage concerns the engineering model of the system. But, the technology push is excused through speculations about what people would like to have and may want to use. Systems are evaluated with regards to reliability, functionality, performance, and how users eventually might adapt to the system.

- *Adaptation to user capabilities.* At this stage, the focus is on whether users actually can make use of the system. Human factors are coming into play, dealing with perceptual, motor, and low level cognitive issues such as, use and layout of cursor keys, function keys, mice and buttons, command names, menu navigation and organization, design of icons, graphical layout, use of colour and sound. Systems are evaluated with regards to usability, i.e., effective and efficient user task performance and the major focus is on how to adapt the system to human capabilities.

- *User-centred design.* At this stage, the focus is on a deep understanding of the users' tasks and goals and on how they fit into the environment of the user. This environment can be at work, but also at home, in the car, in the community or any other social setting, depending on where and how the system is going to be used. The context of use is a major concern. Systems are evaluated with regards to usability and user satisfaction, and with regards to how effective they are as carriers for the message or service. Even more important, evaluation with users is part of the system creation and production process. This implies that evaluation results are obtained in early phases of the product creation process and that user feedback and evaluation results can be used to improve successive iterations of system or application prototypes.

- *Emotional attributes.* At this stage, the focus is on the attractiveness of the system and on how pleasant it is to use and/or own the system. Systems are evaluated with regards to, for example, how people like them, how they match their lifestyle, and how they elicit spontaneous user behaviours and unexpected usage.

Figure 1 illustrates these five stages in user interface development. These stages are not independent of each other. Each stage subsumes the previous one. In other words, it is not likely that a good user interface can be developed by following user-centred design methods without paying attention to the previous stage of human factors or without sufficient technical reliability. This stage model of user interface development can help to disentangle the complex user interface aspects and to structure the development process. Structuring this process and being able to distinguish between the attributes is becoming more and more important, especially with the onset of multimedia applications. That is, determining which attributes should be assigned to the users, to the system, or to the applications is now at the forefront.

The one-user-one-interface fallacy

The familiarity that users have with systems in one environment and their expectations of its behaviours are hard to carry over to other environments. For example, a

Figure 1: Five stages in user interface development

skilled professional user of a Computer Aided Design (CAD) system can be totally unfamiliar with the user interface of a videogame and the conventions that underlie the design of such an interface. Or, the same professional can be totally versatile and very proficient with videogames, but would most certainly not expect the same user interface presentation in these two different domains. An experienced user of word processors can be totally overcome by the user interface of a CAD system or even a PC-presentation program. Conventions for user interface development can be classified along two dimensions: domains of use and settings for use. Domains of use are, for example, Entertainment, Communication, and Intelligent Work. Settings for use are, for example, Professional, Education, and Home. Table 1 illustrates how this classification can be used as a reference model. The examples in Table 1 are used to highlight the contrasts in settings for use and user backgrounds. They are intended as a guide for user interface designers. The examples in Table 1 are not conclusive and they do not limit the use of the systems to one category of the classification.

Table 1: Classification of user interfaces

	Entertainment	Communication	Intelligent Work
Professional	authoring tools	electronic mail system	CAD CAM systems
Educational	reference works	distributed education	tutorial systems
Home	computer games	telephones	word processors

In addition to differences in domain and setting of use, design of user interfaces is also affected by cultural differences between user populations. Different categories of cultural differences can be distinguished. The most obvious differences comprise those between different national, ethnic and religious communities. These have to be taken very seriously when systems are being designed with end-user goals and tasks in mind. However, these differences can be subordinate to the homogeneity of professional societies and corporate cultures. For example, the user interface design of a multimedia application for professional chemists is less hampered by national and linguistic differences than the design of a public service information system for the European Union. Cohort differences pose a totally different challenge to user interface design. These differences originate from experiences that are universal for a generation of users. For example, people born in the 1950s are oriented towards text and books for information acquisition, while people born in the 1980s are oriented towards audio and video sources for information acquisition. In comparison, the generation of the 1990s is keyboard oriented and the generation of the 2000s might be oriented towards interactive multimedia for information acquisition. In addition, expectations about the functionality and the behaviour of systems is affected by the experiences that people from different cultural backgrounds and from different generations have.

It is impossible to determine user needs and requirements in advance. People cannot provide direct information about their desires for unknown systems; they can, however, provide much evaluative information about existing systems: how they like them, how they use them, what is lacking, and they might be able to provide wish lists. This information, however, is not sufficiently specified for system design and implementation and its validity for new situations is questionable. In other words, the design and development methods from Stage 1, 2, and 3 in Figure 1 are not sufficient to address the human system interaction issues. User-centred design methods are being developed to address the elicitation and validation of user needs and requirements in the early phases of the design process. Defining user needs and specifying user requirements to develop applications and to design the user interface is already a difficult tasks when the target user group is identified and consists of a homogenous population of users for a well-defined application. When user populations are becoming heterogenous and the applications are aiming at general use, the complexity of defining the user needs and requirements increases dramatically.

User-centred design

In the early days of system design, senior developers designed applications and user interfaces entirely guided by their experience and intuition. They and their peers were the end users. The user populations for our current systems, however, are so vastly different that this experience of developers is almost irrelevant and their intuitions about end users inappropriate. Instead, system prototypes, usability and acceptance

tests are needed to validate the designs. Designers need feedback about users' skills, wishes, and orientation by means of direct interaction with users during the design phase, development process, and throughout the lifecycle of the system.

The traditional way of system design follows the so-called 'waterfall' model (Boehm, 1976). This model starts with requirements analysis by systems analysts who are usually not the user interface designers. These requirements are transformed into system specifications. Hardware, underlying software, and user interface are designed to meet those specifications. The phases or steps in the classic waterfall model are: Requirements analysis, Specification, Planning, Design, Implementation, Integration, and Maintenance. This model has proven to be a poor approach to software that has an important user interface component, as is the case for most multimedia systems. Meeting the specifications is the major concern of a development process that follows the waterfall model. In contrast, achieving quality of the user's experience is the major concern of a development process that is user-centred. The difference between design approaches that are user-centred and the traditional approaches derived from the waterfall model are the iterative character of the design process and the active role of users. Iterations are not permitted in the waterfall model and user evaluations are conducted at release time. A thorough understanding of the user's task and how the task fits into the rest of the user's environment is needed. That understanding cannot be derived from a set of abstract specifications. User-centred design (e.g. Norman & Draper, 1986) has emerged as one of the most compelling mandates for developing user interfaces; it implies designing the interaction from the view of the user, rather than the view of the system. Unfortunately, what is best for the user may not be natural for the designer to design or for the programmer to implement. User-centred design takes time, effort and expertise. Producing effective user interaction requires focusing on what is best for the user, rather than what is quickest and easiest to implement.

The first step in a user-centred design process is to conduct a task and user analysis to acquire a thorough understanding of the users and their tasks, i.e., figure out who is going to use the system to do what. To know the user means to understand human behaviour. It implies knowing the characteristics of the classes of users that will be using a particular system. The need for a task analysis is obvious. A system needs to do what is needed. It has to merge smoothly into the user's existing world and work. It should request information in the order that the user is likely to receive it. It should make it easy to correct data that is often entered incorrectly. Its hardware should fit in the space that users have available and look like it belongs there. These kind of considerations can get easily lost in traditional requirements analysis. Knowing the users' background will help answering questions such as, which names to use on menu's, what to include in training and help systems and what features should be included. Knowledge about how confident users are or how motivated they are to learn to use a new system supports decisions about design choices. Task and user

analysis requires an early and continued contact between designers and users. This is already difficult to accomplish when system and users are known. In many cases however, especially when introducing new technologies as in multimedia applications, the users are not known in advance. Furthermore, they are totally unfamiliar with the novel ideas for system implementation. Task and user analysis needs to be extended for these situations and emphasis will be on communicating the ideas to potential users and eliciting feedback from them before any implementation of the system has been done.

Nearly all the methods used to conduct user, task, and domain analyses are derived from psychology and sociology. To communicate the ideas and concepts of the system to the potential user community, i.e., in psychological terminology to develop the appropriate and valid stimulus material, is a challenge. For example, stories, pictures, collages, video clips, scenario's for use, mock ups of systems, system simulations and system prototypes can be used. Getting to know the user does not happen by simple observation or arbitrary interviews. In-depth qualitative and quantitative methods are required to answer questions concerning the expected users' cognitive, behavioral, anthropometric, ergonomic, and attitudinal characteristics. The analysis of the tasks users will perform in order to achieve some purpose is crucial for a design that is tailored to facilitate the use that a user will make of the system. In this phase, initial design concepts, presented as mock ups, simulations or prototypes can be evaluated with target user audiences and compared against initial design constraints. In sort, this first phase consists of studying the user population in the environment of use, defining user needs, defining conditions for use, defining realistic user tasks and evaluating initial concepts with users.

The next step in a user-centred design process is to generate prototypes or models of the preferred designs. These prototypes aim to approximate the finished system in as realistic a way as possible, without actually implementing it. In this phase, a believable model of the system is built. This model includes the physical design and the user interface design, that is, the housing with buttons, knobs or other physical devices and the screen designs, animations, or interactive demonstrations of how the product should respond to the user. These design prototypes are tested with users for usability and performance, for how the environment affects the design by moving the prototype to a user site, and for user acceptance. Many methods and tools are available for such user studies, for example, questionnaires, interviews, observations, benchmarks, usability tests, focus groups, context dependent tests. The results of these user evaluations are used as feedback in the design process and implemented in the next generation of prototypes. These prototypes are again evaluated with users (see also Chapters 8 and 9). The whole process is conducted in an iterative way, generating a prototype, testing it with users, and iterate these steps till the system satisfies user needs. These user needs can then be formalized in specifications that are used for implementation. In this process users are involved from the very start.

This user-centred design process is well accepted in the development of advanced user interfaces for computer applications. This domain, however, is professionally oriented. It is easier to target and elicit the user needs of CAD designers for a dedicated CAD application than to target users for an all-purpose word processor that will be sold over the counter for general home use and that has a product turnover of 6 months. Limiting the application to specified tasks reduces the design space, facilitates the match between users and product, and enhances the chances of success.

When new technologies have to be introduced, it is not possible to start with the first phase of the user-centred design process: learn to know the user. In these cases, users are not yet targeted and these 'unknown' users are totally unfamiliar with the product concepts. They can neither give reliable feedback nor contribute much to the design process. In these cases, an exploratory phase is deployed in which concepts are being communicated to groups of people, if possible to large samples of different population groups. The open endedness of the engineers' and designers' tasks are narrowed down by means of formal methods or ad hoc delimitations to filter out particular groups of users and promising product concepts. After this exploration the more formal phases of the user-centred design methods, as outlined above, can be deployed.

The incorporation of multimedia poses additional challenges to the user-centred design process. The potential of multimedia depends on a greater understanding of how to exploit this technology more dynamically to enhance its interaction capabilities. For example, we need a better understanding of:

- The nature of multimedia data, such as, mechanisms for data retrieval, data navigation and browsing;
- The best ways of creating, indexing and presenting material that is stored in multimedia form;
- The best techniques for handling presentation and dialogue involving information in different media;
- When and how to present the same information in different media to achieve optimal communication?
- When are time varying media (video, audio, animation) really needed and why?
- How dynamic should the presentation be?

The most important aspect, however, is how to entice the user into dynamic behaviour and to determine whether that is really necessary for the application at hand? This is a perturbing point: dynamic presentations do not guarantee dynamic users. Multimedia systems might be interactive and dynamic, but that does not mean that the users are enticed into dynamic behaviour. Developers of multimedia applications are swayed back and forth between a 'rock and a hard place'; they have to work out the user-centred design process and put it into place, and they have to work out the particularities of the integrated media.

Conclusion

This chapter has provided an overview of issues and pertinent problems of designing interactive systems. With the onset of multimedia technologies, powerful means to enhance the communication between people and systems are emerging. At the same time, however, the clear distinction that could be made for traditional systems between the user interface, i.e., the medium through which people interact with systems, and the application is diffusing. From a system's point of view, multimedia systems make different forms of information available in one environment and they enable the development of applications that can deal with this information in a very flexible way. Every form of representation, from video to text, can be stored, processed, and communicated using the same device. This is a remarkable technical achievement. With regards to the users, however, many issues remain unsolved and new ones are being introduced. First, methods for user-centred system design that have been developed for traditional systems need to be adapted to the specific needs of multimedia systems design. Second, practitioners from other disciplines need to participate in the design of multimedia systems. For example, artists, communication specialists, educational specialists, social scientists and cognitive psychologists are needed to structure and represent the contents of multimedia applications in accordance with people's capabilities and to develop valid evaluation methods. Third, user interface guidelines are needed that go beyond the design of graphical user interfaces. They have to provide guidance for the selection of media, for the planning of the presentation or scripting, and for the validation of the system with regards to common cognitive and attentional problems.

References

Boehm, B.W. (1976) Software engineering, *IEEE transactions on computers*, 25,12: 1226–1241.

Gentner, D. R. and Grudin, J. (1990) Why good engineers (sometimes) create bad interfaces. *Human factors in computing systems*, CHI'90 conference proceedings (Seattle, WA), ACM, New York, April, 1990, 277–282.

Grudin, J. (1990) The computer reaches out: the historical continuity of interface design. *Human factors in computing systems, CHI'90 conference proceedings* (Seattle, WA), ACM, New York, April, 1990, 261–268.

Norman, D. A. and Draper, S. W. (eds.) (1986) *User-centred system design: New perspectives on human-computer interaction*. Hillsdale, NJ: Lawrence Erlbaum.

13 Predicting Consumer Adoption of Information Technologies

Harry Bouwman and Anne de Jong

This chapter examines how predictions are made regarding new media developments. The overall functions of predictions are considered, but particularly their validity. Several methods employed for technological prediction are critically assessed. From this assessment none seems appropriate for determing consumer adoption. This is mainly due to the complex environment in which new media develop and the many factors and actors which play a role therein.

Although the concept of information technology is often used to describe a variety of developments, no universally accepted definition exists. The definition proposed by Fulk and Steinfield (1990:95) is suitable for the purposes of this chapter in which information technology refers to applications of modern communication and computer technologies used for acquisition, storage, analysis, distribution and presentation of information. One of the developments within the domain of information technology is multimedia which is, in turn, a frequently used expression with a diversity of meanings. Multimedia in the context of this chapter refers to integration of text, images and sound that is digitally stored and which can be transported by computer or telecommunications networks.

A distinctive feature of multimedia[1] is interactivity. Williams *et al.* (1988:10) describe interactivity as 'the degree to which participants in a communication process have control over, and can exchange roles in, their mutual discourse.' The level of interactivity is variable per medium; see Chapter 5 for further elaboration of the term.

[1] The simultaneous but separate use of different media (e.g. hybrid applications) – for example, a computer disc or an audio cassette supplied with a book – are not included within the concept as used here (see Bouwman & Pröpper, 1993).

In spite of the exclusion of hybrid applications from this definition of multimedia, the field still spans an enormous range of different applications and possibilities. The potential of these new media has attracted overwhelming interest on the part of industries and scientists concerned with information processing.

Technological developments

Where did all this attention come from? The main source is obviously the enormous technological progress which has been achieved during the past few decades. Without providing detailed descriptions, some of these developments are worth mentioning here.

Regarding infrastructures, data networks have been developed along with various forms of mobile communication. Besides twisted pairs of wire and coaxial cables, fibre optics and cellular communications offer new possibilities for data transmission. Network protocols and compression techniques allow for considerable expansion of network capacity. Increasing amounts of data, including compressed digitalized images, can be transmitted by network. Value added networks and services – videotex, teletext, video conferencing, electronic data interchange, e-mail, electronic fund transfer, premium rate services (audiotex), video-on-demand, home shopping, telebanking and interactive television – have become not only feasible, but are claimed in some cases to already be highly successful (Stoetzer, 1991). So-called stand-alone multimedia systems – e.g. CD-ROM, CD-i and Atari and Nintendo game machines – are developing further. The possibilities, we are told, are by no means exhausted.

A large part of this technological progress is made possible through temporary alliances in which several companies pool their financial and intellectual resources (see also Chapter 3). Many new applications are, in fact, so-called interlocked innovations – innovations involving combinations of hardware, software and use. Electronic highway developments involve many diverse parties, all looking for a particular sector providing financial gain. Some are looking for new possibilities to expand because their current markets are diminishing, such as the computer market and consumer electronics; some are concerned with protecting their present markets, such as many cable companies; some have defensive motives, such as broadcasting organizations and publishers; others expect stimulating effects for their own company – like various telecom operators – or for the economy in general, like many national governments and the European Union (Bouwman, 1993; European Commission, 1993; Gore, 1993; Bangemann *et al*, 1994).

The main issue in this development is who will acquire a firm grip on the market and become a major player in the field. This grip on the market depends partially on where computer intelligence is located: in the network itself as telecom operators

161

and cable companies hope or in the peripheral equipment as advocated by the computer industry and electronics giants. A strategic game is being played in which all parties are dependent on one another and are watching each other's moves very carefully.

Success in this world, however, is an ambiguous concept. It is not clear whether short-term success also produces results in the long run. A case in point here is the initial success of videotex in France. Success can be defined in terms of technological, economical, political and socio-cultural aspects. Most of the time, however, the term success is used to manipulate public discourse and, as such, functions as a marketing tool. Predictions that indicate the presumed success of multimedia are therefore essential, not only for the development of marketing strategies, but as an indispensable element in those same strategies.

Predictions and management of expectations

In the past many attempts have been made to predict buying behaviour of consumers regarding all kinds of new information technologies. Regardless of origin and scope, the findings are widely quoted and influence both manufacturers and consumers (Saffady, 1991). Predictions, especially when only market volumes are mentioned, are often made to prove the social or economical importance of these innovations and serve as an argument from consultancy firms and other interested actors to convince other parties to invest in the specific technology. This phenomenon is often called *management of expectations* and refers to shaping of public and business opinion. Supported by predictions and sales figures, these statements are supposed to give potential users the impression that they are the only ones not yet using this indispensable application or service.

However, surprisingly few of these predictions have proven accurate. Most have been overly optimistic. Predictions of videotex in the 1980s, for example, were highly unrealistic; see Table 1. In many cases the market seemed to be intentionally exaggerated. This seems also to be the case with providers of recently operationalized systems, like that in Ireland.

Table 1: Predictions and realisation of videotex use

Country	Forecast		Reality	
Denmark	1990:	100,000	1992:	12,000
France	1990:	1,000,000	1992:	6,300,000
Germany	1990:	3,600,000	1992:	410,000
Ireland	1995:	110,000	1992:	4,000
Switzerland	1987:	100,000	1992:	87,000
Sweden	1990:	260,000	1992:	30,000
United Kingdom	1990:	6,500,000	1992:	45,000

Source: Bouwman and Christoffersen (1992)

A question often ignored in both the development of new information technology applications and in prediction of their success, is whether these applications are actually useful to consumers. A further issue is whether consumers can afford to invest – and keep investing – in CD-ROM, faster personal computers and modems, Internet, CD-i, set-top boxes and pay-per-view programmes, all at the same time.

Both organizations and the public at large are expected to fit these new products into their daily routines. In many cases, however, this does not happen. For instance, the services and applications which exist today in the field of electronic information services in the Netherlands are hardly used, and when successful are not perceived as part of the electronic highway (Boelrijk *et al.*, 1994). The debacle of the Picturephone is another example. AT&T lost over 500 million dollars in the development and marketing of this device, which was intended to replace the 'plain old telephone,' but which consumers failed to purchase (Schnaars 1990; Hough, 1993). The over-estimation of the acceptance of videodisc players by consumers, and the underestimation of the success of the VCR (Klopfenstein, 1989; Schnaars, 1990) are also illustrative of this point.

Methods for predicting use of information technology

There are several methods available for predicting the breakthrough of technologies. The predictive validity of any forecast, however, correlates directly with the phase of development of the technology in question and the kind of prediction method used. This is especially important for predicting feasibilty and viability of the technology, possible trends, and the degree to which professional or private users will accept a specific technology.

In general, when a technology has only recently been 'discovered' or when only a design or prototype of the technology is available, researchers are forced to chose qualtitative methods, such as monitoring and Delphi. When a technology is further developed, laboratory or field trials are more suitable. Furthermore, it is possible to use methods such as historic analogies or scenarios. Once introduction has been achieved, more quantitative methods, based on product lifecycle and adoption or S-curves, are more appropriate. Regarding information technology, industry favors quantitative methods, while policy institutions employ Delphi or scenario research designs.

Delphi

In using Delphi methods, the opinions of experts are collected on developments of technologies with which one has limited 'real-world' experience. In general, an open survey is used, either in the format of a mail or computer-delivered questionnaire.

The answers are processed and incorporated in a second survey among the same experts. This iterative procedure supports the process of a general open approach to a more specific estimation of likely developments. Although this method has distinct advantages, such as a rich body of knowledge not otherwise avaliable and high reliability and validity, the method is quite sensitive. The results strongly depend on the choice of experts, the questions asked, biases of panel members and time effects.

This last factor in particular makes predictions based on Delphi methods, when reviewed some years after the investigation, quite hilarious. In a study done by De Bens and Knoche (1987), for instance, experts were asked what the pentration in European households would be of, among other things, 20 television channels, VCRs, HDTV, ISDN and fax machines in the year 1995 and 2005. However, no attention was paid to technologies such as CD-ROM, already available at the time, and CD-i which was announced as a consumer product by Philips as early as 1986. Internet and interactive television were not even considered viable consumer products. The experts predicted a 25% penetration of personal computers in European households and 17% penetration of ISDN by 1995. HDTV, which was being debated in the press at the moment of research, was expected to be available in 22% of the households by 1995.

Introduction of these technologies, as we now know, turned out differently. Still, it is doubtful whether more accurate predictions would have been possible. Delphi results tend to be formulated in a more general nature than in the study by De Bens and Knoche. For instance, in a Delphi-based investigation of laser discs, experts expected the educational market to be the most viable; music video discs were not seen as a commercial option and it was expected that the price of discs would drop considerably (Klopfenstein, 1989). In another Delphi study (Heyne & Andriesse, 1991) concerning electronic publishing, expectations of the experts interviewed suggested there would be only a limited substitution of folio printing by electronic publishing, that the value chain would be supported by information technology to an increasing degree, and that it would become common practice to pay for electronic information.

In conclusion, Delphi studies are valuable in illustrating general trends, but are unable to provide specific predictive information. Expectations made by experts fail to give sufficient basis for conclusions regarding market changes and adoption rates. Further, they do not make clear the basis for estimating aspects which are claimed to contribute to the predicted rate of adoption and use.

Scenarios

In general, practioners of scenario development start with a set of well-defined assumptions on the basis of which alternative developments are described. The qual-

ity of the scenarios depends on the degree to which these assumptions are realistic. Therefore, development of a conceptual model which describes the basic relationships between the most central variables is helpful. This basic model can serve as the starting point for determining which actor is able to influence a specific variable, and how this variable will influence other variables and the behaviour of other actors. The result is a description of possible outcomes. Mostly, scenarios are based on data gathered via literature research and from experts in the field. The purpose of scenarios is to support decision makers in their choices and in the estimation of the possible effects of these choices.

In the Netherlands scenarios were developed in the early 1990s by Arnbak *et al.* (1990) regarding information technology. These scenarios played a role in the debate on telecommunications issues, although the study was more generally directed to the information policy of the government. Three scenarios are described in the study. In the 'pilot' scenario the role of the governement in steering developments is stressed; in the 'free trade' scenario the market mechanism is perceived as the leading principal for developments; in the third 'convoy' scenario both market and government are anticipated to cooperate in developing information policy. For each scenario the consequences for broadcast media and telecommunication services are assessed, based on criteria such as privacy, access and transparancy.

More specific scenarios are found regarding development of entertainment (Eertink & Velthausz, 1995) and multimedia (Gurchom & Van Rijssen, 1995). The predictive validity of scenarios depends, however, on the way developments and the interrelation between developments are assessed and described. Also, an assessment of the power and influence of involved actors is essential. Scenarios are heuristic tools for determining possible outcomes of behaviour of specific actors. However, so many actors and factors are involved that it is very difficult to predict the actions of consumers within a specific context.

Actors and intervening factors
These factors and actors can be arranged in four categories: technological, economical, political and socio-cultural. Here, these actors and intervening factors are listed for each category and discussed in relation to consumer adoption of multimedia and other information technologies.

Developers of hard and software are the main actors in the *technological* area. Obviously, high quality and compatibility of hard and software are crucial ingredients to the success of a new technology, as the public has to be convinced that a particular product is better than its alternatives. As technology is the main feature which distinguishes products, specification of these factors differs per sector. In the case of telecommunication network-based services (TNS), technological factors include,

for example, 'network development and architecture, the choice of equipment and standards, which, in turn, have an impact on user friendliness, flexibility, functionality, and compatibility of telecomunication services' (Bouwman & Latzer, 1994:168). For CD-ROM and CD-i optical technology, however, integration of video technology and the speed of the computer chip used, are more essential factors.

Regarding the level of interactivity of multimedia systems, Hietink and Bouwman (1994) identify some obvious but nevertheless important requirements for success: the system should react quickly and be reliable; users should know what is expected of them and be able to find information sought, and the communication between user and system should be direct, logical and many-sided.

Economic factors and actors are – for reasons of clarity – divided into three levels: micro, meso and macro-economical. Macro-economical factors include the international conjuncture, international trade relations relevant to consumer electronics, national conjecture and industrial politics in North America, European Union, the Far East, divisible into government grants and research and development programmes (Hietink, 1994). The primary actors on this level are, as would be expected, governments and international trade associations.

On the meso-economical level the 'movers and shakers' are primarily multinationals. The actions of these companies concerning coalitions, standards and the development and distribution of hard and software are of major importance to the success of multimedia applications and other information technologies. The introduction of videotex in the Netherlands illustrates this point well. The creation of a consortium in which the PTT, publishers and all others concerned were integrated took about ten laborious years, and whether videotex will ever be a success on the consumer market is still unclear (Bouwman & Hulsink, 1992).

On the micro-economical level, market research before as well as after the introduction can supply valuable insights in further actions that are required to make a new information technology successful. Moreover, promotion and marketing of hard and software are, of course, vital to the adoption of a new information technology. Essential decisions concern market segmentation, price setting and elasticity and available consumer applications.

In addition, sales figures are an important factor. Availability of applications and sales figures lead to two central issues: the critical mass of both applications and users. A critical mass of applications, regarding interactive services such as those in telecommunication systems and multimedia, can be analyzed in terms of the number of users of a specific service or the number of multimedia applications (software) that must be available before a customer will use a telecommunication system or invest in multimedia hardware. On the other hand, producers of multimedia appli-

cations want to know beforehand whether the number of installed platforms is sufficient to recapture investments made (i.e. a critical mass of users). The same goes for services providers on telecommunications networks. They are also interested in the future number of users before developing their products.

Politically, legislation and regulation concerning multiple topics – on a national and international level – can have a major impact on the development of a market for new technologies. For instance: grants, copyrights, regulation of telecommunications, technology and industrial policy strategies and standardization. Standardization facilitates exchangability of hard and software, and therefore enlarges the market, and allows for the protection of markets. Apart from governments, international associations like the European Commission and the International Standards Organization can have a considerable influence regarding the marketing of new information technologies.

Socio-cultural factors in the development of TNS include, 'the general attitude of the potential users toward technology and innovations, adoption and implementation strategies, the social acceptability of the services offered, privacy issues, consumer rights, and labor positions' (Bouwman & Latzer, 1994:169). These issues also apply to multimedia and other information technologies. Inasmuch as the press is a powerful actor in shaping public opinion, it is worthwhile keeping track of positive and negative reactions to products being introduced. Furthermore, national differences should not be overlooked; Minitel in France was a huge success, while similar videotex services in the Netherlands, Denmark, Germany, Italy and Austria developed slowly (Bouwman & Christoffersen, 1992). See Table 1. Another example of a considerable difference between countries in acceptance of a new technology by the public, is the case of the compact disk audio player. In the Netherlands these players are present in 85% of the households, while penetration in the United States is a mere 30% (Hietink, 1994). Other examples are the popularity of electronic book in Belgium and the lack of interest for CD-i in Germany (IMO, 1993; 1994); see also Chapter 2.

Table 2 gives an overview of possible effects of several factors as estimated in research projects on the introduction of CD-ROM, CD-i and 3DO (Hietink & Bouwman, 1994; Heemskerk, 1995). It is not possible here to elaborate on the basis of the assessment noted below, but it should be clear CD-ROM has more factors operating in its favour than the CD-i or 3DO platforms.

An overview of factors, as in Table 2, which play a role in the adoption of multimedia can only indicate the time needed for introduction, but it does not guarantee consumers are actually going to use a specific application or system. However, econometric models offer possibility to estimate market size for a limited set of variables. Usually assumptions about populations are used together with indicators on, for instance, network deployment, tariffs and usage in order to estimate potential

revenues. Based on these techniques, the following estimates for videophone, interactive telegames and teleshopping have been made; see Table 3.

Table 2: Factors influencing adoption of CD-ROM, CD-i and 3DO

	Technique	CD-ROM	CD-i	3DO
Technological	Data capacity	++	+	++
	Compatibility	–	+/–	+/–
Economical	International conjecture	0	–	–
Macro level	Industrial policy	0	0	0
	EC	++	+	–
Meso level	Hardware alliance	++	+/–	+/–
	Software alliance	++	+	–
Micro level	Niche marketing	++	+	–
	Distribution	+	++	–
	Price software	+	+	+
	Critical mass of titles	++	+/–	–
Political	Standardization	++	+	–
	Regulation	–	–	–
Social-cultural	Attitude towards hardware	+	+/–	+
	Attitude towards software	++	+	–
Availability platforms	++	++	–	
	public opinion	++	+/–	–

++ = strong positive effect, + = positive effect, +/– positive nor negative, 0 = no effect, – = negative

Source: Hietink & Bouwman (1994), adapted from Heemskerk (1995)

The problem with this type of model is that one has to estimate the parameters in the equations inasmuch as no real sales figures are available. In that sense, the extrapolations made are only as valid as the assumptions about market developments. In general, adoption follows the well-known S-curve in diffusion studies and one may assume as a rule of thumb that a technology will break through once 5% of the market has accepted the technology. Regarding interactive media, it has been shown that once a critical mass has been reached, growth will accelerate. On the other hand, if a critical mass is not reached the adoption curve will drop. The time scale in which a specific critical mass will be reached is not clear, however. CD-audio players became a success in ten years time, while in the same period pay television has encountered limited acceptance. However, given the current discussions on interactive television, the time might be right for a breakthrough. Still, more than a decade of time is required for penetration of 50% of the mass market (Martin, 1994).

Table 3: Market volumes predicted on econometrical models

	1995	2000	2005	2010	max.
Videophone	2%	10%	25%	35%	50%
Interactive telegames	2%	10%	10%	15%	22%
Teleshopping	3%	9%	15%	20%	30%

Source: Eurescom, 1995

Survey research

Usually empirical data are necessary to make scenario's and econometric models more valid. These data might include already available sales figures or those from survey research. A detailed description of consumer characteristics used to predict adoption and use of videotex is given by Bouwman and Neijens (1991) and Bouwman *et al.* (1991). Based on a meta-analysis of literature, two groups of models were developed, concerning factors regarding acceptance of videotex: models related to the consumer and models related to the videotex system and services. The validity of the consumer models was empirically tested. Directly or indirectly the following variables were found to influence acceptance of videotex: the background variables age, sex and education, attitude towards technology in general and information needs of consumers. As the model was 'primarily directed to the explanation of a general positive or negative attitude towards the acceptance of mass telematics,' these variables are probably also valid for explaining the acceptance of multimedia and other information technologies.

Examples of important questions regarding the attitude of consumers include whether the public is ready to replace a passive entertainment form like television for new interactive media, whether they take an interest in information technology and how much time they are willing to invest in learning to operate new devices. These questions should be included in panel or a trend studies in order allow extrapolation across time. There are several techniques available for extrapolation, but most extrapolations are still far to optimistic and do not take everyday reality into account. For instance, it is often forgotten that most of the time a choice for specific services will be at the expense of other services. Video-on-demand will lead, inevitably, to a decrease in conventional television viewing.

In another research project, a panel of consumers were asked questions about several devices such as videotex (Bouwman *et al.*, 1991) HDTV (Bouwman *et al.*, 1993) and CD-i (Bouwman *et al.*, 1994), and recently summarized over the period 1990 – 1993 (De Jong & Bouwman, 1994). In that time frame, public discussion was mainly centered on videotex, HDTV and CD-i, and 'killer applications' such as home shopping and telebanking. The Electronic Highway was not yet in vogue. Questions were asked about familarity with the different technologies as well as questions intended to determine knowledge of these technologies, readiness to adopt them and the amount of money persons were prepared to pay for them. A stable pat-

tern through the years was found in which possesion and readiness to adopt seemed to be gradually increasing. Also, these two aspects were strongly dependent on respondents' attitude towards information technology, knowledge of new media, education, age and gender.

Conclusions

Most of the time, predictions are used to contribute to a public opinion climate which, in turn, is meant to stimulate attitudes towards adoption of information technology in a positive way. Providers and developers of services use predictions both for stimulating public discourse and as a legitimation for their own research and development programmes. The methods used for prediction have limited value, however, and predictions should be read carefully. This is not only because they have a 'political' function but also because most predictions overestimate actual market developments. In a critical review of technological market failures Schnaars (1990) formulates three guidelines worth repeating here.

- *Avoid technological wonders.* Usually predictions are made in a time of turbulence in which euphoria with new technologies is dominant and the outcome is uncertain. The needs of consumers should get the attention they deserve, and not be ignored in favor of stressing what is technologically possible.

- *Ask fundamental questions about markets.* In general, this means there must be clarity as to who the intended customers of a new application are, how large their share of the market is, what the added value of the new services or devices is for them and whether it fits within their traditional behaviour, whether there are cheaper alternatives, whether there is a balance between costs and benefits, and what public discussion has taken place regarding the innovation. All predictions, in other words, should be approached sceptically.

- *Stress cost benefit analysis.* Opt for cost benefit analysis which not only takes financial indicators into account, but also more qualitative measures for user satisfaction.

One should be very suspicious about the personal interest some parties may have in predictions. A simple way of assessing the value of a prediction, is to look at its source. If the source is an actor financially involved or dependent on explaining the developments in the field or diminishing uncertainty, as is usually the case with consultancy firms, scepticism is mandatory. Also very unlikely forecasts should be discarded. Assessments based on sound conceptual models, for instance as in scenarios and longitudinal research, are more trustworthy then market extrapolations or Delphi methods. In sum, predictions can be useful, but should always be judged on their own merits and be assessed in the context in which and by whom they are used.

References

Arnbak, J., Cuilenburg, J. and Dommering, E. (1990) *Verbinding en Ontvlechting in de Communicatie*, Amsterdam: Otto Cramwinckel.

Bangemann, M. *et al.* (1993) *Europe and the global information society*, recommendation to the European Council, Strasbourg: European Council.

Bens, E. de, and Knoche, M. (1987) *Electronic mass media in Europe; prospects and developments*, Brussels: EC-Fast.

Boelrijk, E., Ligthart, J. and Waes, M. van (1994) *Aanbieders elektronische informatiediensten*; totaal-beeld, Amsterdam: Van der Bunt.

Bouwman, H. (1993) De doos van Pandora, in: H. Bouwman and S. Propper (eds.) *Multimedia; tussen hype en hope*, Amsterdam: Otto Cramwinckel.

Bouwman, H. and Christoffersen, M. (1992) *Relaunching Videotex*, Dordrecht: Kluwer.

Bouwman, H. Hammersma, M. and Peeters, A. (1993) The demand for better television and acceptance of HDTV, paper, International Communication Association conference, Washington, May.

Bouwman, H., Hammersma, M. and Peeters, A. (1994) Acceptatie van CD-I: Marktkansen en belem-meringen, *Massacommunicatie*, 22, 1: 27–40.

Bouwman, H. and Hulsink, W. (1992) The evolution of system cooperation in the Netherlands: Bundling successes or bundling failures, in: H. Bouwman, and M. Christoffersen (eds.) *Relaunching Videotex*, Dordrecht: Kluwer.

Bouwman, H. and Latzer, M. (1994) Telecommunication network based services in Europe, in: C. Steinfield, J. Bauer, and L. Caby (eds.) *Telecommunications in transition: Policies, services and tech-nologies in the European Community*, Thousand Oaks, CA: Sage.

Bouwman, H. and Neijens, P. (1991) Een meta-analyse van videotex-literatuur: Een aanzet tot een acceptatiemodel voor de consumentenmarkt, *Massacommunicatie*, 2: 134–148.

Bouwman, H., Neijens, P. and Peeters, A. (1991) A model for the acceptance of mass telematics: The case of videotex in the Netherlands, paper, International Telecommunication Society conference, Nice, France.

Bouwman, H. and Pröpper, S. (1993) *Multimedia tussen hope en hype*, Amsterdam: Otto Cramwickel.

Eertink, E. and Veltauhsz, D. (1995) *Entertaining telematics; inspannede ontspanning*, Enschede: Telematica Research Centre.

European Commission (1993) Growth, competitiveness, employment, white paper, Commission of the European Communities, Brussels.

Fulk, J. and Steinfield, C. (1990) *Organizations and communications technology*, Newbury Park: Sage.

Gore, A. (1993) The administration's agenda for action, version 1.0, Internet document.

Gurchom, M. and Rijssen, E. van (1995) *Vizier op multimedia: twee toekomstscenario's*, Enschede: Telematica Research Centre.

Heemskerk, A. (1995) Het geruisloos success van CD-ROM, master's thesis, University of Amsterdam, Department of Communication.

Heyne, G. and Andriessen, E. (1991) De informatieverzorging in het jaar 2000, in: G. Kempen and P. de Vroomen (eds.) *Informatiewetenschap* 1991, Leiden: Stinfon.

Hietink, A.J. (1994) CD-i 3DO; *De kansen van twee interactieve CD systemen op de consumenten-markt*, master's thesis, University of Amsterdam, Department of Communication.

Hietink, A.J. and Bouwman, H. (1994) CD-i versus 3DO, *Informatie & informatiebeleid*, 12,2: 6–10.

Hough, R.W. (1993) Multimedia communications in the future; Realistic forecast versus vague con-jecture, in: D. Phillips and P. Desroes (eds.) *Forging the link: Market technology policy*, Amsterdam: IOS Press.

IMO (1993) *Overview of the CD-based Media Market 1987–1992*, Luxembourg: Commission of the European Community.

IMO (1994) IMO report 1993–1994, Internet document.

Jong, A. de and Bouwman, H. (1994) *Consumenten en nieuwe media 1990–1993*, Amsterdam: Stichting Het Persinstituut.

Klopfenstein, B. (1989) Problems and potential of forecasting the new media, in: J.L. Salvaggio, and J. Bryant, (eds.) *Media use in the information age: Emerging patterns of adoption and consumer use*, Hillsdale, NJ: Lawrence Erlbaum.

Martin, P. (1994). The consumer market for interactive services: Observing past trends and current demographics, *Telephony*, 2: 126–130.

Saffady, W. (1991) The market for optical disk products: A review of published forecasts, 1980–1990, *Document Image Automation*, September/October.

Schnaars, S.P. (1990) Megamistakes; *Forecasting and the myth of rapid technological change*. New York: Free Press.

Stoetzer, J.M. (1991) *Der Markt für Mehrwertdienste: Ein kritischer überblick*, Bad Hoffel: WIK diskussionsbeitrag, nr. 69.

Williams, F., Rice, R.E. and Rogers E.M. (1988) *Research methods and the new media*, New York: Free press.